MODELING
IN
LIGHTWAVE

R. Shamms Mortier

CHARLES RIVER MEDIA, INC.
Hingham, Massachusetts

Publisher: Jenifer Niles
Production: Paw Print Media
Cover Design: The Printed Image
Cover Image: Shamms Mortier

CHARLES RIVER MEDIA, INC.
20 Downer Avenue, Suite 3
Hingham, Massachusetts 02043
781-740-0400
781-740-8816 (FAX)
info@charlesriver.com
www.charlesriver.com

This book is printed on acid-free paper.

Shamms Mortier. *Modeling in LightWave.*
ISBN: 1-58450-034-4

Library of Congress Cataloging-in-Publication Data

Mortier, R. Shamms.
 Modeling in LightWave / Shamms Mortier.— 1st ed.
 p. cm.
 ISBN 1-58450-034-4 (paperback with CD : alk. paper)
 1. Computer animation. 2. Computer graphics. 3. LightWave 3D.
I. Title.
 TR897.7 .M677 2001
 006.6'96—dc21
 2001006499

Printed in the United States of America
01 02 7 6 5 4 3 2 First Edition

DEDICATION

FOR MATT STRAUSS. WHOSE WORK AND VISION INSPIRED SO MANY LIGHTWAVERS OF ALL AGES . . . AND STILL DOES.

Acknowledgments

This book owes its existence to the contributed efforts of many individuals:

To Dave Pallai and Jenifer Niles at Charles River Media.

To Hollie Wendt at NewTek.

To all of the plugin and application developers whose software is mentioned and tutorially referenced in these pages.

To David Fugate, my esteemed agent at Waterside Productions.

Contents

Contents

Preface

LightWave is one of the primary progenitors of everything that is happening in computer graphics and animation today. As a LightWave owner and user since its version 1 inception on the Amiga computer in the early eighties, I have watched LightWave evolve along with the industry it serves so well. I have lost count of the number of broadcast TV shows and Hollywood films whose computer graphics and animation FX owe their existence to LightWave over the years. While dozens of its competitors have faded from view and fallen by the wayside during this time, LightWave continues to reinvent itself, incorporating new tools of the trade and enhanced capabilities, all in response to the needs of its large devoted user base. This book concerns itself with LightWave modeling and FX, and I hope that you find it enjoyable as well as informative.

Introduction

There are many levels of use that can describe the LightWave artist. Because the LightWave interface (or rather interfaces, since we are dealing with both the Layout and Modeler modules) is so different from any other 3D application, LightWave users tend to limit their non-LightWave 3D work to fewer external applications. The reason for this is that LightWave demands a more thorough memorization of its hierarchical command structure, a structure not aided by symbols or icons. This may change in some future version, but there's no telling when this might happen. While other 3D applications offer recognizable symbols and icons whose purpose can be recalled by the user without too much struggle, the beginning-to-intermediate LightWave user must restrict themselves to LightWave use for a significant period of time in order to get the hang of things. Working with LightWave therefore requires more diligent study of the documentation and more time spent exploring and experimenting than most other 3D applications. In the end, however, it is time well spent. LightWave rewards the user who devotes time and energy to learning its command structure with creative options and opportunities that push the envelope of computer art and animation.

This book is unique and was written for a few specific reasons. The first was to act as a resource that will tutorially guide the beginning-to-intermediate user through the ins and outs of LightWave modeling and a selection of F/X applications in a clear manner. This does not mean that this book may be substituted for a detailed knowledge of the LightWave documentation; rather, it is assumed that readers already have a solid understanding of LightWave's

fundamentals. This book also points out a number of interesting plugins that can be used to stretch the bounds of what LightWave can do on its own, although the plugins covered here represent only a portion of those that are currently available or that will become available in the future. The third major focus of this book is "handshaking" applications: 3D software that is able to read, write, or both read and write files that LightWave users will appreciate. (This type of software must be purchased separately.)

One more thing: This book is not a LightWave animation book per se, although it does require that you be familiar with features that are centered in the Layout module, where animations are created. You will need to know how to place objects in Layout, transfer them back and forth between Layout and the Modeler, compose scenes in Layout, and set and perform renders. You should also know how to create keyframe animations, since some effects (even if your final goal is the creation of an image as opposed to an animation) can only be appreciated if a keyframe animation of the effect has been set up.

How to Get the Most Out of the Tutorials

If you are a beginner, the best way to maximize your learning experience from the tutorials in this book is to complete each of them three times. The first time, follow the instructions exactly as they are written. The second time, explore how altering some or all of the parameters changes the results, and make a mental note of those changes. The third time, incorporate elements learned in other tutorials, radically altering the parameters as you like. This will greatly enhance your learning experience and will also help you to develop your personal creative style.

Conventions and Shortcuts

In this book, we use the standard convention of pointing out where a command is located. For example, "File>Load>Load Scene" means go to the File menu heading, select the Load item from the list, and then select the Load Scene item from the sublist. Similarly, "Create>Objects>Gear" means go to the Create tab in Modeler, look under the Objects heading, and select the Gear item from the sublist. Make sure you understand this convention and are "working-familiar" with it.

While other 3D applications might consider keyboard shortcuts to be an option (usually referred to as "Expert Mode"), they are regarded as an absolute necessity in LightWave. This equates to a lot of memorizing. Since the documentation lists all of the shortcuts, we will refrain from repeating them here

with the exception of two that are especially essential for your work in this book:

- Keystroke "K." Hitting the "K" key when you have an object in the Modeler workspace will kill all of the object's polygons, leaving nothing but its vertex points. There are many things you can create with just points, so this shortcut is a good one to commit to memory.
- Keystroke "N." This is without a doubt the most valuable shortcut of all. Hitting the "N" key brings up the Numeric window, allowing you to numerically alter the parameters of a selected object in Modeler. In some ways, accessing the Numeric window in Modeler is equivalent to accessing the Object Properties window in Layout. See Figure I.1.

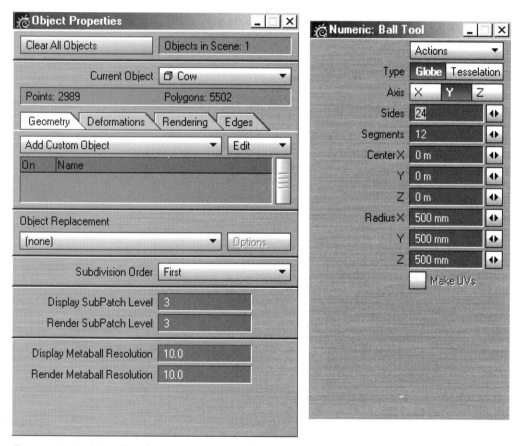

FIGURE I.1 *On the left is the Object Properties window in Layout, and on the right is the Numeric window in the Modeler. They have different uses and controls, but each allows you to adjust the parameters of selected objects.*

VERSION 7 AND ABOVE

This book will serve for versions of LightWave equal to or higher than version 7, but will have limited use for versions below that. This is because the hierarchical command structure—the way subcommands are nested under specific headings—was altered globally, with many resulting changes, in version 6.5 and again in version 7. When suitable, the book will tell you where specific commands can be found, though you will be expected to already have this knowledge in most cases.

If you are using a version of LightWave higher than 7, you may find that some of the commands in your version differ from those alluded to in this book. If this is the case, you should still be able to find your way around by paying attention to the LightWave documentation.

If you prefer using the LightWave 5.6 or 6.0 interface and want to return to that interface configuration because you are more comfortable with it, do the following:

1. Go to Layout>Interface>Menu Layout.
2. Under Presets, activate either 6.0 Style or 5.6 Style. See Figure I.2.

Your interface will change to that of the selected previous version. You can return to the version 7 interface in the same manner.

THE HUB

LightWave contains two separate modules, each of which is booted on its own: Layout and Modeler. In Modeler, you create the objects that will be used in a scene. In Layout, you compose the scene, configure animations, and render the final results to storage media. The Hub is a new feature in LightWave that allows instant communication between the two modes or modules. You can instantly transport a 3D object from Modeler to Layout, and altering the object in either module will instantly update it in the other. Make sure you read the documentation and know how this function works in both Layout and Modeler so that you can perform object transporting when called upon to do so in a tutorial.

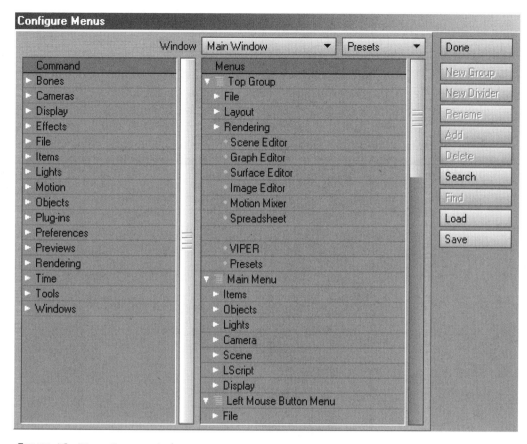

FIGURE *The Menu Layout window.*
I.2

DISPLAY OPTIONS

For the tutorials in this book, we will use a grid setting that sets each grid to one meter. To set the grid, do the following:

1. Go to the Display Tab in Modeler. Select View Options from the command list on the left (by default, this is its position).
2. The Display Options window will appear. See Figure I.3.
3. Go to the Units Tab. Set Unit System to Metric and Grid Units to 1. Select None for Grid Snap. Click on OK.

FIGURE *The Display Options window.*
I.3

4. Go to the Display Tab in Layout.
5. In the Command List, under Options, click on Display Options. The Layout Display Options window opens. See Figure I.4.
6. Set Grid Square Size to 1 m, for one meter. Close the window.

Make sure you work with these settings throughout this book unless it is suggested otherwise.

THE STRUCTURE OF THIS BOOK

This book is separated into five main parts:

- Part I: Basics of LightWave Modeling. This is a tutorial refresher course that targets all of the basic LightWave modeling techniques. Its use is both as an introductory text for LightWave beginners and as a pointer for more advanced users, showing where the new commands are in version 6.5 and higher.

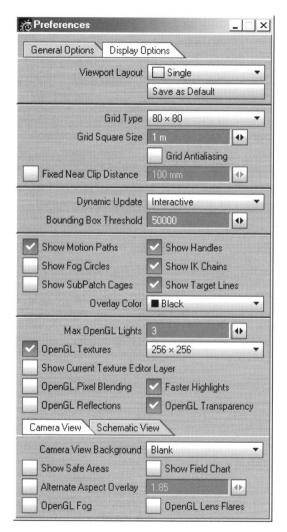

FIGURE *The Layout Display Options list.*
I.4

- Part II: More Advanced Modeling Techniques. This part of the book walks you through more complex modeling alternatives, including Displacement Modeling, Metaballs, HyperVoxels, Metaform Modeling, Self-Similar Modeling (Mirror, Array, Clone, Symmetrize), Modeling with Particles, Pivots/Parenting/Hinges, and more.
- Part III: Plugins. Chapters in this section of the book deal with the specific use of both commercial and shareware/freeware plugins.

- Part IV: Handshaking Applications. Included here are a number of tutorials on external applications that may be useful to your LightWave work. These include DarkTree Textures, Surface Toolkit from dvGarage, Eovia's Amapi, ElectricImage's Amorphium, and Onyx Software's Tree Professional
- Part V: Projects. This section includes a selection of project tutorials.

At the end of the book are two appendixes. Appendix A describes the content of the CD, which includes all of the tutorials as well as a wealth of value-added files. Appendix B lists vendor contact information.

HOW TO USE THIS BOOK WISELY

The best way for you to make use of this book will depend upon your level of prior experience with LightWave. See which of the following categories of users best describes your interaction with LightWave:

- Brand-new LightWave user with no previous experience with any other 3D application: You will want to spend as much time as it takes working through all of the LightWave documentation before approaching this book. When you do use this book, do all of the tutorials. You can skip the section on handshaking applications (Part IV) if you don't own any of them, although a quick read of this section may give you what you need for future purchases.
- User with intermediate experience with another 3D application, but new to LightWave: LightWave's interface and way of going about things is different enough from other 3D applications to warrant your completing all of the tutorials in this book. At the very least, you will become working-familiar with the structure of LightWave's command interface.
- User with intermediate experience with a version of LightWave prior to version 6.5: You can use Part I of this book to familiarize yourself with the changed location of commands in the newer versions of LightWave. Your main interest will probably center upon the plugins and handshaking applications (Parts III and IV).
- Professional LightWave user: If you frequently work with LightWave to create professional graphics and animations, you can pretty much skip Parts I and II of this book. Read and work through Part III, especially if you have recently purchased one of the mentioned plugins. Do the same with Part IV if you have one of these applications or to familiarize yourself with additional software that might be useful at a later date.

Basics of
LightWave
Modeling

1

Loading/Importing Models and Using Primitives

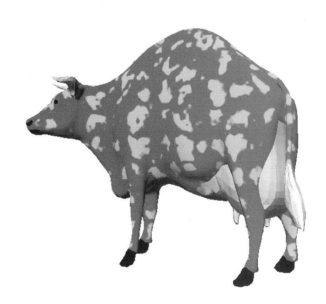

With some variations, there are three basic ways to access 3D models for placement in a LightWave scene. Models can be loaded from the Objects folder that is installed when you install LightWave. The Objects folder contains a number of subfolders that are separated by object category, allowing you instant access to a wealth of modeling content. You can also import 3D models from other storage folders on your system or from CD collections. In past versions of LightWave it was fairly difficult to import non-LightWave object formats, but that is no longer the case. In addition to LightWave-created objects, you can import DXF, OBJ, and 3DS objects.

Working with Primitive objects is very important for LightWave artists. Primitive objects are placed in the Modeler by accessing their type from the Create tab. Primitive objects are most often used as a first step in creating more complex models, by either combining them or by modifying their form.

LOADING OBJECTS

The same command, Load Object (from the File menu), is used to place either LightWave or non-LightWave objects in either the Modeler or Layout. Objects placed in Layout can be tweaked in a limited number of ways, while objects placed in Modeler can be almost infinitely modified. Using the Hub, objects can be transported to and from Layout and Modeler.

TRANSFORMING LOADED OBJECTS

In 3D graphics, "transformation" refers to the scaling, rotating, or repositioning of an object. Other options for altering a selected object's form go under the heading of "modifying." Three-D objects can be transformed in either Layout or Modeler. Objects are most frequently modified in Modeler, although some special modification operations can be activated in Layout.

TUTORIAL

LOADED 3D OBJECT PLACEMENT AND TRANSFORMATION EXERCISES

Do the following:

 1. Go to File>Load Object in Modeler.

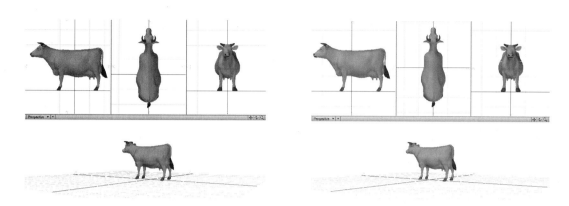

FIGURE **1.1** *The model of the cow appears in the workspace.*

FIGURE **1.2** *The cow object is centered and sits on the grid plane.*

2. Locate the Objects folder in your LightWave folder. Open the Animals subfolder, and select the cow. Load it. The famous LightWave cow appears in the workspace. See Figure 1.1.
3. Any object that appears in Modeler is open to all of the modification tools. Go to Modify>More>Rest on Ground, then to Modify>More>Center ID Data (use the Y axis). The cow is now centered on the grid and rests on the plane. See Figure 1.2.

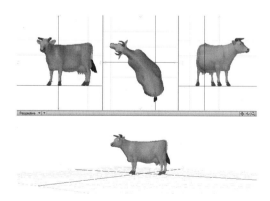

FIGURE **1.3** *Adding a simple bend can give an organic object more personality and life.*

FIGURE *The cow's back is modified with the*
1.4 *Magnet modifier.*

4. Go to Modify>Rotate>Bend. Use the Bend tool in the Front View. Start at the middle of the cow, and click-drag the mouse to the right to give the cow a bend on its Y axis. See Figure 1.3.
5. Go to Modify>Move>Magnet. Place the mouse pointer at the top center of the cow's back in the left or right view, and click-drag upward. This gives the cow a large humped back. See Figure 1.4.

NOTE

You cannot use the Hub to send the object to Layout until it is first saved.

FIGURE *The cow appears in the Layout*
1.5 *workspace.*

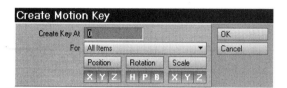

FIGURE *The Create Motion Key window.*
1.6

FIGURE *The modified cow model is now seen in*
1.7 *the altered Camera view.*

6. Go to File>Save Object As. Save the cow to the same folder it came from, but save it as MyCow1.lwo.
7. Go to the Hub commands list at the top right of the Modeler (the downward pointing arrow). Select Send Object to Layout. The Layout screen appears with the modified cow placed at the center of the grid. See Figure 1.5.
8. Go to the Camera view in Layout. Move and rotate the Camera so that you have a better view of the cow as a profile.

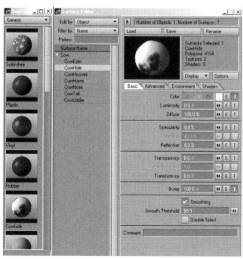

FIGURE *The Surface Editor and Surface Preset*
1.8 *windows appear.*

You should get in the habit of creating a keyframe every time you make adjustments to the camera position or rotation so that the new position/rotation is set from that point on.

9. Click on the Create Key button at the bottom of the Layout interface. Select For All Items, leaving all other settings at their default. Click on OK. See Figures 1.6 and 1.7.

10. If you have read and worked through the LightWave documentation carefully before opening this book, then you are aware that object textures are applied to Surfaces. Any object can have one or multiple Surfaces, so the texture (usually referring to Bitmap images) or Materials (usually referring to procedural or algorithmic textures) that any object displays can be quite complex. Many 3D models in the Objects folder are composed of subobjects, each of which has its own Surface components. You can alter preassigned Surface attributes, or you may create your own Surfaces for newly modeled objects. We are going to alter the cow's preassigned Surface components. Click on the Surface Editor item in the command bar in Layout. The Surface Preset Shelf is accessed by clicking on Preset in the toolbar.

 The Surface Editor and Surface Preset windows appear. See Figure 1.8.

11. You can see in the Surface Editor window that there are tabs and commands that allow you to alter a Surface map in a number of ways. For now, we will use some of the Preset Surfaces just as they are to alter the look of the cow.

FIGURE **1.9** *The Render Options window.*

FIGURE **1.10** *The Effects window is where your backdrop for the rendered image is configured.*

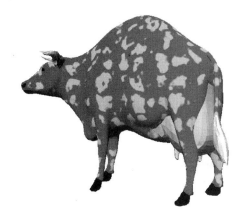

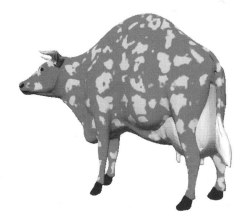

FIGURE **1.11** *The finished rendering of our strange cow.*

FIGURE **1.12** *The model's parts now appear much smoother than before.*

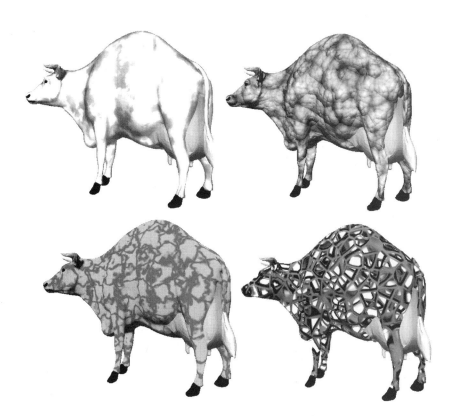

FIGURE **1.13** *Alternate CowHide surface textures.*

To apply a Surface Preset to any selected Surface part of the cow, select the part from the Surface Editor/Surface Name item in the list (on the upper left of the Surface Editor window). Then choose a Preset you like in the Surface Preset window, and double-click to apply it to that part of the geometry.

12. Apply the following Surface Presets to the cow's parts: Eyes, Hooves, and Nose to solid black from the Colors Presets; Tail Bisque from the Colors Presets; CowHorns Eggshell from the Colors Presets; CowUdder Pink from the Colors Presets; CowHide to Splotches from the Generic Presets. The unique cow is now Surfaced with multiple textures.

13. Now to create an image. Go to Rendering>Render Options. When the Render Options window appears leave all at their defaults, which should resemble Figure 1.9.

14. Go to Scene>Backdrop, which brings up the Effects window. Change the backdrop color to white from its default of black. See Figure 1.10.

15. Go to Rendering>Render Current Frame to create the image. Save the image to disk. See Figure 1.11.

16. Go to Modeler>Construct>Triple. This makes all polygons in the model triangular. Select Construct>SubDivide>Smooth. This creates twice as many polygons and smooths the model. Return to Layout and render again. See Figure 1.12.

17. Using the Surface Editor, explore the use of alternate textures for the CowHide component. See Figure 1.13.

If you have access to DXF, OBJ, or 3DS models, use the Load command to import them into LightWave. Use similar techniques to those covered in the previous tutorial to alter their geometry and surface components.

NOTE

TUTORIAL

USING OBJECT PRIMITIVES

Object primitives are common to all 3D applications, although each 3D application has its own particular selection. LightWave object primitives are created and modified in Modeler. Object primitive types include the box, ball, disk, cone, capsule, platonic solid, superquadratic, wedge, gear, gemstone, equilateral triangle, toroid, quadratic, parametric object, bubbles, helix plot 1D, and plot 2D. From time to time, if you browse various LightWave sites on the Web, you may discover additional object primitives to add to your collection. Object primitives are found in Modeler>Create>Objects. Use the short exercises that follow to get the hang of creating models based upon some of these object primitives.

It's best to create object primitives with the assistance of the Numeric window (activated by hitting the "N" key on your keyboard after selecting the object primitive), although you can also just click and drag out most of their forms interactively in any viewport. It's very important to remember that you can always bring up the Numeric window for the object after you create it manually, allowing you to tweak any or all of the object's parameters.

THE BOX

Use the Box command to create cubes or all manner of elongated rectangular solids. You can select the Box command and click and drag in any viewport to form the box's base, then click-drag in another viewport to control its depth. A preferred method is to use the Box's Numeric window as follows:

1. Select the Box command.
2. Hit the "N" key, which brings up the Numeric Box window.
3. Under the Action button, select Activate. A box appears on the screen immediately.
4. Alter the Low/High XYZ values while keeping an eye on the model until you get the dimensions you require.
5. If you plan to bend or otherwise deform the box later, increase the Segment values to get a smoother effect. XYZ Segment values from 4 to 8 are the most common, but higher values are possible.
6. Close the window when your adjustments are complete. See Figure 1.14.

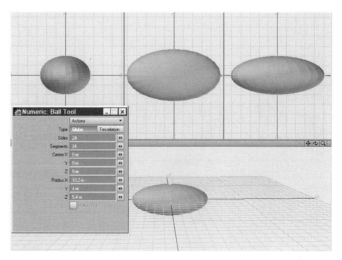

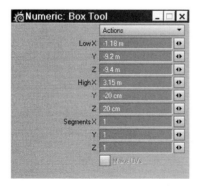

FIGURE **1.14** *The Numeric Box window.*

FIGURE **1.15** *The Numeric Ball window helps you create and adjust ball-like objects.*

THE BALL

Use the Ball command to create spheres or all manner of elliptical solids. You can select the Ball command and click and drag in any viewport to form the ball's base, then click-drag in another viewport to control its depth. A preferred method is to use the Ball's Numeric window as follows:

1. Select the Ball command.
2. Hit the "N" key, which brings up the Numeric Ball window.
3. Under the Action button, select Activate. A ball appears on the screen immediately.
4. Alter the Radius XYZ values while keeping an eye on the model until you get the dimensions you require.
5. If you plan to bend or otherwise deform the ball later, increase the Side and Segment values to get a smoother effect. XYZ Side and Segment values from 24 to 48 are common, but lower and higher values are possible.
6. Close the window when your adjustments are complete. See Figure 1.15.

THE DISK

Use the Disk command to create a flat 2D disk or ellipsoid, or all manner of cylinders. You can select the Disk command and click and drag in any viewport to form the Disk's base, then click-drag in another viewport to control its depth. A preferred method is to use the Disk's Numeric window as follows:

1. Select the Disk command.
2. Hit the "N" key, which brings up the Numeric Disk window.

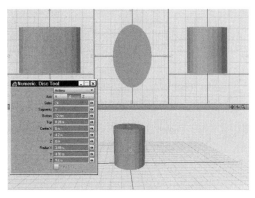

FIGURE
1.16 *The Numeric Disk window helps you create and adjust cylindrical objects.*

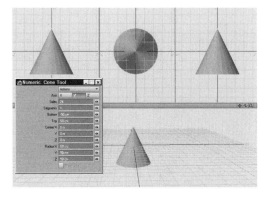

FIGURE
1.17 *The Numeric Cone window helps you create and adjust conical objects.*

3. Under the Action button, select Activate. A cylinder appears on the screen immediately.
4. Alter the Radius XYZ values and other parameters while keeping an eye on the model until you get the dimensions you require.
5. If you plan to bend or otherwise deform the cylinder later, increase the Side and Segment values to get a smoother effect. XYZ Side and Segment values for a smooth cylinder normally range from 24 to 48 Sides and 8 or more Segments. Lower and higher values are possible.
6. Close the window when your adjustments are complete. See Figure 1.16.

THE CONE

Use the Cone command to create any cone-like solids. You can select the Cone command and click and drag in any viewport to form the cone's base, then click-drag in another viewport to control its depth. A preferred method is to use the Cone's Numeric window as follows:

1. Select the Cone command.
2. Hit the "N" key, which brings up the Numeric Cone window.
3. Under the Action button, select Activate. A cone appears on the screen immediately.
4. Alter the Radius XYZ values while keeping an eye on the model until you get the dimensions you require.

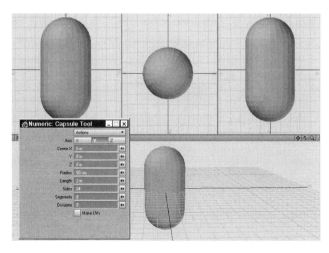

FIGURE *The Numeric Capsule window helps you create and*
1.18 *adjust capsule objects.*

5. If you plan to bend or otherwise deform the cone later, increase the Side and Segment values to get a smoother effect. The Segment values are especially important for smooth modifications, ranging from 8 upward.
6. Close the window when your adjustments are complete. See Figure 1.17.

The Capsule

Use the Capsule command to create all manner of cylindrical solids with rounded ends. You can select the Capsule command and click and drag in any viewport to form the capsule's base, then click-drag in another viewport to control its depth. A preferred method is to use the Capsule's Numeric window as follows:

1. Select the Capsule command.
2. Hit the "N" key, which brings up the Numeric Capsule window.
3. Under the Action button, select Activate. A capsule appears on the screen immediately.
4. Alter the Radius XYZ values while keeping an eye on the model until you get the dimensions you require.
5. If you plan to bend or otherwise deform the capsule later, increase the Side, Segment, and Division values to get a smoother effect. Click to activate the UVM mapping texture wrapping option if this is desirable.
6. Close the window when your adjustments are complete. See Figure 1.18.

The Platonic Solid

Use this option to create any of the platonic solids. Unless you want to create the same platonic solid selected the last time you used this command, it is required that you use the Numeric window to select the platonic solid type. There are seven platonic solids to choose from: tetrahedron, cube, octahedron, cubeoctahedron, icosahedron, dodecahedron, and icosidodecahedron. Each has some unique parameter settings. Use the Platonic Solid's Numeric window as follows:

1. Select the Platonic Solid command.
2. Hit the "N" key, which brings up the Numeric Platonic Solid window.
3. Under the Action button, select Activate. A default platonic solid appears on the screen immediately.
4. Alter the parameters for the specific platonic solid you are working with to fashion the exact 3D object you require.
5. Close the window when your adjustments are complete. See Figure 1.19.

The SuperQuadratic

Explore the use of the SuperQuadratic command to create unique toroid or ellipsoid forms. Use the SuperQuadratic's Numeric window as follows:

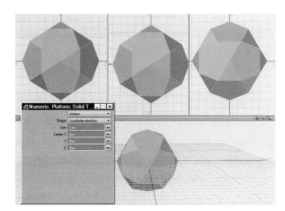

FIGURE **1.19** *The Numeric Platonic Solid window helps you create and adjust any of the seven platonic solid objects.*

1. Select the SuperQuadratic command.
2. Hit the "N" key, which brings up the Numeric SuperQuadratic's window.
3. Under the Action button, select Activate. A default superquadratic appears on the screen immediately.
4. Select either Toroid or Ellipsoid. Alter the parameters for the specific superquadratic you are working with to fashion the exact 3D object you require.
5. Close the window when your adjustments are complete. See Figure 1.20.

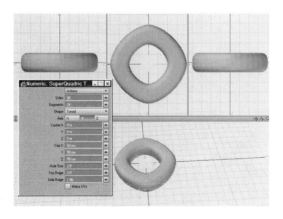

FIGURE **1.20** *The Numeric SuperQuadratic window helps you create and adjust the resulting 3D objects.*

The following object primitives can found under Objects>More.

THE WEDGE

Use the Wedge (Annulus) command to create solids that resemble tubes or slices of a hose. Use the Annulus Numeric window as follows:

1. Select the Wedge command.
2. Hit the "N" key, which brings up the Annulus Numeric window.
3. Unlike other objects, you will not get automatic visual feedback. You must configure the form and then close the window to see the object.
4. Alter the parameters for the specific wedge object you are working with to fashion the exact 3D object you require.
5. Close the window when your adjustments are complete, and the object will appear. See Figure 1.21.

THE GEAR

Use the Gear command to fashion gear objects according to your needs. Use the Gear Numeric window as follows:

1. Select the Gear command.
2. Hit the "N" key, which brings up the Gear's Numeric window.
3. You will not get automatic visual feedback. You must configure the form and then close the window to see the object.

FIGURE **1.21** *The Annulus Numeric window allows you to adjust any of the wedge parameters.*

FIGURE **1.22** *The Gear's Numeric window allows you to configure all of the necessary parameters.*

4. Alter the parameters for the specific gear object you are working with to fashion the exact 3D form you require.

5. Close the window when your adjustments are complete, and the object will appear. See Figure 1.22.

THE QUADRATIC

Explore the uses of the Quadratic command to create unique solids related to rounded cubic forms with or without holes. Use the SuperQuadratic Object window as follows:

1. Select the Quadratic command.
2. Hit the "N" key, which brings up the SuperQuadratic Object window.
3. You will not get automatic visual feedback. You must configure the form and then close the window to see the object.
4. Alter the parameters for the specific quadratic object you are working with to fashion the exact 3D form you require.
5. Close the window when your adjustments are complete, and the quadratic object will appear. See Figure 1.23.

FIGURE *The SuperQuadratic Object window allows*
1.23 *you to adjust any of the quadratic parameters, including determining whether or not the form will have a hole in it.*

THE PARAMETRIC OBJECT

Explore the parameters of this function to create unique solids based upon mathematical equations. The legitimate terms are listed in the appendix of the

documentation (in the introductory manual). If you are a math whiz, you can use this feature to create some interesting solids. If not, you may start by just playing around with the default equations. See Figure 1.24.

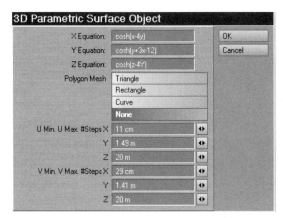

FIGURE *The Parametric Surface Object settings*
1.24 *window.*

PLOT 1D/PLOT 2D

We'll take a look at these options later, when we discuss Extrusion and Lathing.

ONWARD

In this chapter, we have introduced the topic of LightWave modeling by taking a look at what can be accomplished when importing a 3D object. We also looked at how the basic primitives are configured. In the next chapter, we will investigate how to transform 2D shapes into 3D forms.

CHAPTER

2

From 2D to 3D

S o far, we have explored the creation of models by using commands that allow us to import models already created and then tweaking them, as well as commands that allow us to use object primitives to create diverse types of 3D forms. We'll now take a look at LightWave's capability to allow you to transform a 2D shape (line or curve) into a 3D object through the use of special tools under Multiply>Extend Modeler: Lathe, Extrude, Bevel, Rail Bevel, Smooth Shift, Path Extrude, and Rail Extrude. We will also investigate Create Skin (under Multiply>Extend>More).

DOUBLE-SIDED POLYGONS

Before walking through tutorials for each of these 2D to 3D operations, however, you must understand the importance of creating double-sided polygons. This is because single-sided polygons have their normals projecting from only a single side. This is fine in most instances, as long as you don't have to see the inside of an object. With the LightWave cow model, for example, nothing would render unless you translated the cow's single-sided polys into double-sided ones. This problem is more common when creating objects like vases or tubes, objects whose insides become apparent from certain vantage points. There are two ways of transforming single-sided polys to double-sided polys in LightWave.

METHOD #1
Do the following:

1. Open the Surface Editor for the object.
2. The first thing you should always do is to rename the Surface from its default name, making it unique so it will be permanently identified with the object. Click on Rename, and type in a unique surface name. See Figure 2.1.
3. Check the box next to Double Sided. This makes sure that after the object is saved and ported over to Layout, any renders will take notice of both sides of all object polygons. This is important when you want to drill holes in objects and need to show the inverse side of polys.

METHOD #2
Using this method, you can create true double-sided polygons for any object. Do the following:

1. Select all of the polygons in the targeted object, or select those you want to be double-sided (the top part of a vase, for instance). If you do not understand how to select polygons, reread the documentation.

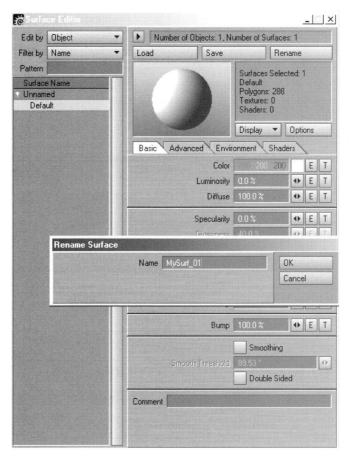

FIGURE *The Surface Editor for a selected object, with the Rename*
2.1 *window open.*

2. Go to Edit>Copy and then Edit>Paste. This places a duplicate of the object in the same position as the source object.
3. Go to Detail>Polygons>Flip. This flips the normals of the polygons on the duplicated (pasted) object.
4. Select all of the points on the source and duplicated object. Finally, go to Construct>Reduce>Merge Points. This command merges all points on a selected object that are coincident.

Performing both of these operations as a matter of course on most objects you create will guarantee that you will be able to render both the inside and outside of the objects. Keep this in mind.

FIGURE **2.2** *Create a random shape with the Pen tool in the front view.*

FIGURE **2.3** *The Numeric Lathe tool window.*

TUTORIAL

2D TO 3D OBJECT OPERATIONS

Complete the following tutorials to understand the options for creating 3D objects from 2D components. These commands are listed under Multiply>Extend.

NOTE

Many of these operations require that you are working-familiar with the concept and use of Layers in the Modeler. If you are not, reread the LightWave documentation.

LATHE

A lathed object is called an "object of revolution." That's because it's created by revolving a 2D shape around an axis in 3D space. To create the 2D shape, we will start with the Pen tool. Do the following:

1. Go to Create>Elements>Pen in the Modeler. Click down randomly to create a shape in the front view. See Figure 2.2.
2. Go to Multiply>Lathe and bring up the Numeric window. See Figure 2.3.
3. Change End Angle to 180 degrees as shown, and set the XYZ centers to 0 m. Look at the object you created. See Figure 2.4.

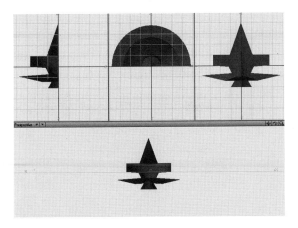

FIGURE
2.4
The object as it appears in Modeler.

FIGURE
2.5
The rendered object.

4. Create a surface with double-sided polygons. Send the object over the Hub to Layout. Position and render. See Figure 2.5.

An Alternate Lathing Method
Here's another way to lathe a shape. Do the following:

1. Use the Pen tool to create a shape in the front view, as displayed in Figure 2.6.

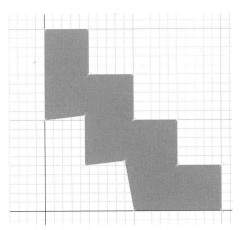

FIGURE
2.6
Create a shape that resembles this one.

2. Select Lathe. Without bringing up the Numeric window, click and drag the mouse in the front view. Note that as you move the mouse, the axis of rotation changes, resulting in a constantly altered lathed object. Let up on the mouse when you like what you see. See Figure 2.7.

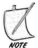

Remember that clicking on the 0 Numkey will toggle the viewport currently under your mouse to full screen and back again, which is great for drawing shapes.

EXTRUDE

Extruding an object adds 3D depth to an otherwise flat surface. You have already seen this when we extruded the Disk object to create a cylinder in Chapter 1. Extrude can be used on a line, a curve, or an enclosed shape. It is important to select the viewport you are applying extrude to very carefully in order to extrude along the correct axis. If you use Extrude without the benefit of the Numeric controls, you can add a slant to the extrude simply by moving the mouse to another location. Do the following:

1. Go to Create>Elements>Sketch and draw a free-form curve in the top view that resembles the one displayed in Figure 2.8.
2. Go to Multiply>Extend>Extrude. Use the front view and click-drag the mouse until you have created a 3D form you like. Make polys double-sided. This method can be used to create all manner of wavy forms. See Figure 2.9.

FIGURE **2.7** *One of many possible resulting lathed objects.*

FIGURE **2.8** *Draw a curve that resembles this one.*

FIGURE *The extruded form.*
2.9

BEVEL

A Bevel is a variation of an Extrude operation that resizes the extruded surface at the same time. Do the following:

1. Go to Create>Objects>Disk and place a disk in the top view.
2. Go to Multiply>Extend>Bevel and create a 3D beveled object by click-dragging in first the top view and then the front view. See Figure 2.10.
3. With the Bevel tool still selected, right click (Win) or Opt Click (Mac) in a viewport. This ends the Bevel operation, but leaves the top surface still selected for another Bevel operation.

FIGURE *Your first beveled object should look like a peanut-*
2.10 *butter cup.*

4. Apply another Bevel operation. Repeat this procedure one more time. The result is a very complex object. Save the object and give it double-sided polys. See Figure 2.11.

5. Just for the fun of exploration, do this: Go to Modify>Stretch>More> Smooth Scale, and apply the default values. This alters the sharpness of the object's polys. See Figure 2.12.

FIGURE **2.11** *The multibeveled object.*

FIGURE **2.12** *After Smooth Scaling has been applied, the object looks like this.*

RAIL BEVEL

This is a fairly bizarre and unintuitive object creation tool. You may get the best results by placing a curve in a background layer and a 3D object in a foreground layer. Try this:

1. Place a disk in a background layer. This will act as an oval.
2. Place a cone in a foreground layer. See Figure 2.13.
3. Go to Multiply>Extend>Rail Bevel and click-drag the mouse in any se- lected viewport to create the object, which resembles a fancy lamp. See Figure 2.14.

If any object creation method demands exploration in order to get a more in- tuitive feel for the possibilities, this one does. Use different shapes and forms in the layers, and keep some notes on the process.

SMOOTH SHIFT

Smooth Shift is another variation of the Bevel tool. It moves selected polys along their Vertex Normals, either in or out. Do the following to explore it:

FIGURE *The disk is in the background layer and*
2.13 *the cone is in the foreground layer.*

FIGURE *The rail beveled creation.*
2.14

1. Use the Numeric window to create a spheric ball object.
2. Select the polys along the top of the ball, as shown in Figure 2.15.
3. Go to Multiply>Extend>Smooth Shift. Click and drag the mouse left to shrink the polys and right to expand them. See Figure 2.16.

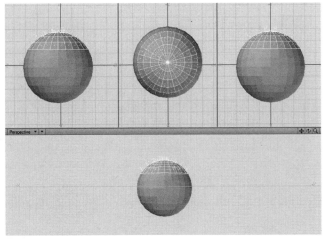

FIGURE *Select the polys along the top of the ball.*
2.15

PATH EXTRUDE/RAIL EXTRUDE

These two operations are basically the same, except that Path Extrude works with a motion path and Rail Extrude works with a 2D curve (a "rail"). Do the following to explore their use:

1. Create a curved shape using the Sketch tool in a background layer, front view. See Figure 2.17.
2. Create another shape with the Sketch tool in the top view, using a foreground layer. See Figure 2.18.
3. Go to Multiply>Extend>Rail Extrude. Select Automatic from the window that appears, and click on OK. The rail extruded 3D object is created. See Figure 2.19.

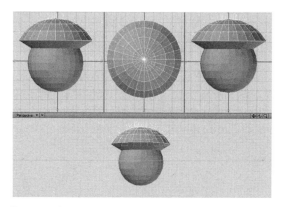

FIGURE *After a Smooth Shift operation.*
2.16

FIGURE *Create a curve.*
2.17

FIGURE *Create another shape on a foreground*
2.18 *layer.*

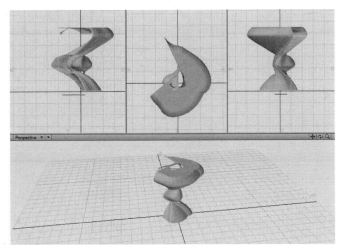

FIGURE *The rail extruded object.*
2.19

CREATE SKIN

A "skin" is a surface that connects two or more cross-section shapes. The order in which you create the cross-sections is very important, since the skinning operation will follow that order. Do the following:

1. Create a closed curve with the Sketch tool in any view. If the curve doesn't close automatically, select all of its points. Then go to Create>Elements> Make Curve>Make Closed Curve. See Figure 2.20.
2. Go to Multiply>Duplicate>Clone, which brings up the Clone window. This is where we will create multiple clones of the selected shape (cross-section) so that a skin can be generated to connect them. Input the values displayed in Figure 2.21.
3. Select Polygons from the bottom menu bar, and select all of the 2D curves. Go to Multiply>Extender>More>Create Skin, and a skin will be generated that connects all of the cross-sections. Make all double-sided polygons. See Figure 2.22.

When it comes to 2D shapes, it is far better to create them in a vector drawing application like Illustrator or Freehand than to use the Pen, Sketch, or Bezier tools in LightWave. That's because vector applications allow more fine-tuning of shapes. You can simply import the shapes into LightWave as EPS files.

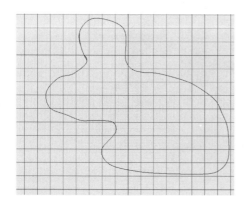

FIGURE *A closed curve.*

2.20

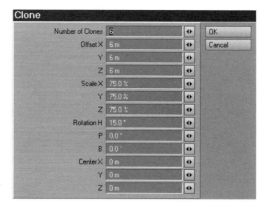

FIGURE *Input these values.*

2.21

FIGURE *A skinned object is created.*

2.22

ONWARD

In this chapter, we have explored how some 2D shapes can be used to create 3D forms. The examples given represent only the bare minimum of what can be accomplished, so it's really up to you to explore additional possibilities. In the next chapter, we will look at some special modeling alternatives.

There are a few modeling alternatives contained in the Modeler that allow you to create some unique 3D objects, including SeaShell Tool (Multiply>Extend>SeaShell Tool), Spikes (Multiply>Extend>Spikey Tool), Teapot (Construct>Additional>Teapot), and Patch Modeling.

TUTORIAL

SeaShell Tool

After you take a good look at the LightWave logo, you will understand why there is a SeaShell modeling operation in Modeler. The spiral is and always has been the symbol that NewTek has used to stand for LightWave, though it has appeared in some different variations. There's more than that, for those of you either knowledgeable about or interested in doing some research on the Italian mathematician and philosopher Fibonacci or on the use of the geometric principle known as the Golden Section. Resource information can be found by placing either "Fibonacci" or "Golden Section"—or both—in your Web search engine.

The SeaShell Tool is located at Multiply>Extend>More>SeaShell Tool. To explore its use, do the following:

1. Draw a squiggly line in the front view with the Sketch tool.
2. Go to Multiply>Extend>SeaShell Tool.
3. Hit the "N" key to bring up the Numeric SeaShell Tool window. See Figure 3.1.
4. Leave the default values as they are, and close the window to create a seashell. See Figure 3.2.
5. Bring up the Numeric window again, and change the values to those shown in Figure 3.3.

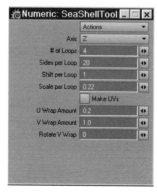

FIGURE **3.1** *The Numeric SeaShell Tool window.*

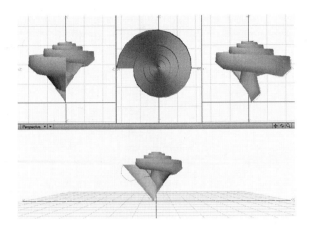

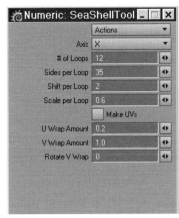

FIGURE *A seashell that follows the default values.*
3.2

FIGURE *Use these values.*
3.3

6. The result is a different helical solid. See Figure 3.4.

MORE VARIATIONS

Try these variations:

1. Create a default box using the values in the Numeric window.
2. Go to the SeaShell Tool and use the values shown in Figure 3.5.
3. The result is a square screw or drill bit. See Figure 3.6.

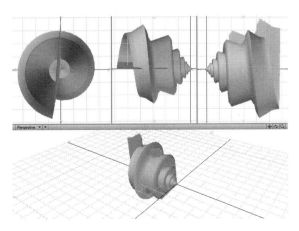

FIGURE *A seashell variation.*
3.4

FIGURE *Use these values.*
3.5

FIGURE *The resulting 3D model.*
3.6

FIGURE *Use these values.*
3.7

4. Start with a default ball object.
5. Use the SeaShell Tool values shown in Figure 3.7.
6. The result is a model that can be used as the top of an Eastern temple. See Figure 3.8.
7. Depending upon the 3D object or 2D shape you start with, its position and orientation, and the values for the SeaShell Tool, you can explore the creation of a wide variety of objects. Another important consideration is the axis of revolution, as shown clearly in Figure 3.9.

SPIKES

Spikes are extrusions based upon the normals of any selected polygon. Spikes have as many sides as the polygon they are extruded from, and their base size

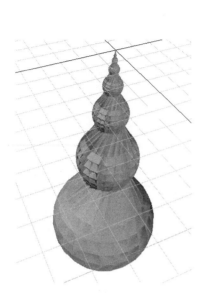

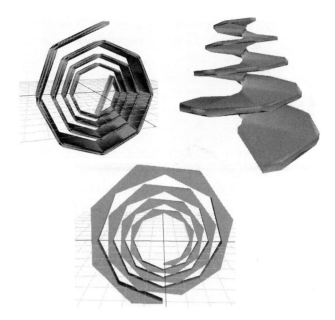

FIGURE
3.8
The resulting 3D model.

FIGURE
3.9
From top left to bottom, the same form (a rectangular solid) was used to generate these three objects. The only difference was the axis of rotation: X, Y, and Z.

FIGURE
3.10
The ball.

is the size of the polygon. The Numeric window for the Spikey Tool (Multiply>Extend>More>Spikey Tool) contains just one value for the length of the spike. Spikes are usually applied by clicking and dragging the mouse in a viewport. The two most common applications for spikes are to create them for an entire object or just for selected polygons, configuring the length as needed. Spikes can protrude outward or inward. Do the following exercises to get a feel for how the Spikes operation works:

1. Create a ball (globe) with 24 sides and 12 segments. See Figure 3.10.
2. Go to Multiply>Extend>Spikey Tool. Click and drag to the right in any viewport. Spikes are created at each polygon normal. See Figure 3.11.
3. Undo and reapply the Spikey Tool by dragging to the left. See Figure 3.12.

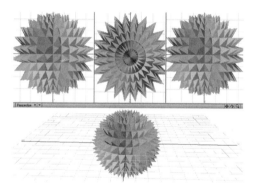

FIGURE **3.11** *Spikes protrude outward from each polygon normal.*

FIGURE **3.12** *By click-dragging to the left, inward-turning spikes are created.*

4. Undo and go to Construct>SubDivide>Triple. All of the quadrangular polygons that make up the ball object are split into triangular polys. Go to Construct>SubDivide>SubDivide. Apply a Smooth SubDivide when the window appears. Now you have twice as many triangular polys. See Figure 3.13.

5. Now apply the Spikey Tool. Notice the difference in both the number of spikes and their base size. See Figure 3.14.

6. Undo the Spike Tool operation. Select only the polygons at the top of the ball.

7. Apply the Spikey Tool again. See Figure 3.15.

FIGURE **3.13** *The polys are greatly multiplied.*

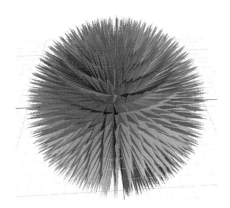

FIGURE **3.14** *The spikes are increased in quantity and decreased in base size.*

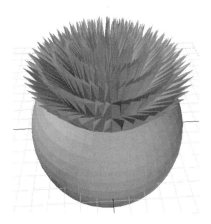

FIGURE *Now the spikes are generated only where*
3.15 *the specific polygons have been selected.*

 Remember to deselect the Spikey Tool after applying the operation or it will remain active.

NOTE

 ## TEAPOT

TUTORIAL

The Teapot control is found at Construct>Additional>Teapot. The teapot is created immediately after the command is selected. See Figure 3.16.

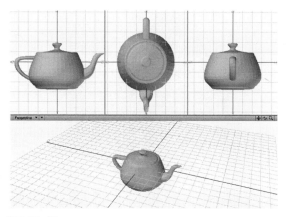

FIGURE *The teapot.*
3.16

If you hit the "N" key after the teapot is created, its Numeric window appears. The only control you have over the Teapot's geometry in the Numeric window is to scale it globally and simultaneously on all axes.

TUTORIAL

SubPatch Modeling

A patch is a flat plane that is deformed into a 3D form and then glued (attached, welded) onto another 3D surface. This allows the user to create detail in a model where it is needed without messing with the entire model's surface. LightWave, however, addresses patch objects differently from other applications. Working in SubPatch mode in LightWave is a lot like working with a free-form deformation cage in 3ds max. The result, no matter what the terminology, makes the object seem very plastic and malleable, like a real lump of clay. Working in SubPatch mode also allows you to model objects that have very low polygon counts. Do the following exercises to explore patch modeling.

The Smoothy Cube

The best way to learn what SubPatch modeling can do is to start with a cube. A cube has a minimum number of polygons—only eight to be exact, unless you have subdivided them beforehand. Do the following:

NOTE

It's a good idea to read and work through the section on employing Weight Maps in the LightWave documentation before exploring the use of SubPatch modeling. Knowing how to weight points allows you to control the SubPatch cage to a finer degree.

FIGURE *This exercise starts with a basic cube.*
3.17

FIGURE *The cube is rounded when SubPatch is*
3.18 *activated.*

1. Create a cube. See Figure 3.17.
2. Go to Construct>Convert>SubPatch. The cube will immediately attain rounded corners. See Figure 3.18.
3. Change all of the views you will be modeling in to Weight Shade views. See Figure 3.19.
4. As you can see in Figure 3.19, the original cubic form is now represented by dotted lines. It has been transformed into a cage, and the SubPatch model is the rounded cube inside it. Make sure you are in Point mode, and select the upper right point of the cage in the front view.
5. Move the selected point away from the SubPatch surface, and watch how the model, as seen in the Perspective view, responds. See Figure 3.20.
6. Continue selecting random points and moving them to get a better feel for this operation. See Figure 3.21.

FIGURE *Weight Shade views are displayed here*
3.19 *at the top.*

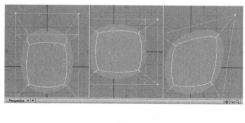

FIGURE *Moving points on the cage reshapes the*
3.20 *SubPatch object.*

FIGURE *All sorts of organic-looking forms can be*
3.21 *based upon a simple cubic SubPatch cage.*

7. Go to Construct>Convert>Freeze to change the model into a polygonal type. A best-fit mesh of polygons will be created, visible in wireframe views. Open the Surface Editor and make the model double-sided and smooth. Rename the Surface "SubX1." See Figure 3.22.

8. Go to Construct>Convert>SubPatch again, and change the modeling views to Weight Shade mode. What do you see? You will notice that the new cage has far more points and that the cage now hugs the model. With more points, you can create more detailed objects. See Figure 3.23.

9. As before, select and move any points you like to create an altered form. See Figure 3.24.

FIGURE *Freezing a SubPatch object reverts it to*
3.22 *polygons.*

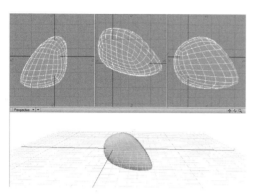

FIGURE **3.23** *The new cage has many more points and now hugs the underlying object.*

FIGURE **3.24** *Select and move points on the cage to create an altered form.*

TUTORIAL

COW DREAMS

Okay, now it's time to see what mischief we can promote by SubPatch altering our favorite LightWave stock model—the cow. Here's what to do:

1. Go to Modeler>File>Close All Objects.
2. Load the cow from the Objects>Animals folder.
3. See Figure 3.25.

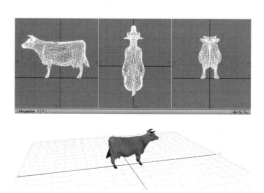

FIGURE **3.25** *The cow has a fairly large polygon count, which will translate into a high number of points to manipulate in a SubPatch cage.*

4. Construct>SubDivide>Triple to transform all polys into triangulated polys. SubPatch will only work on three- and four-pointed polys.
5. Go to Construct>Convert>SubPatch. Make sure you are in Point mode.
6. In the top view, switch on Weight Shade. Start by selecting the tips of both horns and use the Move tool to extrude them. Do the same with the ears, and elongate the muzzle. See Figure 3.26.
7. Create a SubPatch hump on the back, and lower the bottom part of the neck as shown in Figure 3.27.

FIGURE *Reshape the horns, ears,*
3.26 *and muzzle.*

FIGURE *Make the alterations as shown.*
3.27

FIGURE *Was this cow altered by radiation?*
3.28

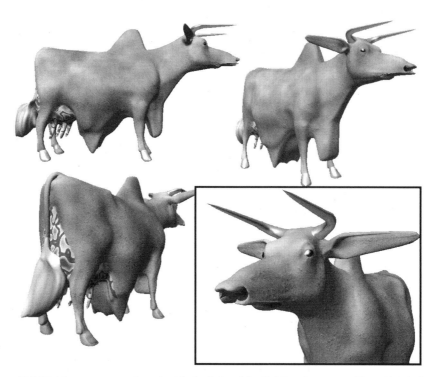

FIGURE *The new cow, altered with the help of the SubPatch process. If you think the*
3.29 *cow is strange, you should taste the milk she produces!*

8. Give the cow a large flabby underhang, increase the length of the nipples, and increase the scale of the end of the tail. See Figure 3.28.

9. Apply all of the Surface maps to the cow's parts, adjusting elements as desired. Save the new cow object to the same folder as the original cow, but under a different name. Use the Hub to transport the new cow object to Layout.

10. Use the Camera view and adjust the cow's location and scale as you like. Configure a white background. Render to preview. See Figure 3.29.

Make sure you spend more time exploring what SubPatch modeling can provide for you.

ONWARD

In this chapter, we have explored a number of unique LightWave modeling tools and procedures. In the next chapter, we'll tackle F/X modifications.

4

F/X Modification

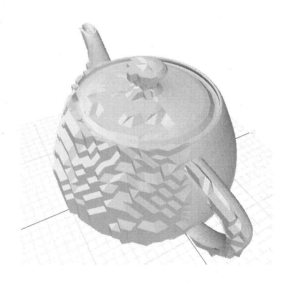

No complex 3D model was ever built in one step. 3D modeling begins by crafting a basic form, and then using a collection of tools and operations to repeatedly alter the form until your efforts result in the desired digital sculpture. This chapter focuses on the 3D modification process and its tools and commands.

The process of modification is optimized when the user is highly experienced and knowledgeable about the location and capabilities of the tools in the software. This chapter should help experienced pre-6.5 version LightWave users by providing a road map to the new locations of tools and commands, while beginning or intermediate users can use this chapter as a quick reference to find out exactly what the modification tools and operations do. The teapot, introduced to you in the last chapter, will be used as the target throughout. This will allow you to see how a single object responds to specific modification tool usage. The teapot, to remind you, is located at Construct>Utility>Additional> Teapot.

We will group modifiers and modification processes as they appear under the various tabs at the top of the Modeler module. They will be looked at in the following order:

- Modify: There are several separate modifiers under this heading: Move, Rotate, Stretch, and Deform.
- Construct: Under this heading we will look at Reduce, SubDivide, and Utility.
- Detail: Layers and Polygons and their contents will be investigated.

We will consider only those listings that can be regarded as object modifiers, tools, or operations whose most frequent use is to alter the geometry of a selected form. Additional modifiers and processes not alluded to here are covered in chapters to come. Exercises in other chapters will also use the teapot object, so you can compare the result of modifications to other modifications. Each exercise presupposes that you have added the teapot to a new session before going through the tutorial.

NOTE

TUTORIAL

THE MODIFY TAB

It would make logical sense if all of LightWave's modifiers were grouped under the Modify tab. Unfortunately, that's not the case, although many of the most common modifiers can be found here.

MOVE

If you haven't selected any specific polys on a model, the Move tool allows you to move the targeted object on any layer around the workspace. When specific polys have been selected, however, the Move tool becomes a polygon mover, altering the object's geometry. Do the following:

1. Select the polygons that make up the knob on the top of the teapot lid.
2. Activate the Move tool and click-drag the knob's polygons upward to re-shape the knob. See Figure 4.1.

The Move tool is one of the most useful tools for object modification. The selected polygons move, and the connected polygons are stretched out. If you use the Numeric window, you can constrain the move along a specific axis direction.

Under Move, we will look at Snap, Drag, Dragnet, Magnet, and More>Shear.

Snap

Snap (really a snap-drag action) attempts to snap your moves to points on the grid. If you bring up the Numeric Snap Drag window, you can select from one of three options: One Point, Connected Points, or All Points. Choosing One Point moves only the point (vertex) that the mouse is over, no matter that you may have selected a group of polys. This is excellent for close-up detailed editing. Using Connected Points will constrain the movement to all points attached to the selected point. All Points will allow you to snap-drag all of the points you have selected. Do the following.

1. Select all of the polys that make up the handle of the teapot.

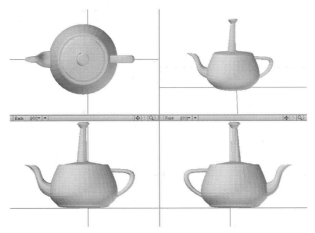

FIGURE *The Move tool is used to alter the selected polys on*
4.1 *the teapot.*

2. Use the Snap operation to move the points to a new position in a profile view. See Figure 4.2.

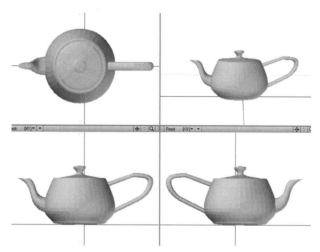

FIGURE *Snap-drag the points of the handle to a new*
4.2 *position.*

Drag

Drag has more axis-specific options than Snap, since it is not constrained to the snap points of the grid. Do the following:

1. Select the polys that make up the teapot handle again, unless they are still selected.
2. Click on the Drag tool and bring up its Numeric window.
3. Use an Offset X of 20 cm and an Offset Y of 40 cm. See Figure 4.3.

The Falloff value in the Numeric Drag window is set to "none" by default. Falloff limits the extent to which poly deformations occur.
NOTE *Explore using different Falloff choices in the Numeric Drag window.*

Dragnet

Dragnet may be used on objects without first selecting specific points or polys, and it may be applied interactively as opposed to using Numeric alterations. That's because Dragnet warps the surrounding geometry so smoothly, giving you very organic results. Do the following:

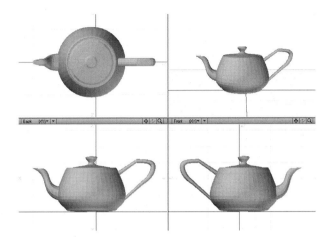

FIGURE *A deform evoked by the Drag tool on the handle's*
4.3 *polys.*

1. Activate the Dragnet tool. Click and drag on random points on the teapot in any view until you create something interesting. See Figure 4.4.

Magnet

Unless you select specific points/polys on the object first, Magnet will simply act as a Move tool and reposition the entire object. Magnet is probably the tool

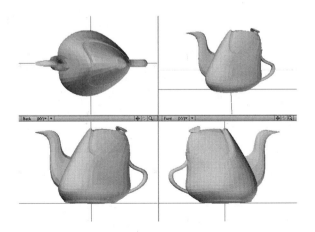

FIGURE *The Dragnet tool works very well for giving objects a*
4.4 *more organically warped geometry.*

selected most often for tweaking small and large areas of a model's geometry. Do the following:

1. Select all of the polys that make up the teapot's lid.
2. Use the Magnet interactively, clicking and dragging the polys upward. See Figure 4.5.

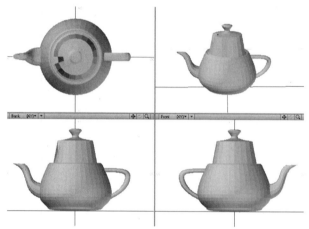

FIGURE *Alter the lid's geometry with the Magnet tool.*
4.5

More>Shear

A Shear operation can be thought of as producing a rhombus. Shearing skews objects or selected polys on an angle. Objects usually become compressed (thinner) in the direction a Shear is applied. Although Shear may be applied interactively, leaving the Numeric Shear tool window open will allow you to switch back and forth to various options to see how they affect the shearing operation. Do the following:

> *It's a good idea to Construct>SubDivide>Triple your object before applying a Shear so that you don't create chaotic normals that*
> NOTE *cause holes in your object.*

1. Before applying a Shear, open the tool's Numeric window so we can investigate some of the options. See Figure 4.6.
2. Look at the top of this Numeric window. Apply the effect interactively and watch the XYZ Offset values. They change according to how the Shear de-

forms the model. You can input different values to tweak a Shear or to create one.

3. Next, open the list options next to Falloff. The choices are None, Linear, Radial, Point, Polygon, Point Radial, and Weight Map. These options set Falloff parameters, areas where the effect of the Shear operation diminishes in strength. The default is Linear. Make sure it is selected.

4. When Linear is selected, there are four default Falloff profiles available to you. You can select Linear, Ease In, Ease Out, and Smooth profiles from the Presets list. Explore all of these options by selecting one and interactively click-dragging the mouse in the same viewport in the same direction; this will help you to appreciate the options' differences.

5. Adjust the sliders to apply modifications to the Falloff curve.

6. Explore the difference between using the Automatic versus the Fixed mode at the bottom of the window. When you get a feel for what some altered values can do, apply them to the teapot. See Figure 4.7.

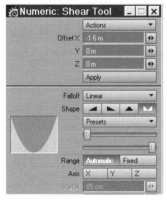

FIGURE 4.6 *The Numeric Shear tool window.*

FIGURE 4.7 *In this case, a Shear with the following parameters was used: Linear Ease Out with Automatic on the Y axis.*

ROTATE

Common rotation is used to spin an object in the workspace, but selected polygons on the object can also be rotated. Do the following:

You can alter the parameters in any Numeric window that contains the Apply command time after time just by applying additional modifications.

1. Select the polygons in the teapot's handle. Activate the Rotate tool and bring up its Numeric window.

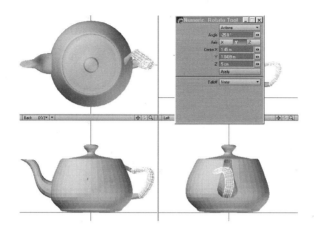

FIGURE *A 77-degree rotation has been applied to the same*
4.8 *polygons on all three axes.*

2. Apply a 77-degree rotation first to the X axis, then to the Y axis, and finally to the Z axis. See Figure 4.8.

Under Rotate, we will cover Bend, Twist, and More>Vortex.

Bend

You may prefer to use the Bend tool interactively, rather than through its Numeric window. Bend works more effectively on whole objects than it does on selected points or polys. Do the following:

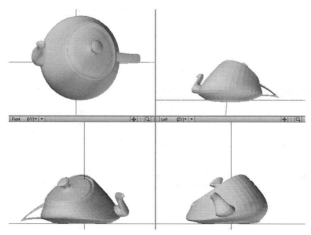

FIGURE *The bent teapot looks like a balloon that has been*
4.9 *deflated.*

1. Click on the Bend tool to activate it.
2. Click and drag to the right in the top view to bend the teapot on its Z axis. Bend again, moving the mouse upward in the top view. See Figure 4.9.

Twist

The most common axis to apply the Twist tool to is the Y axis, from the top or bottom view. It's more common to apply a twist to the entire object than to selected polys, although selecting polys and twisting can tweak a model's geometry in interesting ways. Do the following:

1. Activate the Twist tool.
2. Go to the top view and apply the twist so that the teapot revolves about 90 degrees. See Figure 4.10.

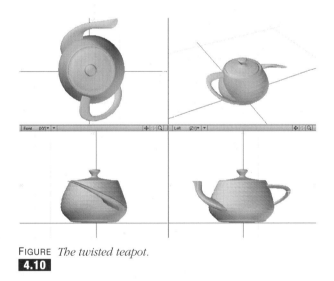

FIGURE *The twisted teapot.*
4.10

Here's another situation where you will want to triple the polys first so that the deformation does not create holes.

NOTE

More>Vortex

A vortex is a radical twist with more pronounced results. One big difference is that Vortex will simply rotate the object, in whatever viewport is selected, unless applied to specific polygons. Vortex pins the outer edge of a selection and rotates the rest of the selected polys from the center. It has more limited use than Twist on objects and is best used to swirl particles. Do the following:

1. Select the half of the teapot with the spout. See Figure 4.11.

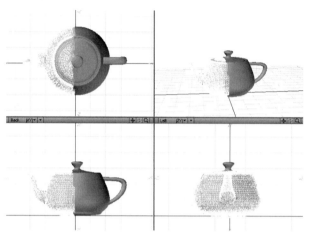

FIGURE *Select the spout half of the teapot.*
4.11

2. Activate the Vortex tool. Bring up the Numeric window and apply a vortex of 15 degrees to the X axis. See Figure 4.12.

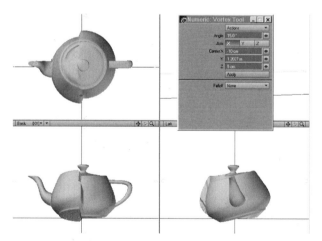

FIGURE *Vortex tends to smear the outer polygons.*
4.12

STRETCH

Stretch can be used on the entire object or on selected polys. Do the following:

1. Select the polys that make up the handle of the teapot.
2. Activate the Stretch command. Click and drag the mouse horizontally to stretch the handle horizontally, larger or smaller. See Figure 4.13.

Under Stretch, we are going to explore Size, Taper 1 and 2, and Pole 1 and 2.

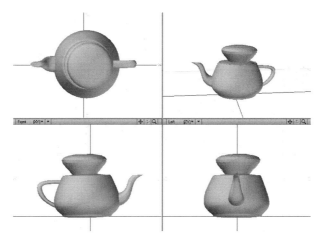

FIGURE *Stretch the handle.*
4.13

Size

Size has an obvious use when it comes to scaling an object, but it can also be used to resize a selected portion of the object. Do the following:

1. Select the polygons that make up the knob on the top of the teapot lid.
2. Go to Scale and click-drag to make the knob the same diameter as the lid. See Figure 4.14.

Taper 1/Taper 2

Taper 1 replaces what was previously named Taper Evenly. It is used to evenly taper the object or selection on both its horizontal and vertical axes, viewport dependent. Taper 2 allows you to interactively address the horizontal and vertical tapering separately, depending upon whether mouse movements are left-right or up-down. Tapers are usually best applied interactively, though there may be times when the parameter adjustments that can be tweaked by bringing up the Numeric window may be desirable. Do the following.

1. Activate the Taper 1 tool.

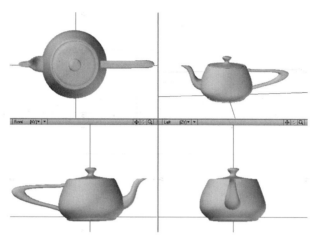

FIGURE *The knob is scaled up.*
4.14

2. Click and drag to the left to taper the teapot so that the top is smaller than the bottom. See Figure 4.15.

Pole 1/Pole 2

The Pole Evenly tool (Pole 1) applies the pole effect to both the horizontal and vertical directions of the object or selected polys, viewport dependent. The Pole tool (Pole 2) separates the horizontal and vertical into left-right and top-bottom

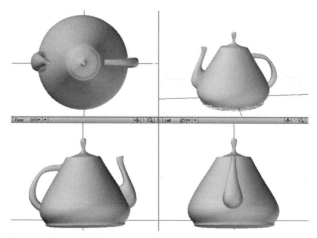

FIGURE *A tapered teapot.*
4.15

mouse movements. If you are applying either Pole effect to an entire object, use a Falloff (try a Radial Falloff first on most objects). You can opt for a zero Falloff (none) if applying to selected polys. Either Pole effect can work wonders for creating very smooth warping results if you configure an area first. Do this by dragging out an area with the RMB in any viewport, then interactively applying the effect. Do the following:

1. Activate the Pole Evenly tool and bring up its Numeric window.
2. In the Numeric window, select a Radial Falloff.
3. Set the horizontal area of the Falloff by using the RMB to drag out a blue area indicator in the top view. Give the area some vertical dimension by doing the same in the front view.
4. Apply the effect interactively (although you can leave the Numeric window open). See Figure 4.16.

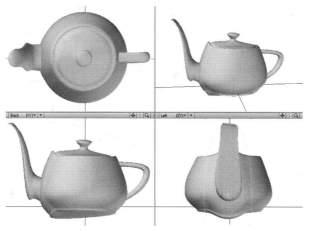

FIGURE *A teapot warped with an area-specific Pole effect.*
4.16

DEFORM

Under Deform we'll look at Jitter, Smooth, More>Quantize, Spherize, and Squarize.

Jitter

Jitter can be defined as 3D noise. Low values for Jitter (object dependent, of course) create nice depressions and bumps on an object or selection of polys. Higher values add severe spike-like distortion. In animations, Jitter can be keyframed to make an object look like it is exploding, from low values to higher values. Do the following:

1. Activate Jitter. The Jitter settings window appears. See Figure 4.17.
2. Select a Radial Falloff. (You don't have to have a Falloff, and if you want to have one you can select any Falloff type from the list, but let's work with the Radial Falloff here.)
3. Select a range of 2 cm for the teapot. Different objects will require an exploration of the right value for that object. Apply the effect by clicking on OK. See Figure 4.18.

FIGURE *The Jitter settings window.*
4.17

FIGURE *A nice bumpy geometry can be created with the*
4.18 *Jitter effect.*

 Jitter looks better on higher-polygon-count objects.

NOTE

Smooth

Smooth attempts to even out any bumpy anomalies on the object or selected polys. Do the following:

1. Make sure your Jittered teapot is still on the screen or recreate it.
2. Activate the Smooth effect and set smoothing to 2 in the window that pops up. See Figure 4.19.

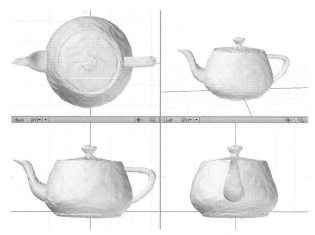

FIGURE *The Jittered bumps are smoothed out a bit.*
4.19

More>Quantize

The Quantize operation looks at the XYZ Step values you enter into its Numeric window and transforms the object by snapping the points to the values indicated. Quantizing an object can make the object, or that part of it which is selected, very blocky looking. Do the following:

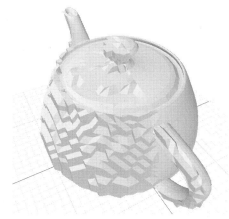

FIGURE *Half of the teapot has been Quantized*
4.20 *(the blocky half), while the other half remains unaltered.*

1. Select the left half of the polygons or points that make up the teapot.
2. Activate the Quantize command. In the parameter window that appears, set X, Y, and Z Step values to 7 cm. Accept the values. See Figure 4.20.

Spherize and Squarize are operations that force the selected polys to become either more spherical or sharper edged. Explore their use with a variety of different objects.

THE CONSTRUCT TAB

A group of important modification tools and operations are found under this tab.

REDUCE

Here we'll look at Remove Polygons and Reduce Polygons.

Remove Polygons

Remove Polygons does just that. Using this command can help you create entirely new object geometry. Do the following:

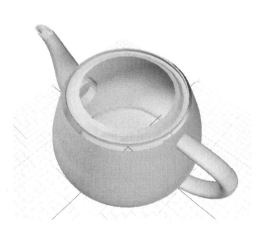

FIGURE **4.21** *The selected polygons have been removed, allowing you to see inside the teapot.*

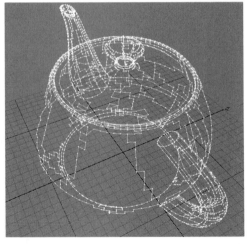

FIGURE **4.22** *Reducing the polys helps create a much more faceted object, which can be seen clearly in this wireframe view.*

 Always create double-sided polygons before removing any, thus ensuring that you will be able to see inside the object where the polys have been removed. An alternate way to do this is to go to Detail>Polygons>Make Double Sided.

1. Select the polys that make up the teapot lid.
2. Activate the Remove Polygons command. See Figure 4.21.

Reduce Polygons

This operation removes coplanar polygons, blending them into one. The Polygon Reduction Angle can be set from 0 to 30 degrees. Do the following:

1. Activate the Reduce Polygons operation.
2. When the parameter window appears, set the Reduction Angle to 15% and accept the setting. See Figure 4.22.

SUBDIVIDE

SubDivide can be used on an entire object or on selected parts to add more polys for later detail modification. The Metaform SubDivide will be explored later in the chapter on metaform modeling.

Under SubDivide, we'll explore the use of Knife, Bandsaw, and Julienne.

Knife

Use the Knife tool to slice apart polys in specific areas of a model where more detail and more polygons will be needed. Do the following:

1. Go to Construct>Reduce>gemLOSS2. Accept the default value of 50% to reduce the number of polys in the teapot. Repeat this action.
2. Go to a wireframe view of the top. Now you have a teapot with large polys that can be seen more clearly.
3. Activate the Knife tool. You will use it interactively, so there is no need to bring up its Numeric window.
4. Use the RMB or the Mac-equivalent mouse action to drag out a line that crosses some of the larger polygons. Select another tool (but not Bandsaw) to apply the cut. The large polys crossed by the Knife are now cut into two polys. After making Knife cuts, it's common to triple the polys in the object for deformation purposes if needed. See Figure 4.23.

Bandsaw works in a similar manner and is especially useful on SubPatch objects. Julienne will be covered in the chapter on displacement modeling.

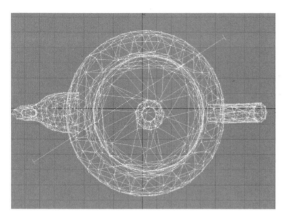

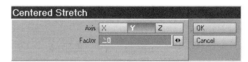

FIGURE **4.23** *The Knife cut is seen extending beyond the edges of the wireframe teapot and has sliced the polys in two.*

FIGURE **4.24** *The Center Stretch parameter controls.*

THE UTILITY TAB

There is just one item here to attend to: Additional>Center Stretch.

Additional>Center Stretch

This modifier gives you exacting control over the axis the Stretch will be applied to. You select the axis and amount via its Numeric window. See Figure 4.24.

Do the following:

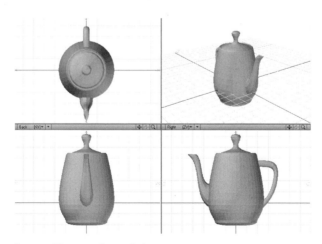

FIGURE **4.25** *The transformed object.*

1. Activate Center Stretch, which brings up its control window.
2. Use a value of 2 on the Y axis to transform the teapot into a coffee pot. See Figure 4.25.

TUTORIAL

DETAIL

There are a couple of vital addendum modification operations under this tab.

LAYERS

The most important modification operation under this heading is Pivot.

Pivot

The Pivot Point of an object is where its rotation and scaling is based, so changing the Pivot Point (usually found at the center of the geometry) can transform the object. Changing the Pivot Point in Modeler is wiser than altering it in Layout. Always save the object anew after its Pivot Point has been moved. Do the following:

1. Go to the top view, making it a wireframe view so you can see the Pivot Point (it will be blue).
2. Select the Pivot command, which will allow you to move the Pivot Point anywhere you like. In this case, move it to the teapot handle in top and side views. Turn off the Pivot Point tool to accept the change. See Figure 4.26.

FIGURE *The Pivot has been moved*
4.26 *to the teapot's handle.*

POLYGONS

Under this heading we'll take a look at SpinQuads.

SpinQuads

SpinQuads, the object or selected area of the object's quad polys, is a very useful operation when you are trying to get rid of an object's visible seam lines.

1. Activate SpinQuads. The operation is instant.
2. Take a look at the object's previous seam lines. If they are still visible in a render, repeat the operation. Repeating it a third time will return you to where you began.

ONWARD

In this chapter, we have explored a number of ways that you can customize your LightWave models. In the next chapter, we'll look at the Layer Copy/Paste technique and Booleans.

5

Layer Copy/Paste and Booleans

To an experienced LightWave user, there are no mysteries or problems with the way the application works or with regard to the location of tools and commands in either Layout or Modeler. A 3D user coming to Light-Wave after experience in another 3D application—or a brand-new 3D hopeful —however, will find some of LightWave's operations unique enough to require extra hours of study and an adjustment in thinking. A good example of such an operation is the LightWave Modeler Layer system.

Few users have a problem with the layering concept since it has become such common knowledge, related to popular 2D painting applications like Photoshop. It is generally expected that elements on a layer can be selected, rotated, scaled, and repositioned independent of other elements on that layer. In LightWave, however, this is not the case. Everything on a specific Modeler layer, for example, is considered to be one glued-together object. The separate elements, however, can each have their own surfaces, right down to the polygon level.

It's important to keep in mind that LightWave looks at everything as being a participant in a global hierarchy. At the top of the hierarchical chain is the Scene. The Scene is made up of objects and also includes lights and cameras (and other items) as well as mesh geometry. At the mesh Object level are items that contain both geometry and surface (texture) components. Layout is used to set the stage components for the Scene, and Modeler is used to create the objects. Using the Layer function in Modeler allows you to create very complex actors for your scenes, as long as you know and obey the rules.

LightWave pros may want to skip or just skim this chapter. If any or all of this is new to you and you want to get a better grip on how to manage layer parts in Modeler, however, work through the exercises that follow.

LAYER RULES

You may discover additional rules for working with Modeler layers over time, but those listed here cover most of the bases:

- Copy/pasting the contents of one layer to another target layer makes everything on the target layer act as a single object. This is very important to realize, because you may find it very difficult to move elements around once they are pasted to a layer that has pre-existing content on it. Make the target layer a background layer first, so you can adjust positions before you copy/paste.
- Any layer can be selected as a background layer for an operation. Once you get the hang of this, you'll be flying through the modeling process.

Layers do not have to be placed in any specific positional order in a stack to serve as background layers, unlike in Photoshop.

- Multiple layers can simultaneously act as background layers. Although putting this concept to use requires spending some time familiarizing yourself with the Modeler layering system, it can result in enhanced speed in your modeling enterprises. To create multiple background layers, simply shift-select them as backgrounds.

- Multiple layers can simultaneously act as foreground layers. This is another action that can help you in the speedy creation of complex models. To create multiple foreground layers, simply shift-select them as foregrounds.

- You can set surfaces (textures) for any selected polygon on any Modeler layer. LightWave's ability to target separate elements (down to the polygon level) for a unique surface gives you very deep multitexturing capability without the complexities associated with this capability in other 3D applications.

- You can increase the number of active layers beyond the ten that are displayed. Access layers beyond the default 10 by selecting them in the Layer Browser (covered later) and placing content on them.

In order to work with Modeler layers, of course, you have to know where they are located and how to navigate through them. You should already have this knowledge from your reading of the LightWave documentation, but if your memory needs refreshing, , let it be noted that the Layer controls are located at the top right of the Modeler interface. See Figure 5.1.

Clicking on the top of a layer turns it yellow and activates it. When the layer has a small triangle in its upper-left corner, that means it has content on it. Clicking on the bottom of the Layer control makes the layer a background layer until it has been deselected.

NAMING AND PARENTING LAYERS

You can name each layer and parent it to other layers. Naming a layer allows you to quickly identify the content it holds. This can be useful when you are creating a com-

FIGURE *Modeler's Layer controls.*
5.1

FIGURE *Type in the name of the selected layer.*
5.2

plex form with elements on many layers. To name the layer, go to Detail>Layers>Layer Settings. See Figure 5.2.

Under Name in the Layer Settings window you will see a Parent control. Opening the list displays all of the other layers, allowing you to select one as the parent of the selected layer. A parent layer controls the content of all of its children, in that operations performed on the parent also occur simultaneously on the child layers. This can be useful when modeling an object.

LAYER BROWSER PANEL

To access the Layer Browser, go to Modeler>Windows>Layer Browser Open/ Close.

TUTORIAL

COPY/PASTE LAYER EXERCISES

Work through the following tutorials to get a better idea of how layers can be used to help you in your modeling with basic copy/paste commands. Do the following:

 1. The first thing we have to do is to create some layer content. Use the Ball command to create an object on the first layer, and name the layer "Layer 1." See Figure 5.3.

FIGURE *Create this content on Layer 1 at this position*
5.3

2. Use the Ball command again to create an object on the second layer, and name this layer "Layer 2." See Figure 5.4.

3. Use the Ball command to create an object on the third layer, and name the layer Layer 3. Note that this ball is larger than the others. See Figure 5.5.

4. Just as a test, make Layers 1 and 2 background layers for Layer 3. The smaller balls should look intersected by the larger ball. See Figure 5.6.

5. Select Layer 3 and Edit>Copy. Select Layer 1 and Edit>Paste. Layer 1's content now looks like Figure 5.7.

FIGURE *Create this content on Layer 2 at this position.*
5.4

FIGURE *Create this content on Layer 3 in this position.*
5.5

FIGURE *With Layers 1 and 2 relegated to backgrounds,*
5.6 *Layer 3 should look like this.*

FIGURE *Layer 1 now looks like this.*
5.7

6. Move the new object, and you will see that it is now a single object. Select all of the polygons that made up the previous smaller ball that you can and move them. You will find that the polygons that bridge the two ball elements are now stretched as you move what was previously the smaller ball.
7. Undo operations until the original three balls are back on their separate layers.
8. Shift>Select all of the layers. Now all of the balls are in view. Use the Move tool to move them, and they all move together. Use any of the F/X tools on

them, and they are all affected at the same time from a common center, just as if they were attached. This is one way to apply a transformation without combining the objects on a single layer.

9. One by one, copy the content of each of the three layers and paste on a new layer (Layer 4). This operation demonstrates that you can use layers to configure parts of a model, and then combine those parts on a separate layer. This makes the original layers 3D "worksheets" for a final Layer operation. In this case, you could delete the original layers before saving the final object.

10. Select Layer 3 and shift>select Layers 1 and 2 as background layers. You will see Layers 1 and 2 as wireframes as viewed from Layer 3. See Figure 5.8.

11. Move the ball on Layer 3. You can see how useful it is to have background layers as a guide, showing you how the active layer contents relate to contents on other layers.

FIGURE *You will see background layers as wireframes.*
5.8

BOOLEANS

Using Boolean operations, objects can be treated as numbers. They can be added together or subtracted from one another and the difference between them computed. Using Boolean operations in the creation of models in Light-Wave requires a thorough knowledge of how layers work.

Game developers sometimes shy away from using Boolean opera-tions to develop models, since Booleans have a tendency to increase the polygon count of a model. Game developers strive to keep a model's polygon count as low as possible for faster game play.

In LightWave 6.5 and higher, Booleans are located by going to Multiply>Combine>Boolean. Activating the Boolean command brings up the Boolean op-tions window. See Figure 5.9.

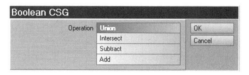

FIGURE *Boolean options.*
5.9

LightWave offers you four Boolean choices: Union, Intersect, Subtract, and Add:

Other 3D applications restrict these options to the first three, omit-ting Add.

- Union: For Union to function properly, the selected layers must contain closed 3D objects. The result is a single object, with all named surfaces in-tact. Objects on the selected layers should overlap.
- Intersect: This operation creates an object that is formed from the overlap of selected layer elements. All named surfaces are kept intact. Selected lay-ers must contain closed 3D objects that overlap.
- Subtract: Selected layers must contain closed 3D objects that overlap. The background layer(s) is/are carved out of the foreground layer content. All named surfaces are kept intact.
- Add: This Boolean operation differs from Union in that you can use 2D shapes as well as 3D forms. When added together, the layer contents share a common edge between them.

BOOLEAN EXERCISES

TUTORIAL

Here you will use the same three layers and content that you did in the previous exercises.

BOOLEAN UNION

Do the following:

1. Select Layer 3 and make both Layers 1 and 2 background layers.
2. Go to Multiply>Combine>Boolean and select Union. Click OK to complete the operation. See Figures 5.10 and 5.11.

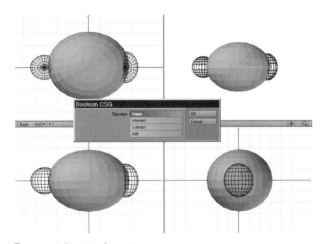

FIGURE *Select Boolean Union.*
5.10

FIGURE *The result is a single object that combines all three*
5.11 *layers, similar to the Copy/Paste operation you did*
previously.

BOOLEAN INTERSECT

Do the following:

1. Select Layer 3 and then shift-select Layers 1 and 2 as background layers.
2. Go to Multiply>Combine>Boolean and select Intersect. Click OK to complete the operation. See Figure 5.12.

FIGURE **5.12** *The result of the Intersect operation is an object that represents the overlap of the selected elements.*

BOOLEAN SUBTRACT

Boolean Subtraction operations are the most called upon Boolean options, since they allow you to negatively sculpt 3D surfaces to create holes and depressions. Do the following:

1. Select Layer 3 and select Layer 2 as a background layer (you can also select multiple layers as background layers for this or any other Boolean operation).
2. Go to Multiply>Combine>Boolean and choose Subtract. Click OK to complete the operation. See Figure 5.13.

BOOLEAN ADD

Do the following:

1. In a separate layer (Layer 4), use the Pen tool to create a 2D shape similar to the one displayed in Figure 5.14. Use the large ball in Layer 3 as a reference, making the shape larger and intersecting. Use a side view.

2. With this layer selected, select Layer 3 as a background layer. Use Boolean Add. See Figure 5.15.

DRILL AND SOLID DRILL

These two operations are located just below the Boolean control button. Drill uses a 2D form as the cutter and operates along a selected axis, while Solid Drill

FIGURE **5.13** *The result is a depression in the selected object made by the subtraction of the background layer contents.*

FIGURE **5.14** *Create this shape.*

uses a 3D form as the cutter and operates by the position of the cutter in 3D space. Both offer four options: Core, Tunnel, Stencil, and Slice.

- Core: This option creates a space inside of the drilled object equal to the geometry of the cutter. It is best used with Solid Drill.
- Tunnel: This is the most common drilling operation and is similar to Boolean Subtract. When Drill is used with this option, the axis of the Tunnel is selected. When Solid Drill is used, the tunneling accommodates the 3D space of the cutter.

FIGURE **5.15** *Using Boolean Add, 2D and 3D forms can be combined into one.*

- Stencil: This option, which is best used with Solid Drill, allows you to create a 3D cutaway on the surface of a targeted 3D object. One of its primary uses is to carve text blocks into solid objects. You can name the surface of the cut, allowing you to make it a separate color or texture later.
- Slice: This is similar to Stencil but does not allow for separate surface names. It is best used with Solid Drill.

A DRILLED TUNNEL

TUTORIAL

Do the following to create a Tunnel with a Drilling operation:

1. Scale the shape you created in Layer 4 so that it is smaller than the ball in Layer 3.
2. Select Layer 3 and select Layer 4 as a background layer.
3. Go to Multiply>Combine>Drill. Select the Tunnel option. Select the axis that is perpendicular to the plane of the cutting shape and click on OK. See Figure 5.16.

FIGURE **5.16** *Using a Drilled Tunnel, a shaped hole is cut away from a solid 3D object by a 2D cutter. Notice here that the 3D object is treated as a shell and not a solid. See the following exercises.*

FIGURE **5.17** *This is what your hierarchy should look like.*

PARENTED LAYER EXERCISES

TUTORIAL

Parenting is an interesting way to affect layer content. Do the following:

1. Select Layer 1. Go to Detail>Layers>Layer Settings. Parent Layer 1 to Layer 3.
2. Repeat the previous step for Layer 2.
3. Go to Modeler>Windows>Layer Browser Open/Close. Use the hierarchy list, and you should see how the layers are parented, resembling Figure 5.17.
4. Save the object. Use the Hub to send it to Layout. Select Layer 3 and move or rotate it. The children objects go through the same transformations. Parenting is very important when you want to develop articulated characters or other movable models.

MULTISURFACING LAYER ELEMENTS

TUTORIAL

Having one model with a variety of textures is something other 3D applications make you struggle to do, when you can do it at all. Here's how LightWave handles it. Do the following:

1. Using the same three-layered object (delete Layer 4) that we have been using, select Layer 1. Make sure you have named all of the layers.
2. Go to Detail>Polygons>Surface. Enter "Layer 1S" in the Name area when the Change Surface window appears. See Figure 5.18.
3. Repeat the previous step for Layers 2 and 3, naming the new surfaces "Layer 2S" and "Layer 3S" respectively.
4. Open the Surface Editor and you will see all of your new surfaces listed. Create whatever surface attributes you like for each of them. You now have one object with three distinct surfaces.

FIGURE *Name the new surface.*
5.18

AT THE POLYGON LEVEL

Not only can you create one object with a different surface for each layer element, but you can create new surfaces for each and every polygon on any object. Do the following:

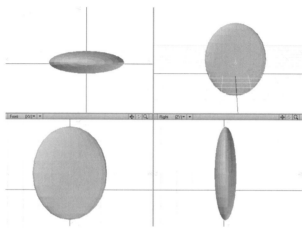

FIGURE *Create this object.*
5.19

FIGURE *Though this exercise is simple, it points*
5.20 *the way towards more complex polygon*
painting that can be used to create all
manner of surface textures on any
single object, polygon by polygon.

1. Create a new object from a ball primitive. Make it a flattened sphere, as shown in Figure 5.19.
2. Hold the Shift key down and select polygons in the front view that describe a smiling mouth.
3. Go to Detail>Polygons>Surface to create a unique color for these polygons.
4. Repeat this action for the rest of the details of a face. See Figure 5.20.

ONWARD

In this chapter, we investigated the use of layers in modeling unique objects. In the next chapter, we'll look at backdrops.

6

2D Backdrops

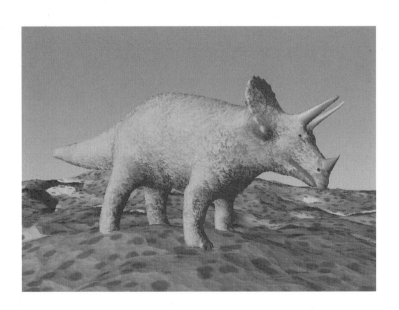

The Mona Lisa would not impact us the same way it does today if Leonardo daVinci had painted clouds in the background or had placed the model against a brick wall. Any foreground form is appreciated as part of the whole, so the background is always as important as the foreground in setting a mood. Context matters. In computer graphics, backdrop content (backgrounds) can be generated in one of two general ways: it can be composed of 2D or 3D objects. When it comes to LightWave's 2D backdrops, you have four basic options: Color, Gradient, Volumetrics, or Image-Based. Backdrops are configured in Layout.

COLOR BACKDROPS

TUTORIAL

Do the following in order to create a backdrop composed of a single hue:

1. Go to Scene>Effects>Backdrop. This brings up the Effects window. See Figure 6.1.
2. Click on the color swatch (which by default is black) next to the word "Backdrop." This brings up your system color picker. Select the backdrop color you want, and close the color picker and Effects window. The next render you perform will show your selected color as the backdrop.

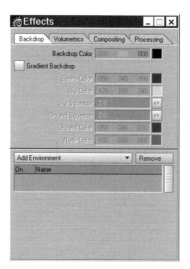

FIGURE *The Effects window with*
6.1 *the Backdrop tab page.*

GRADIENT BACKDROPS

TUTORIAL

Do the following to create a Gradient Backdrop:

Set the horizon line in Camera view.

NOTE

1. Go to Scene>Effects>Backdrop. Click on the box that reads "Gradient Backdrop."
2. Configure the four colors as you like. They represent Zenith (top Sky Color), Sky Color (horizon to Zenith), Ground Color (Ground to horizon), and Nadir (Ground Color at the bottom). Leave the Sky and Ground Squeeze values at their defaults and do a render. See Figure 6.2.
3. Change the Sky Squeeze to 12 and do a render. Note that this squeezes the horizon color to a smaller band, which is great for a sunrise/sunset look. See Figure 6.3.
4. Change the Sky Squeeze value to a -3. This creates a much lighter sky at the top, looking more like high noon. See Figure 6.4.

Explore alternate Ground Squeeze values as well.

FIGURE **6.2** *Gradient Backdrop with a default Squeeze value.*

FIGURE **6.3** *Gradient Backdrop with a higher Sky Squeeze value.*

ENVIRONMENTAL OPTIONS

At the bottom of the Backdrop tabbed page in the Effects window you will see an item named "Add Environment." Clicking here opens a list with three options:

FIGURE *The gradient with Sky Squeeze set to -3.*
6.4

LW_ImageWorld, LW_TextureEnvironment, and SkyTracer2. Each of these options creates backdrop content.

LW_ImageWorld

When you use LW_ImageWorld to configure a backdrop, the image you use will take the place of the sky. The area below the horizon will be black, allowing space for whatever foreground object (terrain, plane, water, etc.) you decide to place there. Do the following:

FIGURE *Load a background image.*
6.5

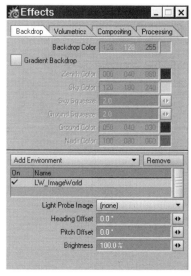

FIGURE *The LW_ImageWorld settings.*
6.6

1. Go to Scene>Backdrop. Select LW_ImageWorld from the Add Environment list.
2. Go to the Compositing tab. To use an image in LW_ImageWorld, you have to load it here first. Here we've used a tiled design created in Photoshop with the Xaos Terrazzo filter. See Figure 6.5.
3. Return to the Backdrop tab and double-click on the LW_ImageWorld entry. This brings up the settings window. See Figure 6.6.
4. By default, the list next to "Light Probe Image" reads "None." Change it to the name of the image you just loaded as a background.

FIGURE *This is the tiled image as a backdrop. Your*
6.7 *rendering will show the image you used.*

5. Render to preview. See Figure 6.7.

LW_TextureEnvironment

Before exploring this option, remove LW_ImageWorld from your active list. Select "None" for background image under the Compositing tab. LW_TextureEnvironment allows you to create a backdrop from a procedural texture, among other options. Do the following to explore LW_TextureEnvironment:

1. Go to Scene>Backdrop. Select LW_TextureEnvironment from the Add Environment list.
2. Double-click on the LW_TextureEnvironment name to bring up the settings. See Figure 6.8.
3. Click on the Texture button to bring up the Texture Editor. See Figure 6.9.
4. Change Layer Type to Procedural Texture.

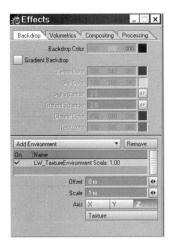

FIGURE *LW_TextureEnvironment*
6.8 *settings.*

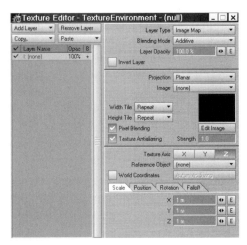

FIGURE *The Texture Editor.*
6.9

FIGURE *The Underwater procedural texture used as a*
6.10 *backdrop.*

5. Change Procedural Type to Underwater. Set Wave Sources to 6, Wavelength to 0.1, and Wave Speed to 0.05. Render to preview. See Figure 6.10.

Considering that you can use any of LightWave's myriad of procedural textures and that you can tweak the settings almost limitlessly, you can create an endless number of interesting backdrops using this method. Explore!

SkyTracer2

SkyTracer2 replaces the original SkyTracer included in LightWave versions previous to 7, with much-improved quality over the original sky generator. SkyTracer2 is a module that allows you to create backdrops with flat or volumetric sky and cloud elements. Volumetric skies are far more real looking than flat sky backdrops, but increased rendering time is needed to generate them. Many times, however, all you need is a quick sky reference, at which point a flat sky backdrop will work fine. Interestingly, you can also start with a flat sky preset and check volumetric parameters to render volumetric clouds. Do the following to explore the use of SkyTracer2:

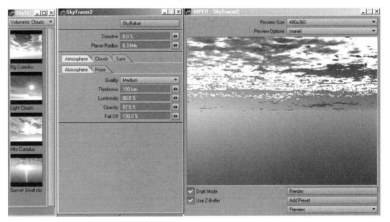

FIGURE **6.11** *The SkyTracer settings window, with the preset volumetric skies on the left and the Viper render on the right.*

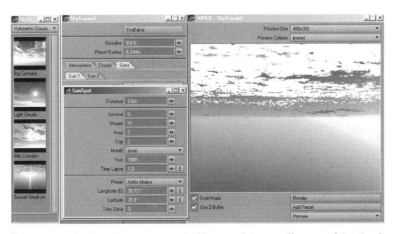

FIGURE **6.12** *Use the Sun Position settings (the panel is actually named SunSpot) to create a sky for any place on earth at any time of the year, and for any year.*

Make sure to first switch on Presets and Viper from the toolbox. This will give you access to preset skies and will allow you to preview the alterations you make.

1. Go to Scene>Effects>Backdrop. Select SkyTracer2 from the Add Environment list.
2. Double-click on the name "SkyTracer" to bring up its settings window. See Figure 6.11.
3. Explore the SkyTracer Sky, Clouds, and Suns settings by tweaking the component values, and watch the Viper rendering window change after each modification. Continue this process until you create a cloud backdrop you like. If you want to see more sky and less of the ground, rotate the Camera upward. Pay special attention to the Sun Position values under either the Sun 1 or Sun 2 Sun tabs. Using these values, you can select any place on earth and any time of day or night to emulate the light at that location and time. Any modifications are updated instantly in the Viper window. It's a good idea to save your favorite SkyTracer image settings so they can be recalled for later use. See Figure 6.12.

VOLUMETRICS

There are basically two types of Volumetrics that LightWave addresses: Fog and HyperVoxels. We'll look at HyperVoxels in a later chapter. Modeling Volumetric elements is important when it comes to giving your scenes that extra push to-

FIGURE *Create this scene.*
6.13

wards realism. The only concern to be aware of is that Volumetrics take render time and render power. The more RAM your system has and the faster the processor, the more Volumetric elements will serve you without torturing you at the same time.

Let's try developing some ground fog for a scene. Do the following:

1. Create a new scene. Use the triceratops from the Objects>Animals folder and the Ground2 object from the Objects>Landscapes folder. Use a Gradient backdrop of your own design. Set the Camera view so the scene appears similar to Figure 6.13.

FIGURE *Use these values.*
6.14

FIGURE *Use these values.*
6.15

FIGURE *The Volumetric fog effect applied.*
6.16

2. Bring up the Volumetrics tab in the Effects settings. Use the values indicated in Figure 6.14.

3. Select LW_GroundFog under Add Volumetric. When the settings appear, use the values indicated in Figure 6.15.

4. In this instance, the fog effect is fairly subtle, but you can see how it blurs out the image content. See Figure 6.16.

Remember that this is only one example of Volumetric fog. Make sure you continue exploring the results of different values on your own.

FIGURE *A sample background image.*
6.17

FIGURE *A sample foreground image.*
6.18

BACKDROP COMPOSITES

LightWave allows you to create image composites utilizing both a background and a foreground image. Three-D objects are seen behind the foreground and in front of the background. Do the following:

1. Go to Scene>Effects>Compositing and load a new background image. Select any image you have in storage.
2. Go to Photoshop or another image editing application. Create an image that has a large solid black with some lighter content. Save it.
3. In Modeler, go to Scene>Effects>Compositing and load the image you just created as a foreground image and as an Alpha. Do a test render. See Figures 6.17 to 6.19.

FIGURE *The composited image created in LightWave Modeler.*
6.19 *A 3D object can be placed between these layers.*

IMAGE PROCESSING THE BACKDROP

If you have loaded an image to use as a backdrop and want to apply some F/X to it, there is no need to leave LightWave. Do the following:

1. Load a new image as a background under the Compositing tab in the Effects window. Here a cloud image rendered in Corel Bryce has been used. See Figure 6.20.
2. Go to Scene>Effects>Image Processing. Go down to the Add Image Filter list and select Negative. See Figure 6.21.

FIGURE *Load a new image.*
6.20

FIGURE *Add the Image Filter first, then select Negative.*
6.21

3. Do a test render to preview the effect. See Figure 6.22.

Make sure to explore the other F/X offered in the list to customize your backdrop imagery.

FIGURE *The blur effect is completed.*
6.22

ONWARD

In this chapter, we detailed a number of ways that you can create and modify backdrops. In the next chapter, we'll look at modeling Lens Flares.

7

Lens Flares

Lens Flares all over the place. What is a Lens Flare, anyway? A Lens Flare is an optical artifact, an interference pattern created by a lens—not an attribute of the light itself. The lens can be a camera lens, the lens of an eye, the lens of a telescope, or the lens created by the curvature of an atmosphere around a planet. Lens Flares (sometimes called Lens F/X in other 3D applications) are targeted towards specific lights in your scene. To see the full effect of a configured flare, the light has to be visible to the Camera.

THE BASIC PROCEDURE

TUTORIAL

Here's how to create a basic Lens Flare. Do the following:

1. In Layout, place the default light so you can see it in Camera view. Make sure to create a keyframe so everything remains in place.
2. Be sure that Lights is selected from the bottom menu. Click on the Item Properties button. The Item Properties settings for the default light appear. See Figure 7.1.
3. Next to Light Type, select Point Light from the list. We could use other light types, but a Point Light is seen from all directions and angles.

FIGURE **7.1** *Item properties for the default light.*

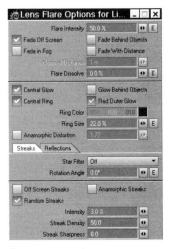

FIGURE **7.2** *Lens Flare settings.*

4. Click Lens Flare and then Lens Flare Options. This brings up the Lens Flare settings. See Figure 7.2.

5. Take a careful look at how this window is laid out. It has three stacked panels. We won't deal with the items in the top panel because they are rather self-evident, allowing you to determine how the light will be affected by and will affect objects in a scene. The middle panel contains controls for the basic Lens Flare components, so we will spend some time exploring these options. The bottom panel has two tabs—Streaks and Reflections— and we will explore altering some of the values here.

6. For the first example, leave everything at its default and do a test render. Make sure you are in Camera view. See Figure 7.3.

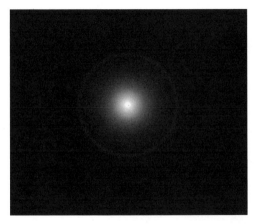

FIGURE **7.3** *The default Lens Flare applied to a Point Light.*

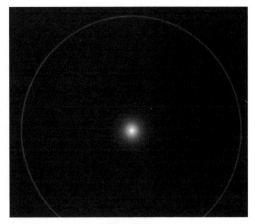

FIGURE **7.4** *A faint ring is added.*

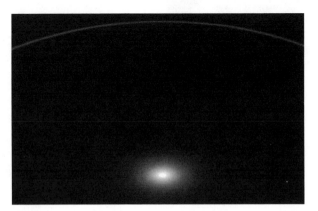

FIGURE **7.5** *Anamorphic Distortion flattens out the flare.*

7. Change the Ring Color to white and set the Size at 100%. Do another test render. You will see a faint white ring around the flare. See Figure 7.4.

8. Check Anamorphic Distortion and leave the default value of 1.77. Do a test render. See Figure 7.5.

9. Change Anamorphic Distortion to 70 to see what happens. Do a test render. See Figure 7.6.

10. Change the Anamorphic Distortion level back to 1 to create circular Lens Flare.

11. Switch the Central Ring off. Go to the bottom panel and select a 2 + 2 Point Star Filter. Do a test render. See Figure 7.7.

12. Select a 10 + 10 Point Star Filter with a Rotation Angle of 25 degrees. See Figure 7.8.

FIGURE **7.6** *The flare gets very stretched out, forming a streak of light across the image.*

FIGURE **7.7** *Adding a Star Filter creates a star flare we are familiar with.*

FIGURE **7.8** *Increasing the arms on the star gives it a more sun-like appearance.*

FIGURE *A burst is created.*
7.9

FIGURE *The streaks get thinner.*
7.10

13. Check Off-Screen Streaks and Anamorphic Streaks and set Intensity to 100%. Set Streak Sharpness to 1. See Figure 7.9.
14. Change the Streak Sharpness to 12 to tone down the spread of the streaks. See Figure 7.10.
15. Change Streak Density to 500 for a more solar effect. See Figure 7.11.
16. Set Streak Density to 12. Go to the Reflections tab and click on Lens Reflections to activate it. Do a test render. See Figure 7.12.
17. Set Polygonal Element Shape to 5 Sided. Set Current Reflection Element to Element 12. Set Element Type to Polygon Even Center. Set Element Position to 1.0 and Size to 45%. Use a light blue Element Color. See Figure 7.13.

FIGURE *A more solar effect.*
7.11

Figure **7.12** *Lens reflections are added.*

Figure **7.13** *Very unique Lens Flare objects can be created with a little experimentation.*

Figure **7.14** *You can use a series of different Lens Flare settings in a single image to create a luminous image or backdrop.*

18. Create an image that features a collection of different Lens Flare lights, utilizing different options. See Figure 7.14.

ONWARD

In this chapter, we explored Lens Flares. In the next chapter, we move on to displacement mapping, which begins the part of the book dedicated to advanced modeling techniques.

P A R T

More Modeling Techniques

CHAPTER

8

Displacement Mapping

Question: When is a texture not a texture?
Answer: When it affects the geometry of a model.

D isplacement maps, the subject of this chapter, are images that affect the geometry of a model. When displacement maps are applied, the light/dark data of the image is read as elevation data. In other applications, in fact, displacement maps are sometimes known as elevation maps. Displacement maps are usually created in grayscale. The lighter the shade (with solid white being the lightest), the "higher" the interpreted elevation. The darker the shade (with solid black being the darkest) the "lower" the interpreted elevation. Let's explore some displacement mapping.

IMAGE-BASED DISPLACEMENT MAPS

TUTORIAL

Do the following:

1. In Modeler, create a default cube by using the Box command.

FIGURE *Create this image.*
8.1

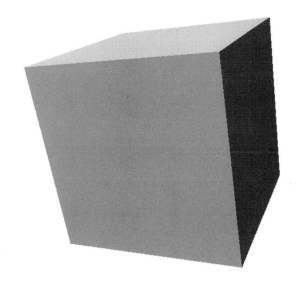

FIGURE *Rotate the cube like this.*
8.2

2. Send the model to Layout by using the Hub.
3. Open Photoshop or an alternate image editing application, and create the grayscale image displayed in Figure 8.1. Make it 5 inches x 5 inches at 300 DPI, and use solid black and solid white. Save the image.
4. Go to Layout, which should now display your cube. Rotate it so you can appreciate its sides in Camera view. See Figure 8.2.
5. Make sure that Objects is selected in the bottom menu. Click on Item Properties. The Item Properties for the cube are displayed. See Figure 8.3.
6. Click on the Deformations tab. Click on the "T" next to Displacement Map. This brings up the settings for your displacement map texture. See Figure 8.4.
7. Go to Image>Load Image, and load the image you created previously. Do a test render with all settings at their default. The test render looks the same as the nondisplacement mapped cube. Do you know why?
8. Select "None" for the Image and close the settings windows. Remember that the Hub is active and that anything you do in Modeler will instantly be translated to the cube in Layout. Go to Modeler.
9. The default cube you created and saved has one problem as far as displacement mapping goes: it has too few polygons. When you apply a displacement map to an object, the texture alters the geometry of the object

FIGURE *Item properties for the cube.*
8.3

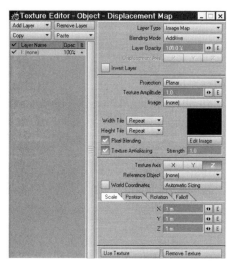

FIGURE *Displacement Map settings.*
8.4

by displacing the polygons. If there are too few polygons, the displacement will either be strange or it won't happen at all. Displacement mapping works more accurately when there are more polygons in the object. Go to Construct>SubDivide. The SubDivide Polygons window appears. See Figure 8.5.

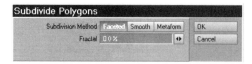

FIGURE *SubDivide Polygons.*
8.5

10. Accept the default setting with "Faceted" selected. Repeat this action.
11. Select a wireframe option for any view, and you will see that the cube's sides, which were previously formed by only one polygon, are now composed of sixteen polygons. Go back to Layout.
12. Return to Item Properties and to the Displacement Map option.
13. Load your image if it is not already loaded. With all settings at their defaults, do a test render. See Figure 8.6.
14. Everything depends upon the strength of the displacement, so change Texture Amplitude from its default of 1 to .2, and do another test render. See Figure 8.7.

FIGURE **8.6** *Wow! Now the polys are really displaced!*

FIGURE **8.7** *A .2 Texture Amplitude.*

15. You'll notice that Planar Mapping is selected. When Planar Mapping is used, it is targeted to an axis. The default is the X axis. Change that to the Z axis and render again. See Figure 8.8.
16. Now try a .2 strength with a cylindrical map on the Y axis. See Figure 8.9.
17. Use spherical mapping on the Z axis. See Figure 8.10.
18. Try cubic mapping on the X axis. See Figure 8.11.

FIGURE **8.8** *Planar mapped on the Z axis.*

FIGURE *Cylindrical mapping with the same*
8.9 *texture.*

FIGURE *Spherical mapping on the Z axis.*
8.10

FIGURE *Cubic mapping on the X axis.*
8.11

MORE POLYGONS!

Remember that the more polygons an object has, the higher the quality of the
displacement maps. Do the following:

1. In Modeler, SubDivide the cube three more times and send to Layout.
2. In Layout, apply a displacement map using the same image as before, with
 Planar .5 on the Z axis. See Figure 8.12.

FIGURE *Higher polys alter the geometry more*
8.12 *effectively.*

FIGURE *A cylindrical map on the Y axis.*
8.13

3. Try a cylindrical map on the Y axis. See Figure 8.13.
4. Use a cubic map on the Z axis and set the XYZ Scale at 50 cm. After rendering, reset the XYZ Scale to 22 cm, 22 cm, and 1 m. Render again. Scale makes a difference! See Figure 8.14.

FIGURE *On the left, Scale is set to 50 cm. On the right, Scale is set to 22 cm, 22 cm,*
8.14 *and 1 m.*

A RADIAL GRADIENT DISPLACEMENT MAP

Displacements are under the control of the image contents that are referenced. Do the following:

1. Create the image displayed in Figure 8.15 by using radial gradients in your 2D image application.

FIGURE *Create this image.*
8.15

2. In Layout, use the same multi-SubDivided cube used earlier. Import this new texture as a displacement map.
3. Set the Scale to 1 m for XYZ. Set spherical mapping on the X axis and render. See Figure 8.16.
4. Turn on Smoothing in the Surface Editor and use the Z axis with a Scale of 50 cm for XYZ. See Figure 8.17.

The jagged elements you see in an object to which a deformation mapping has been applied are caused by the sharp transitions in the image from black to white. To decrease or remove the jagged elements, add blurring to the image.

NOTE

FIGURE *Notice how smooth gradients are translated*
8.16 *into curved surfaces.*

5. Let's add a blur to the image without leaving LightWave. Click on the Edit Image button under the preview window in the Texture Editor. This brings up the Image Editor. Click on the Processing tab. See Figure 8.18.
6. In the Add Filter list, select LW_FPBlur. Set the Horizontal and Vertical values to 15 each and set Strengths to 150%. See Figure 8.19.
7. Return to the Texture Editor and Use Texture. Render. See Figure 8.20.

FIGURE *Surface smoothing creates more curvy*
8.17 *deformation objects.*

FIGURE *The Processing tab in the Image*
8.18 *Editor.*

FIGURE *Set the values.*
8.19

FIGURE *That's a little smoother now.*
8.20

Use Automatic Sizing to map the image exactly to your selected object.

NOTE

CREATING A GREEB MAP

TUTORIAL

"Greebs," also called "Greebles," refer to small random modeling parts that used to be glued to handmade models to create spacecraft. Digital Greebs are used today in the creation of digital spacecraft. Here's how to explore the creation of a Greeb displacement map:

FIGURE *Create an image from random*
8.21 *straight lines.*

FIGURE *Use the basic image to create a more complex map.*
8.22

FIGURE *Add some gray fills.*
8.23

FIGURE *Blur the image.*
8.24

FIGURE *Apply the image as a displacement map.*
8.25

FIGURE *The Beethoven model.*
8.26

1. Create an image in your image editing application from random straight lines. See Figure 8.21.
2. Copy, paste, scale, and rotate the image several times to create a more complex composition. See Figure 8.22.
3. Fill random parts of the image with your choice of grays. See Figure 8.23.
4. Blur the image. See Figure 8.24.
5. Use the image as a displacement map. Set the parameters to create the displaced geometry you like the most, doing test renders in between. See Figure 8.25.

TUTORIAL

PROCEDURAL DISPLACEMENT MAPS

You can use any of the procedural textures in LightWave as displacement maps. This is especially valuable for natural objects like rocks and trees. Do the following:

1. Load the Beethoven model from Objects>Human. See Figure 8.26.
2. Select Procedural Texture as the Layer Type. Apply any procedural texture you like as a deformation map. In this case, a Coriolis option was used. See Figure 8.27.

The Gradient Layer Type is not very useful for modeling. It tends to shift the whole model in space.

NOTE

FIGURE *Beethoven after imbibing a fifth.*
8.27

ONWARD

In this chapter, we took a detailed look at displacement mapping. In the next chapter, we'll move on to Metaballs.

9

Metaball Modeling

Metaballs are sometimes called "Blobbies" in other 3D applications because of their blob-like nature—their ability to stretch and pool together like beads of mercury. Metaballs are defined by points as opposed to polygons. As such, any point-associated operation can affect them. In LightWave, you can use Metaballs in two different ways: you can create objects from them or transform objects into them. The first option is the most common when it comes to modeling, although you may find it useful and interesting to see what an otherwise recognizable object looks like when composed of Metaballs.

METABALL TRANSFORMATIONS

Let's explore the transformation of a model into Metaballs. Do the following:

1. Create a box in Modeler. See Figure 9.1.
2. Go to wireframe mode in the top view so you can see the points of the box clearly. There are eight points, one at each corner of the box. See Figure 9.2.
3. Hit the "K" key to kill the polygons, leaving nothing but the points of the box. See Figure 9.3.

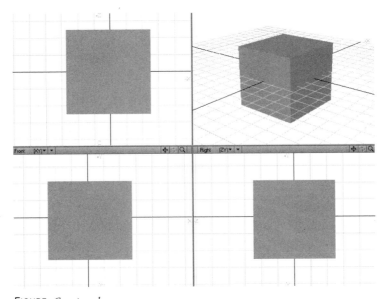

FIGURE *Create a box.*
9.1

FIGURE *The box has eight points.*
9.2

4. Go to Construct>Convert>Make Metaballs. All of the points are converted into Metaballs. See Figure 9.4.
5. Go to Modify>Stretch>Size. Remember that you are only manipulating points. When you size a group of points, you move them closer together or farther apart. Click and drag the mouse to the right to increase the size, which increases the distance between the points. This removes the

FIGURE *Kill the polygons.*
9.3

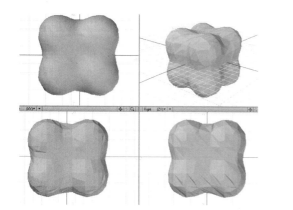

FIGURE *The points are converted to Metaballs.*
9.4

FIGURE *The separate Metaballs are revealed.*
9.5

stickiness from the Metaballs, revealing each one at a corner of the former box. See Figure 9.5.

6. With Size still selected, click and drag the mouse to the left to decrease the distance between the points until the Metaballs form a round-edged cube. See Figure 9.6.

7. Construct>Convert>Make Metaballs twice more to smooth out the object. You've really just increased the power of each Metaball. See Figure 9.7.

8. Use the Size operation again, clicking and dragging the mouse as far to the left as it will go. A sphere is formed. See Figure 9.8.

FIGURE *Create a round-edged cube.*
9.6

FIGURE *The cube is smoothed.*
9.7

9. Move the Metaballs apart again with the Size operation. Go to Modify>
Rotate>Twist in the top view until you can see all eight Metaballs. See Figure 9.9.

10. Use the Size operation to move the Metaballs closer together again, creating an object that is larger at the top than at the bottom. See Figure 9.10.

11. Go to Modify>Stretch>Taper 1 in the top view to create the object displayed in Figure 9.11.

12. Save the Metaball object. Use the Hub to send it to Layout.

13. When it appears in Layout, go to the Surface Editor. Check Smoothing and Double Sided.

FIGURE *A sphere is created.*
9.8

FIGURE *Use Twist in the top view.*
9.9

FIGURE *This object is created.*
9.10

14. Open Object Properties for the object. At the bottom of the Geometry tab page, you will see two entries: Display Metaball Resolution and Render Metaball Resolution. Each reads 10 by default, resulting in a rather chunky object. See Figure 9.12.

15. Change both of these parameters to 25. The object should instantly look nice and smooth. See Figure 9.13.

FIGURE *Tapering creates this new object.*
9.11

FIGURE *The Object Properties*
9.12 *Geometry tab page.*

FIGURE *The object is modified and looks smoother.*
9.13

16. Go to the Surfaces Editor and apply a Hammered Copper texture to the object from the Metals list. Render. See Figure 9.14.

17. Now that you know how to alter the smoothness of a Metaball construct in Layout, it's time to learn how to do it in Modeler. Altering the Metaball's smoothness in Layout does not automatically alter the object in Modeler. Go to Modeler. Go to Modeler>Options>General Options. The General Options window appears. See Figure 9.15.

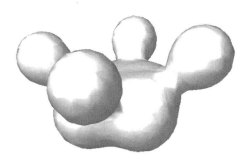

FIGURE *The finished object.*
9.14

FIGURE *General Options.*
9.15

18. Under Metaball Resolution, change the default value of 10 to 25 and close the window. The Metaball object is now much smoother. See Figure 9.16.
19. Go to Construct>Convert>Freeze. This transforms the Metaball object into a polygonal object. Export the new polygonal object in any format useful to you (as a 3DS object, for instance). See Figure 9.17.

FIGURE *The smoothed Metaball object.*
9.16

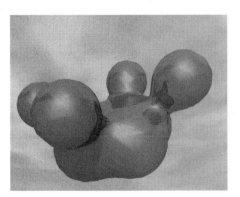

FIGURE
9.17 *After the object has been frozen and exported as a 3DS object, it is imported into Corel Bryce and rendered.*

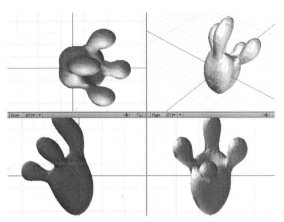

FIGURE
9.18 *Apply a Magnet and a Bend.*

20. Since the object is now a polygonal object, you can modify it in other ways. Apply a Magnet and a Bend to create a flower-like model. See Figures 9.18 and 9.19.

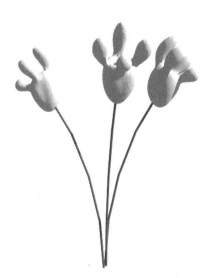

FIGURE
9.19 *Add a simple stem to create alien flowers.*

METABALL CONSTRUCTS

In the previous example, you saw how you can transform an object—in our case, a box—into a Metaball object. LightWave also allows you to create an object from scratch with Metaballs. Do the following:

1. In Modeler, set all of the views except the Perspective view to wireframe mode. Metaballs have light blue control areas that can best be seen in wireframe.

2. Go to Create>Elements>Metaballs. Click in a viewport to create the first Metaball. As long as you don't deselect the Metaballs command, you can move and resize any Metaballs placed down. By clicking and dragging the Metaball by its center point you can reposition it. By clicking and dragging the smaller circle you can scale it. Use the Perspective view to determine how the Metaball actually appears. Experiment with repositioning and scaling one Metaball before moving on. See Figure 9.20.

3. Click somewhere outside of the control area and a new Metaball will be created. All Metaballs can be positioned and/or scaled as long as the Metaballs command remains active (highlighted). See Figure 9.21.

Each Metaball you place on a layer affects the power of the other Metaballs on that layer.

NOTE

FIGURE *Use the control area to position and scale a*
9.20 *Metaball.*

FIGURE *Place and scale another Metaball, keeping an eye*
9.21 *on the Perspective view to see how they are reacting
 to each other.*

4. Position and scale the two Metaballs to create a rough simile of a head and nose. See Figure 9.22.
5. Go to Construct>Convert>Freeze. A polygonal object is created.
6. Go to another layer, selecting the previous layer as a background.
7. Create a Metaball upper lip in the right view and freeze. See Figure 9.23.
8. Copy the upper lip. Paste to Layer 3 and rotate for the lower lip. Cut from Layer 3 and paste to Layer 2 for both lips. See Figure 9.24.

FIGURE *Create a head and nose.*
9.22

FIGURE *Create an upper lip.*
9.23

FIGURE *The lips.*
9.24

FIGURE *A simple but effective head.*
9.25

9. Either scale and position the lips and copy to the first layer or export each component separately. Add some button eyes. See Figure 9.25.

Another Metaball construct version 7 and above of LightWave allows you to create is Metaedges. Just select "Metaedges" from the Create menu in Modeler. Click and drag the mouse to create tube-like Metaball structures. See Figure 9.26.

FIGURE *A Metaedge structure.*
9.26

FIGURE *A Metaface replaces the selected polygonal face.*
9.27

Version 7 and above of LightWave also allows you to create Metafaces, another Metaball option. To explore this feature, create a cube and select one face of the cube. Go to Construct>Convert>Make Metafaces, and the selected face will become a Metaball structure. See Figure 9.27.

ONWARD

In this chapter, we explored the world of Metaballs. In the next chapter, we'll delve into the mystery of HyperVoxels.

10

HyperVoxels

HyperVoxels are the kissing cousins of Metaballs. If you are adept at working with Metaballs, you will have little trouble mastering Hyper-Voxels. The difference is that while Metaballs are used for modeling objects, HyperVoxels are used for modeling natural and organic effects. This includes smoke, fire, and a wide array of additional substances and volumetrics. HyperVoxels can be surface or 3D volumetric based. Volumetric-based Hyper-Voxels offer the most realism, but at the cost of longer render times. Like Meta-balls, HyperVoxels are targeted to points rather than polygons. HyperVoxels are created and controlled in Layout.

BASIC HYPERVOXEL EXERCISES

Here are some basic exercises to get you acclimated to HyperVoxel use.

SPRAYED POINTS

In this example, we'll use sprayed points as a HyperVoxel target. Do the following:

1. Go to Modeler and to Create>Elements>Spray Points. Use this process in the front wireframe view. See Figure 10.1.
2. Save the points as "Points_01.lwo," and port them through the Hub to Layout.
3. Activate the Camera view in Layout, and scale the points to fill the viewspace.
4. Go to Scene>Effects>Volumetrics, then Add Volumetric>HyperVoxel Filter. See Figure 10.2.

FIGURE *Start with some sprayed points.*
10.1

FIGURE *The Effects window.*
10.2

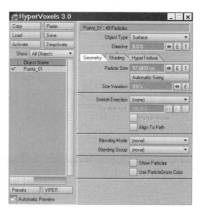

FIGURE *The points item is now activated*
10.3 *for HyperVoxels.*

5. Double-click on the HyperVoxels entry to bring up the HyperVoxels controls. Select your points item and click on Activate. See Figure 10.3.
6. Activate Viper to get a preview of the present HyperVoxel settings as applied to the points. See Figure 10.4.
7. Note that in the present HyperVoxels setup, Surface is selected for the Object Type. Set the Stretch Direction to X and the value to 250%. Look at the Viper preview now. See Figure 10.5.

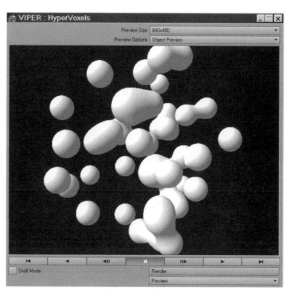

FIGURE *Viper shows the present HyperVoxel settings*
10.4 *applied to your points object.*

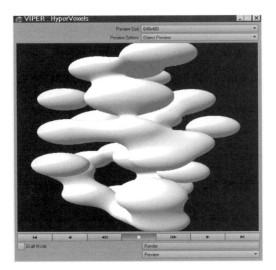
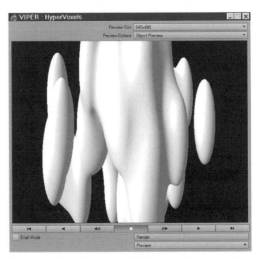

FIGURE **10.5** *The point blobs are stretched on the X axis, so they congeal in that direction.*

FIGURE **10.6** *The look is very different with a stretch applied to a different axis.*

8. Stretch on the Y axis at 400% and preview. See Figure 10.6.
9. Stretch on the X axis at 350%. Preview in Viper. Now check Maintain Volume and look at Viper again. Notice that the HyperVoxels will not blend if their volume is maintained. See Figure 10.7.
10. Uncheck Maintain Volume and set the Size Variation to 200%. This creates more randomly sized HyperVoxels. See Figure 10.8.

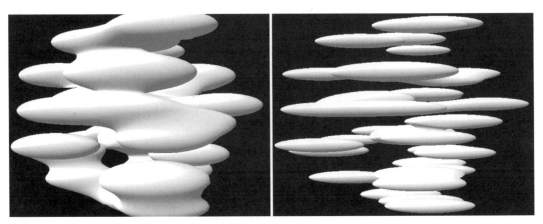

FIGURE **10.7** *Maintain Volume is unchecked on the left but activated on the right.*

11. Change the Particle Size value to about half of what it is presently. Altering the particle size affects the blobby blending because the HyperVoxel blend areas are either enlarged or truncated. See Figure 10.9.

12. Click the "T" (for "texture") next to the Stretch Amount to control the stretch with a texture. Select a procedural type, and explore whatever procedural texture you like. See Figure 10.10.

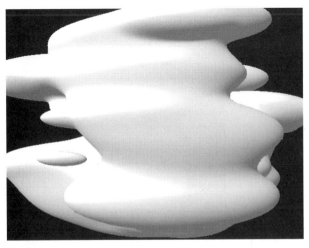

FIGURE *Size variations create more random HyperVoxel*
10.8 *sizes.*

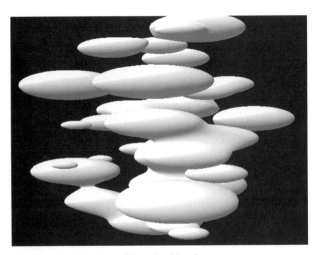

FIGURE *Particle size affects the blending amounts.*
10.9

13. Remove the texture used to control the stretch and go to the Shading tab. Under the Basic tab, set Bump to 500%. Use a Coriolis procedural texture with the values displayed in Figure 10.11. See Figures 10.11 and 10.12.

14. Now try a Bump Array procedural with the values displayed in Figure 10.13. See Figures 10.13 and 10.14.

15. Let's explore another one. Set the texture to an Underwater procedural. See Figures 10.15 and 10.16.

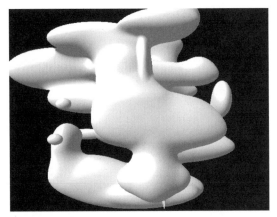

FIGURE **10.10** *The possibilities are limitless. In this case, a Coriolis procedural controls the stretch on all axes.*

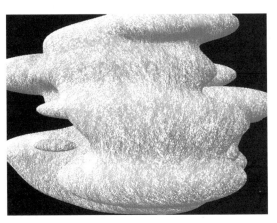

FIGURE *Use these values.*
10.11

FIGURE *The bump map result.*
10.12

FIGURE *Use these values.*
10.13

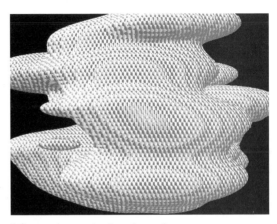

FIGURE *The result of applying the Bump Array*
10.14 *procedural.*

FIGURE *Use these values.*
10.15

FIGURE *The result of applying the Underwater*
10.16 *procedural.*

16. Remove all procedural textures. This time, apply a Veins procedural in the Transparency channel, using the values displayed in Figure 10.17. Make sure Self Shadow and Full Refraction are checked. See Figures 10.17 and 10.18.

17. One more option before we move on (you have to experience this one!). Go to the Shaders tab and to Edge Shaders>Edge Transparency. Set the values as indicated in Figure 10.19 and render to preview. See Figures 10.19 and 10.20.

FIGURE *Use these values.*
10.17

FIGURE *The result of the transparency map.*
10.18

FIGURE *Use these values for Edge*
10.19 *Transparency.*

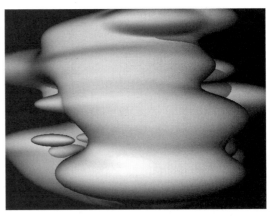

FIGURE *Use this effect to create globs of whipped cream*
10.20 *or soft ice cream. It even works for surface-
based alien clouds (with Refraction off).*

USING HYPERTEXTURES

HyperTextures are textures especially formulated for HyperVoxels. The best way to describe them is to compare them to a bump map. Bump maps add a fake 3D look to the surface of an object. When you look at the object's edges, however, you can see that the surface is not really bumpy. With HyperTextures,

the edges of an object also display the texture bumpiness, so the results are far more pleasing. Explore HyperTextures by doing the following:

1. In the HyperVoxels window, go to the HyperTextures tab and select the Smoky 3 HyperTexture from the Texture list of options. Set the parameters as displayed in Figure 10.21.
2. Watch the Viper preview to see what the HyperTexture looks like. See Figure 10.22.

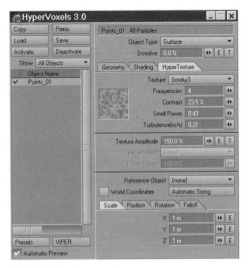

FIGURE *Use these values.*
10.21

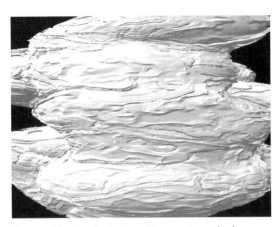

FIGURE *The Smoky 3 HyperTexture is applied.*
10.22

So far, we have only scratched the surface (pun intended) of the options you can use to apply texture variables to HyperVoxels. It's up to you to spend the necessary time deepening your discoveries.

THE REAL DEAL: HYPERVOXEL VOLUMETRICS

Volumetric HyperVoxels can be used to create very realistic particle system effects without using a particle system. They can also be integrated with a particle system to add textural reality to streaming particles. Do the following to begin exploring Volumetric HyperVoxels:

1. Delete all objects from both Modeler and Layout.
2. Create a four-point array in the front view of Modeler. Save it and port it over the Hub to Layout.
3. In Layout, go to the Camera view. Place the four-point array in the center of the screen and go to Create Keyframe>All Items.
4. Go to Scene>Effects>Volumetrics.
5. Go to Add Volumetric>HyperVoxels. Bring up the HyperVoxels controls.
6. Apply HyperVoxels to your four-point array and select Volume Object Type. Activate Viper to see what the default HyperVoxel parameters do to the four-point array. See Figure 10.23.

Using volumes as opposed to surface attributes increases render times dramatically. It's a good idea to use a fast system when creating Volumetric HyperVoxels, although even with a fast system you'll notice a comparative slowdown in renders.

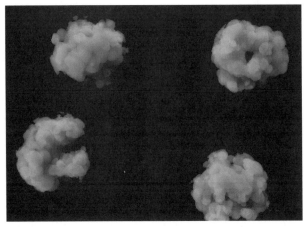

FIGURE *Your Viper preview may look something like this,*
10.23 *depending upon how much space is between your four points.*

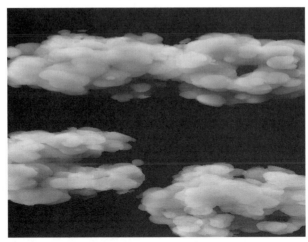

FIGURE **10.24** *Stretching the HyperVoxels on the X axis by 250% adds realistic blending so that the image looks less like four separate puffs.*

7. Use an X Stretch Direction with a Stretch Amount of 250% to get a more blended image. See Figure 10.24.
8. Let's explore some HyperTextures to create more variable Volumetric constructs. Increase the Particle Size setting by 50%. Go to the HyperTextures tab. Select the Crumple Texture. Input the values displayed in Figure 10.25. See Figures 10.25 and 10.26.

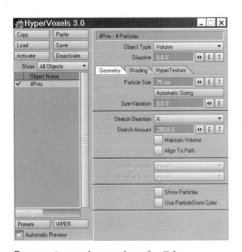

FIGURE **10.25** *Input these values for Edge Transparency.*

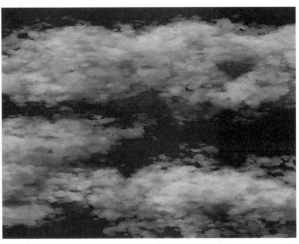

FIGURE **10.26** *This is the result; the image now looks more like clouds of highly particulate matter.*

When working with Volumetric HyperVoxels, it's a good idea to check Draft Mode in Viper. This significantly increases the speed of preview renders. You can also set Render Quality and Shadow Quality under Shading>Advanced to Low.

NOTE

9. Select a Ripples2 Texture, using the parameters displayed in Figure 10.27. This creates alien strata-like cloud layers. See Figures 10.27 and 10.28.

FIGURE *Use these parameters.*

10.27

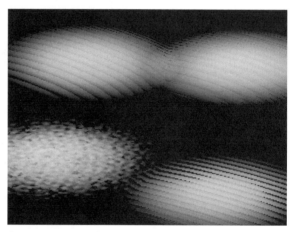

FIGURE *The Ripples2 Texture creates this effect.*

10.28

10. Here's a way to create those great rolling storm clouds that can be seen approaching from the horizon on a hot summer's afternoon or an image resembling the aftermath of some giant conflagration as seen from afar. Use the Dented texture with the parameters shown in Figure 10.29. See Figures 10.29 and 10.30.

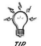

Try using a HyperVoxel render as a displacement map to create some interesting terrains.

TIP

11. Let's do one more. Here's one that creates something that resembles an Impressionist painting. Use a Hybrid MultiFractal texture with the parameters displayed in Figure 10.31. See Figures 10.31 and 10.32.

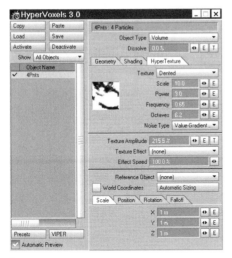

FIGURE *Use these parameters.*
10.29

FIGURE *Rolling thunder is the result.*
10.30

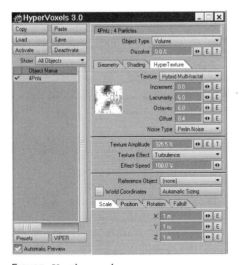

FIGURE *Use these values.*
10.31

FIGURE *An experiment in pointillism.*
10.32

LIGHT SPEED

Would you like super-fast HyperVoxel natural renders that offer even more variety? If so, select the Sprite Object Type instead of Volume. The Sprite Object Type is used to create effects like billowing smoke and explosions. Do the following to explore some variable themes:

1. Select the Sprite Object Type from the HyperVoxels window.
2. Double the particle size.
3. Go to the HyperTextures tab. Set the Texture to Turbulence. Set the parameters as displayed in Figure 10.33 to create a great plasma gas. See Figures 10.33 and 10.34.

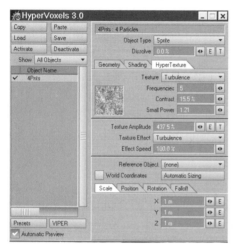

FIGURE *Use these settings.*
10.33

FIGURE *The plasma gas is rendered very quickly.*
10.34

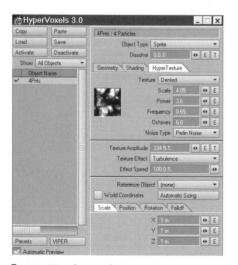

FIGURE *Use these values.*
10.35

FIGURE *The clouds look real and render very fast,*
10.36 *unlike images produced with Volumetrics.*

To create a plasma gas orb like a neuron star, use these parameters on spherical points.

TIP

4. Use these parameters to very quickly create a cloudy sky. Set Texture to Dented and use the values displayed in Figure 10.35. See Figures 10.35 and 10.36.

FIGURE *Use these parameter settings.*
10.37

FIGURE *The result is an abstract painting.*
10.38

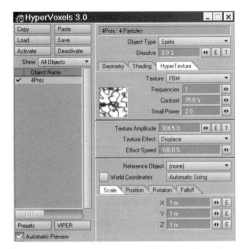

FIGURE *Use the parameters displayed here.*
10.39

FIGURE *Ripples, ripples everywhere. All of this was*
10.40 *generated from just four points.*

5. A much more abstract look can be achieved by using the FBM Texture with the parameters displayed in Figure 10.37. See Figures 10.37 and 10.38.

6. What if you are hard-pressed to create the waters of a hyperborean ocean? Have no fear, Sprites are here. Select the Ripples2 Texture. Use the parameters displayed in Figure 10.39. See Figures 10.39 and 10.40.

ONWARD

In this chapter, we covered the uses HyperVoxels can be put to, including Surface, Volume, and Sprite variants. In the next chapter, we'll inquire into the use of MetaForming as a modeling process.

11

MetaForm Modeling

etaForming is a smoothing operation, meaning that it increases the polygon count of the targeted object. MetaForming is not a suggested modeling technique if you are developing models for a game, because there you'll want to keep the polygon count low. (Of course, you could use MetaForming and then reduce the polygons afterwards with the gemLOSS2 command, Construct>Reduce>gemLOSS2.) MetaForming is especially useful for creating curved surfaces from sharp-cornered objects. Let's do some exercises to demonstrate the power of MetaForming.

TUTORIAL

MetaForming a Cube

A cubic solid is the best starting point for MetaForming, since it is a basic form that displays noticeable results quickly. Do the following:

1. Use a quadrangular viewport configuration. Set the top viewport to wire-frame and the rest to Texture. This will allow you to see the object's polygons in the top viewport.
2. Bring up the Numeric window for the Box form in Modeler. Set Actions to Activate. You will see a cube appear in the viewports with the default pa-

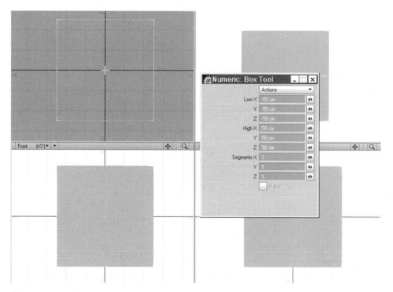

FIGURE *Use the Numeric operation to create a default cube.*
11.1

rameters. Zoom in on it so that its polygonal structure can be seen. See Figure 11.1.

3. With only one segment per XYZ axis, the cube has the minimum number of quadrangular polygons for its form—six. Let's see what happens when we apply MetaForming to the present form. Go to Construct>SubDivide> SubDivide to bring up the SubDivide Polygons parameters. Click on the MetaForm button. See Figure 11.2.

4. Click on OK. Look at the form in the viewports. It has become as spherical as it can be, given its limited number of polygons. See Figure 11.3.

FIGURE *The MetaForm tab parameters in*
11.2 *the SubDivide Polygons window.*

FIGURE *The basic cube is MetaFormed.*
11.3

5. Undo the operation until you have returned to the basic one-segment-per-axis cube again.

6. Go to Construct>SubDivide>SubDivide and select Faceted. Click on OK to double the number of polygons in the cube. See Figure 11.4.

7. Now apply MetaForming as before. Notice how different this form looks from the basic cube MetaFormed in Figure 11.3. See Figure 11.5.

8. MetaForming a faceted object is usually followed by a smoothing operation. Go to Construct>SubDivide>SubDivide. Click on the Smooth button, which by default is set to a value of 89.5 degrees. This means that all edges not set to a right angle (90 degrees) will be smoothed out. Click on OK to apply smoothing. See Figure 11.6.

FIGURE *The cube now has four quadrangular polys per side,*
11.4 *as can be seen in the top wireframe view.*

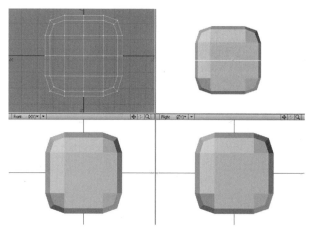

FIGURE *MetaForming results are always based upon the*
11.5 *number of polygons targeted.*

NOTE

*MetaForming a faceted cube can create beautiful gemstone ob-
jects, in which case you would not want to apply smoothing.*

9. What if you want the benefits of smoothing without the increased poly-
gons? Undo the Smooth operation to return to the faceted MetaFormed
cube. Bring up the Surface Editor. See Figure 11.7.

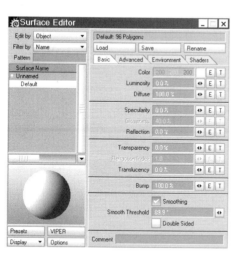

FIGURE **11.6** *The MetaFormed cube is smoothed, losing the faceted look and resulting in many more polygons.*

FIGURE **11.7** *The Surface Editor for the MetaFormed and faceted cube.*

10. Check Smoothing at the bottom and watch the object in the viewports. The polygon count remains the same, but the facets look smoothed. Use this method of smoothing when you need to keep the polygon count low. See Figure 11.8.

FIGURE **11.8** *Objects can also be smoothed by altering their Surface parameters.*

MetaForming can be applied to just the selected polygons.

NOTE

11. Undo smoothing in the Surface Editor. In the top wireframe view, select just the polygons on the right of the faceted cube. They will light up, allowing you to see their normals. See Figure 11.9.

FIGURE *Select the polys on the right in the top wireframe*
11.9 *view.*

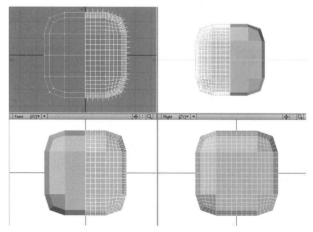

FIGURE *The object should now look like this.*
11.10

12. Hit Construct>SubDivide>SubDivide>Faceted twice. Your object should now resemble that in Figure 11.10.

13. Deselect all polygons. Go to Construct>SubDivide>SubDivide>MetaForm. You get an error flag. What's wrong? See Figure 11.11.

14. The error flag reports that you cannot subdivide polys with more than four sides, indicating that your MetaForming has generated polys with more than four sides. What can you do? Go to Construct>SubDivide>Triple to create triangular polys for the entire object. Now MetaForm. The resulting object has a very complex web of polygons, but there are more on the right side. If you were to vertex edit this object, you would have more opportunities for achieving finer variations on the side with more polygons. See Figure 11.12.

15. To prove this, go to Multiply>Extend>More>Spikey Tool and click-drag the mouse to the right. Notice that the spikes that appear on the side with more polygons take advantage of the increased polygon count. See Figure 11.13.

Subdivide Polygons

Polygons with more than four sides cannot be subdivided.
Use Triple command to convert larger polygons to triangles. [OK]

FIGURE *This error flag appears.*
11.11

FIGURE *The top wireframe view of the object.*
11.12

FIGURE *The spikes look different on the side with more polygons.*
11.13

TUTORIAL

METAFORMING LIBRARY OBJECTS

When you first take note of the number of objects contained in the Objects folder that ships with LightWave, they seem like a wealth of extra content, and they are. There's more there than meets the eye, however. Any of the objects listed in the folder can be customized infinitely, with any of Modeler's tools and operations. This means that there is a potentially fathomless collection of models available to you. MetaForming is one way to customize a stock object. Sometimes, it's all that you need to create a unique model of your own. Here's one example. Do the following:

1. In Modeler, go to File>Load Object>Electronics>TV. This loads a television model. See Figure 11.14.
2. Open the Surface Editor. We are going to alter the image currently on the TV screen. Select the TV_Screen item from the Surfaces list at the left. See Figure 11.15.
3. Click on the "T" next to the Color item, and click on Remove Texture at the bottom of the Texture Editor.
4. Change the color from black to a light blue.
5. Go to Detail>Polygons>Make Double Sided.
6. Select the polygons displayed in Figure 11.16 in the top wireframe view.

FIGURE *The TV model is loaded.*
11.14

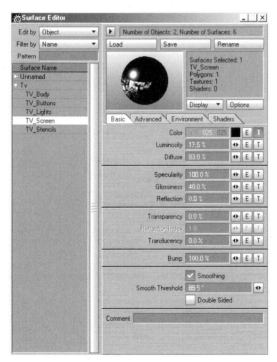

FIGURE *The Surface Editor displays all of the*
11.15 *surfaces used for the TV model.*

FIGURE *Select just these polygons.*
11.16

7. Go to Construct>SubDivide>SubDivide>MetaForm. Use a Max Smoothing Angle of 89.5 and click on OK. Repeat. Notice how you have altered the shape of the back of the TV. See Figure 11.17.
8. Go to Modify>Move>Magnet to pull the MetaFormed selection straight back. See Figure 11.18.
9. Deselect all polys. Edit>Copy and Paste to a new layer. Rotate and move each layer's contents to create the doubled TV displayed in Figure 11.19.

FIGURE
11.17 *The back of the TV has been MetaFormed and is rounder.*

FIGURE *Pull the polys straight back.*
11.18

FIGURE *The doubled TV.*
11.19

10. Activate a third layer. Place a default cube on it, using the Numeric Box operation. MetaForm it once at the default 179 degrees to create an octagonal volume.

11. Place the TV's (now robotic) "eyes" in the background, and scale the "head" in proportion to the eyes. Save as "MetaHd1.lwo." See Figures 11.20 and 11.21.

FIGURE *MetaHead lives and is ready for a body.*
11.20

FIGURE *The TV screen surfaces are mapped with a picturesque*
11.21 *scene, making it seem as if the eyes are looking out into*
the world.

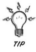
You can place any image you like on either TV screen surface to
simulate an eye reflection.
TIP

METAFORMING A BLOCKHEAD

TUTORIAL

Normally, the term "blockhead" is reserved as an insult. In this case, however, it's an allusion to a 3D modeling process you can utilize to create a wide variety of character heads and other parts.

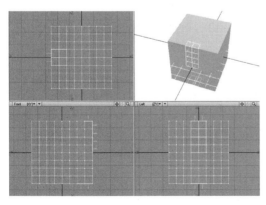

FIGURE *Create a default box. Go to*
11.22 *SubDivide>Facet three times. Select the*
polys shown here.

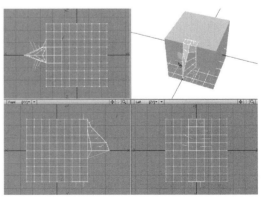

FIGURE *Go to Modify>Move>Magnet to pull out a*
11.23 *nose. Deselect all polys.*

This tutorial will be presented with graphics alone. It centers upon the creation, scaling, and movement into place of a series of boxes. Each component is created on a new layer, adjusted (scaled and positioned), then cut and pasted to the root layer to form one connected unit. You have already used this technique in other tutorials, so the step-by-step images with brief captions should suffice. Use a similar process with your own variations to create unique LightWave characters. See Figures 11.22 to 11.34. Do the following:

Add ears by modeling them separately. Extruded ears never look right. Eyes and other features can be added at a later stage.

NOTE

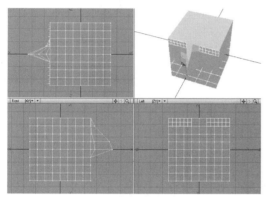

FIGURE **11.24** *Go to SubDivide>Facet to delineate brow areas.*

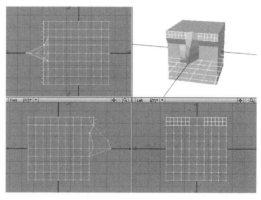

FIGURE **11.25** *Go to Modify>Move to generate brows, then deselect all polys.*

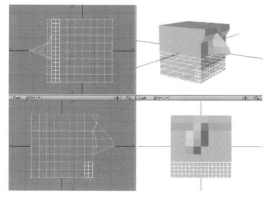

FIGURE **11.26** *Select and SubDivide>Facet the polys shown for mouth and chin areas.*

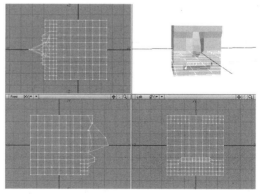

FIGURE **11.27** *Select the appropriate polys and go to Modify>Move to extrude an upper lip. Deselect all polys.*

FIGURE **11.28** *Create a lower lip by first SubDividing by Facet and extruding outward.*

FIGURE **11.29** *Select the appropriate polys and points and move to give the head a better shape.*

FIGURE **11.30** *SubDivide>Facet the appropriate polygons and use the Move tool to extrude out a neck.*

FIGURE **11.31** *Select and move appropriate polys to give the character a high cheekbone look.*

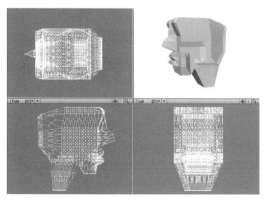

FIGURE **11.32** *Go to Construct>SubDivide>Triple so you can MetaForm the head to round out the features, repeating as many times as required.*

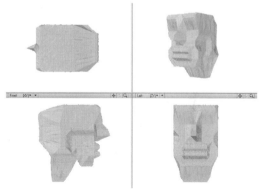

FIGURE **11.33** *Go to Construct>Merge Points to get rid of unneeded points. Smooth in the Surface Editor. Use the Magnify operation to give the character more unique features.*

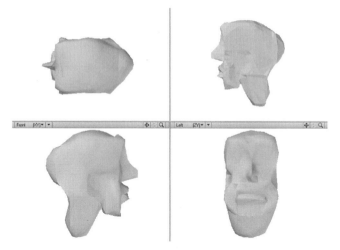

FIGURE **11.34** *Keep tweaking until you get the look you want. Make sure to explore reducing the polys along the way. The final head here looks very craggy.*

ONWARD

In this chapter, we investigated how to use MetaForming to customize and create objects. In the next chapter, we'll take a look at what we call self-similar modeling.

12 Self-Similar Modeling

What do we mean when we say "self-similar modeling"? To model an object using this (or rather, these) technique(s), all of the components of the model must reference a single form. For instance, creating a model with spheres alone is one self-similar modeling technique. The most famous self-similar models are fractal models. A fractal model consists of smaller and larger duplicates of the same form. That's why fractal formulae are often used to create 3D objects that appear in nature, like trees and clouds. Zooming in close enough on a fractal model of a tree—close enough to see a small branch—presents you with what appears to be a smaller version of the whole tree. In this chapter we are going to investigate a group of self-similar modeling techniques, including mirroring, arrays, cloning, symmetrizing, path/rail cloning, and point clone plus.

MIRRORING

If you are familiar with what mirroring does and how it is activated in other 3D applications, you will have to get acclimated to the unique way mirroring works in LightWave. Mirroring always refers to an operation on nonsymmetrical objects. Mirroring an object flips the object on a selected axis so that what was once a feature on one side becomes a feature on the opposite side. Mirroring is especially useful when you want to create just half of a complex object and then clone and mirror it to create an opposite half—like using half of a face to create a whole face. The difference in LightWave is that the cloning (or duplication process), usually the first step, is built into the Mirror operation.

Mirroring always refers to the object's pivot point/origin point as a center of rotation, so it's best to move the origin point where you want it before beginning the mirroring process.

A BASIC MIRRORING PROJECT

Do the following to explore the Mirror operation:

1. In Modeler, create a default box form. See Figure 12.1.
2. Triple and SubDivide to create a thicker polygon mesh.
3. Select random points in the top view and use the Move tool to create a nonsymmetrical form. See Figure 12.2.

FIGURE *Create a default box form.*
12.1

FIGURE *Create a random form.*
12.2

4. At the moment, your object's approximate center should be fairly coincident with the Grid Origin. Move the object left so that its right edge (top view) is coincident with the Z axis of the Grid Origin. See Figure 12.3.

5. Go to the bottom of the Modeler interface to the Modes list. This is where you can determine how an operation will reference a pivot point. Select Action Center: Origin. This should set the pivot at the 0, 0, 0 Grid Origin. Rotate the object to see that this is the case.

6. Undo after you have explored the results to rest the rotation at 0.

FIGURE *Move the object so that its right side approximately*
12.3 *matches the Z axis origin (top view).*

7. Go to Multiply>Duplicate>Mirror. LightWave does not really allow you to mirror an object without the duplication happening first. In the top view, use the Mirror operation to rotate a mirrored duplicate around the pivot point you set at the Grid Origin. See Figure 12.4.

8. When you perform a Mirror operation, there are two separate elements involved. First, you rotate the object commensurate with the view you are working in. Second, you click-drag the mouse to position the duplicated object in accordance with the axis perpendicular to the direction of rota-

FIGURE *The mirrored duplicate is created.*
12.4

FIGURE *Move the mirrored duplicate in the same view the*
12.5 *rotation took place in.*

tion. To get a feel for this, without selecting any other operation first, click-drag the Mirror tool after the duplicate has been rotated into position. See Figure 12.5.

9. As long as the Mirror tool remains active, you can reposition the duplicated object. Once you deselect the Mirror tool, the source and duplicate elements become one object on the selected layer. Deselect the Mirror tool and select it again. Create a mirrored duplicate of the new object. See Figure 12.6.

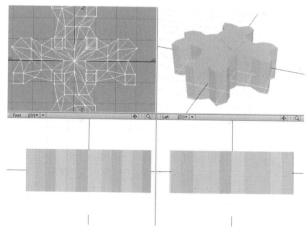

FIGURE *Mirror the new object to create a more complex*
12.6 *result.*

10. Go to Detail>Layers>Pivot to access the pivot point directly. Select Pivot from the Modes list, and mirror to explore how your movement of the pivot point affects a Mirror operation. See Figures 12.7 and 12.8.

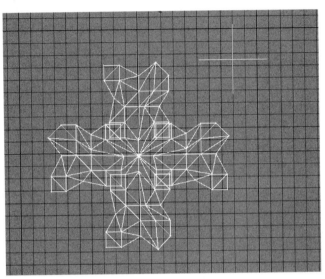

FIGURE *Move the pivot point directly.*
12.7

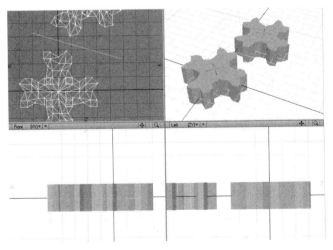

FIGURE *Mirror on the new pivot point.*
12.8

ARRAYS

The description of what an Array operation does will vary according to the 3D software you are using. In LightWave, an array is a grouped construct based upon one element in that construct. Spaces between the elements can be varied, but the structure of the element itself remains exactly the same. Two types of arrays can be created in LightWave: rectangular and radial.

TUTORIAL

RECTANGULAR ARRAYS

A rectangular array may be based upon one, two, or three dimensions. A one-dimensional rectangular array is linear. The elements are duplicated in a straight line, like a tower (if the array is created relative to the Y axis). A two-dimensional rectangular array can be compared to a flat plane, which will have whatever thickness the selected element possesses. A three-dimensional rectangular array encloses a 3D volume. Think of a Rubik's Cube, where separate cubic elements are arranged in a 3D cubic array. Do the following to create a three-dimensional array in LightWave:

1. Place a default cube (box) sized to 1 m on each axis in your workspace in Modeler. See Figure 12.9.

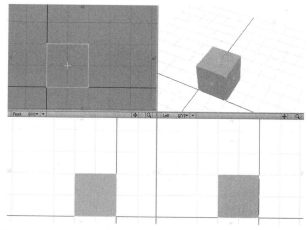

FIGURE *Start with a 1 m cube.*
12.9

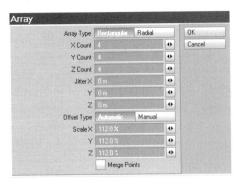

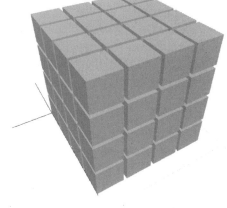

Figure *The Array settings.*
12.10

Figure *The result is this perfect cubic array.*
12.11

2. Go to Modes>Action Center>Pivot. By default, the pivot is centered in the cubic box.

3. Go to Multiply>Duplicate>Array to bring up the settings. See Figure 12.10.

4. Input the values displayed in Figure 12.10. By using scaling factors higher than 100%, you create a space between the elements on the selected axis. See Figure 12.11.

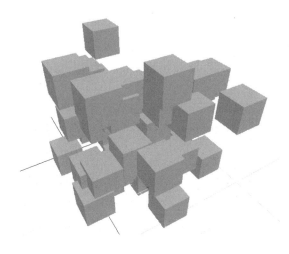

Figure *A Jittered array.*
12.12

5. Let's alter one of the parameters to create a more chaotic array. Undo the array you just created and bring up the Array command parameters again.
6. This time, add a Jitter factor of 1 m on each axis to vary the placement and click on OK. This array looks very different from the perfectly ordered one we created previously. See Figure 12.12.

Explore additional parameters on your own to create variations on the rectangular array theme.

RADIAL ARRAYS

TUTORIAL

Think of a radial array as a series of equidistant marks on the face of a clock denoting time markers. Do the following:

1. Undo the previous Array operation so you have just one cube in the workspace. Bring up the Array parameters.
2. Set the Array parameters as displayed in Figure 12.13.
3. Notice that the resulting elements in the array are rotated according to the center of the array. See Figure 12.14.
4. Let's use this initial array to create a spherical array. Use the settings displayed in Figure 12.15.
5. The resulting array has more 3D interest. See Figure 12.16.

Explore other Radial Array parameters on your own to master the technique.

FIGURE *Use these values.*
12.13

FIGURE *The resulting radial array.*
12.14

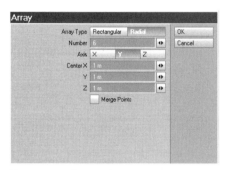

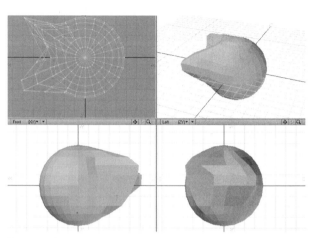

FIGURE *Use these values.*

12.15

FIGURE *The resulting array.*

12.16

CLONING

TUTORIAL

Cloning differs from copy/paste as a duplication method in that the cloned elements can have size and placement attributes that differ from the original. Do the following to begin to explore the possibilities:

 1. Create any object you like for the Modeler workspace. Here we've used a default ball (sphere) in which a few points have been Magnetized outward. See Figure 12.17.

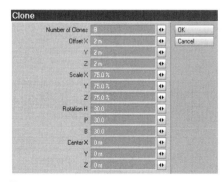

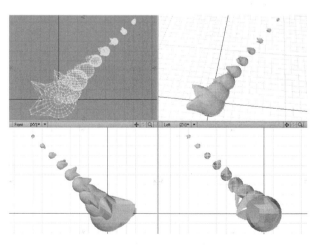

FIGURE *Use these values.*

12.17

FIGURE *The cloned result.*

12.18

2. Go to Multiply>Duplicate>Clone to bring up the Cloning parameters. Use the values displayed in Figure 12.17.
3. Note that the scaling and rotation values are applied to each successive element in the chain. See Figure 12.18.

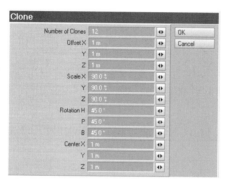

FIGURE **12.19** *Input these parameters.*

FIGURE **12.20** *You may not know what it is, but complexity is its game.*

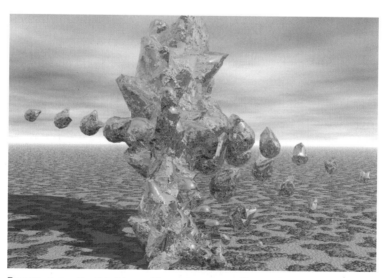

FIGURE **12.21** *Actually, this bizarre form sits quite well in a dreamscape.*

4. Let's further complicate matters. Bring up the Cloning parameters again, and input the values displayed in Figure 12.19.
5. The result can't be modeled any other way. See Figures 12.20 and 12.21.

TUTORIAL

SYMMETRIZING

Symmetrizing an object is similar to creating a radial array. Do the following:

1. Start with whatever object you created from the last exercise. Reduce the polygons twice (Construct>Reduce>gemLOSS2 or Reduce Polygons).
2. Go to Multiply>Duplicate>Symmetrize to bring up the parameter settings. See Figure 12.22.
3. The choices are simple. You select an axis and the number of duplicated elements. Use the parameters shown in Figure 12.22 to create an arrangement similar to Figure 12.23.

Explore this process further on your own. Try symmetrizing just a portion of a 3D object.

FIGURE *The parameter settings.*
12.22

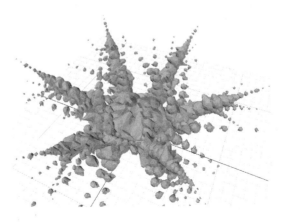

FIGURE *The symmetrized result.*
12.23

PATH/RAIL CLONING

TUTORIAL

Path/rail cloning allows you to control the resulting elements by targeting a path. Path cloning requires that you load a Motion Path. Rail cloning allows you to simply sketch out the rail. Do the following.

1. Create a new object. Use the Sketch tool to create a rough spiral as seen from the top view on Layer 1.
2. On Layer 2 create a box.
3. Move the box so that its pivot point is roughly over the first point of the spiral rail on Layer 1. See Figure 12.24.

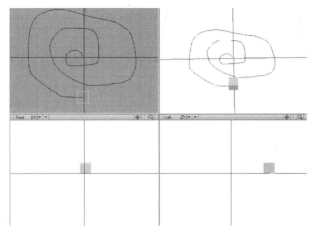

FIGURE *The rail and the box are placed on separate layers.*
12.24

If you place the object to be rail cloned at a distance from the first point of the rail, the results will be unpredictable.

NOTE

4. Go to Multiply>Duplicate>Rail Clone to bring up the parameters. See Figure 12.25.

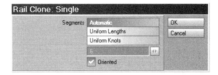

FIGURE *The Rail Clone parameters.*
12.25

5. Although you can explore different settings, using Automatic with Orientation checked on works the best in most situations. Do it. See Figure 12.26.

6. You can rail clone 2D shapes as well as 3D objects. When rail cloning 3D objects, you will always want to reduce the polygon count and merge points. Do that now.

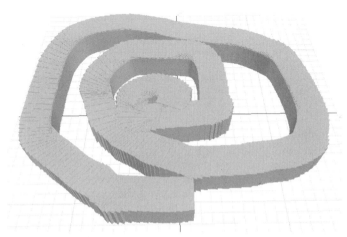

FIGURE *The resulting object.*
12.26

FIGURE *Create this composition.*
12.27

7. Let's explore a variation. Start with a rough spiral rail on Layer 1 again. Place a box on Layer 2 and a ball on Layer 3. Place the ball above the box, and center both in the top view over the spiral rail on Layer 1. See Figure 12.27.

8. Place the rail in the background and shift-select the ball and box as foreground layers. Automatic rail clone. See Figure 12.28.

FIGURE *Does this process give you any creative ideas?*
12.28

POINT CLONE PLUS

When the resulting model that is constructed of cloned elements is too mechanical for your needs, you might want to try the Point Clone Plus operation. Do the following.

1. Use a similar rough spiral rail as a background layer, and place a box in Layer 1 for a foreground.

2. Go to Multiply>Duplicate>Point Clone Plus to bring up the parameters. See Figure 12.29.

3. As you can see, there are numerous controls for randomizing the construct. Try using the parameters in Figure 12.30 to achieve something like Figure 12.31.

4. Use this object as a rocky piece of terrain. See Figure 12.32.

FIGURE *The Point Clone Plus parameters.*
12.29

FIGURE *Use these parameters for a start ...*
12.30

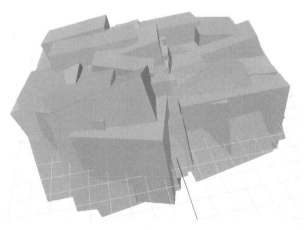

FIGURE *... to get a result like this. This jumble of blocks makes*
12.31 *a great rock face.*

FIGURE *A rendering of rocks produced by using the Point Clone Plus operation.*
12.32

ONWARD

In this chapter, we explored tools that can be used to create self-similar models. In the next chapter, we'll take a look at modeling with particles.

CHAPTER

13

Modeling with Particles

articles are points that are renderable on their own. LightWave has its own integrated particle system, called Particle FX. Particles are usually associated with animation, but there is no reason you can't think of a particle system as a modeling tool and use it to render one or more selected frames to create an image. Particles are used to create things like fire and water, with all of their variant states. In Particle FX, particles are sculpted by using Controllers, Emitters, Wind, Collision, and Gravity. After configuring a controller for a specific effect, you can save it so it can be used later on another project. Controllers are added in the Particle FX Browser, which is accessed in Layout by going to Scene>FX_Browser. See Figure 13.1.

FIGURE *The Particle FX Browser.*
13.1

By hitting the Play button in the animation controller in Layout as you work with particles, and tweaking the parameters of any particle image, the effect is real-time updated. This makes it easier for you to design just the effect you want. If you open the list next to Add, you will see the controllers that can be accessed. They include HV Emitter (HyperVoxel Emitter), Partigon Emitter, Wind, Collision, Gravity, and Load Item. Of all of these choices, our attention will focus mainly upon the two emitter types: HyperVoxels and Partigons.

CREATING HyperVoxel Particle F/X

Using the HV Emitter, you can create particle systems that utilize any of the three HyperVoxel types: Volumes, Surfaces, or Sprites. Each has a definite use when it comes to particle object F/X modeling.

- Volumes: Use Volumes for any effect you want to image as if the camera were in the middle of the effect, like fire or water F/X.

- Surfaces: Use Surfaces when you want to create nonvaporous matter. Examples might be Jell-O, lava, mud, or alien goo.

ON THE CD *Look in the Anims folder on the CD for the Hyper1.mov Quick-Time animation, which was created with Surface HV Particle FX.*

- Sprites: Use Sprites for all F/X images that are to be appreciated at a distance, which is what you will be interested in most of the time. Sprite HyperVoxels render far faster than Volumes.

A HyperVoxel Particle F/X Exercise

TUTORIAL

Let's do an example exercise that displays some of the power of the HV Emitter. Do the following:

1. Go to Scene>Dynamics>FX_Browser in Layout. Click on HV Emitter in the Add list to place a HyperVoxel Emitter in the scene. See Figure 13.2.

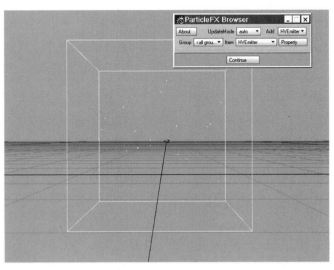

FIGURE *Activate and place an HV Emitter.*
13.2

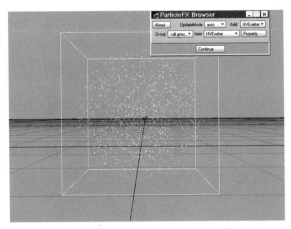

FIGURE **13.3** *Moving the Animation Slider control increases the number of particles streaming from the HV Emitter.*

2. Move the Animation Slider to Frame 50. Notice that the particles have increased in quantity. See Figure 13.3.
3. Render the current frame for preview. It's blank! Why? You haven't set the HyperVoxel parameters yet.
4. Go to Scene>Effects>Volumetrics and add a HyperVoxel Volumetric. See Figure 13.4.
5. Double-click on the HyperVoxels entry to bring up the parameter settings. Double click on the HV Emitter entry in the list. See Figure 13.5.

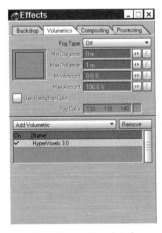

FIGURE **13.4** *A HyperVoxel Volumetric is added.*

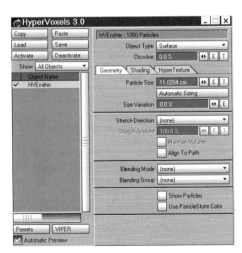

FIGURE **13.5** *The HyperVoxel parameters with the HV Emitter selected.*

FIGURE *The HyperVoxels Color Texture*
13.6 *Editor.*

FIGURE *Use these values.*
13.7

6. Under Shading>Basic>Color, click on the "T" (textures). This brings up the Texture Editor for HyperVoxels Color. See Figure 13.6.
7. Select a Procedural Texture Layer Type and a Coriolis Procedural Type. Use the Coriolis parameters displayed in Figure 13.7. Accept the texture.
8. Back in the Geometry tab in HyperVoxels Parameters, use the values displayed in Figure 13.8. Note that we are targeting a Sprite HyperVoxel type.

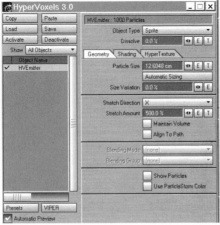

FIGURE *Use these values.*
13.8

FIGURE *Use these values.*
13.9

FIGURE *This is the result.*
13.10

9. Under the HyperTexture tab, use the values displayed in Figure 13.9.
10. Now do a test render. As you can see, the particles have formed to create a glowing vaporous cloud. See Figure 13.10.
11. Change the HyperVoxels type to Surface, and use the HyperTexture parameters shown in Figure 13.11.

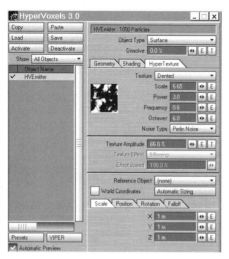

FIGURE *Use these values for the surface*
13.11 *type HyperTexture.*

FIGURE *The HV Emitter is now using the surface*
13.12 *HyperVoxels type.*

12. Do a test render. Notice the difference apparent in the HyperVoxel Emitter's composite particle structure? This object looks more like 3D Styrofoam. See Figure 13.12.

13. Now change the type to Volume, and use the HyperTexture values displayed in Figure 13.13.

14. Do a test render to see how Volumetric HyperVoxels with the same basic settings as the other two types differ from them. See Figure 13.14.

Now we wind up with billowing 3D clouds. Obviously, we have only explored a tiny fraction of the possible HyperVoxel Texture settings. Your explorations will no doubt produce even more astounding results.

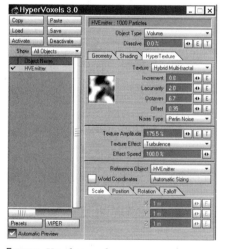

FIGURE *Use these values.*

13.13

FIGURE *The Volumetric type is applied to the HV Emitter*

13.14 *particles.*

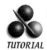

TUTORIAL

PARTICLE FX PROPERTIES

No matter which emitter you use, you must set particle parameters. These parameters determine things like particle size, direction, and speed, as well as how long a particle "lives." Do the following to set particle properties for our present exploration:

1. First, reset the HyperVoxel texture type to Surface. Return to the Particle FX Browser and click on the Property button. The parameters for the HV Emitter will appear. See Figures 13.15 and 13.16 for the values to set for our surface particles.

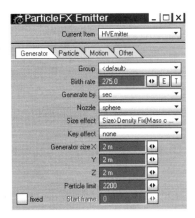

FIGURE
13.15 *Use these generator values.*

FIGURE
13.16 *Use these particle values.*

2. Render a test image for Frame 22. See Figure 13.17.
3. Bring up the Particle FX Gravity properties and add a gravity effect. Set the values as displayed in Figure 13.18.

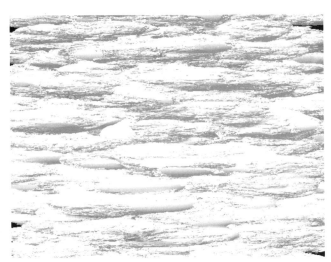

FIGURE
13.17 *The results are computed for the particle properties that were set. Because the particle size, particle quantity, and dimension of the HV Emitter were increased, the HyperVoxel particles fill the view.*

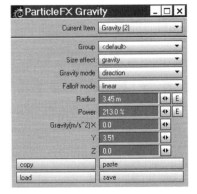

FIGURE
13.18 *Use these values.*

Because we have increased the gravity on the Y axis to such a huge degree, the particles will fall to the ground in an animation, and there will be less and less image content per frame. Make sure to explore a wider variety of HV Emitter parameter settings.

CREATING PARTIGON PARTICLE F/X

TUTORIAL

Partigons are special one-dimensional shapes that can be used for a particle surface. You can use HyperVoxel Volumetrics to surface the Partigons. Here's an interesting way to create exploding popcorn using a Partigon method. Do the following:

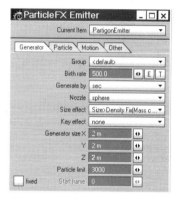

FIGURE *Use these values.*
13.20

FIGURE *Select Partigon from the Browser.*
13.19

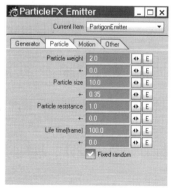

FIGURE *Use these values.*
13.21

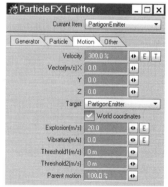

FIGURE *Use these values.*
13.22

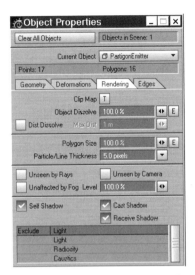

FIGURE *Use these parameters on the*
13.23 *Rendering page in Object Properties.*

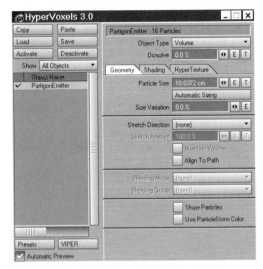

FIGURE *Select the Volume HyperVoxels type.*
13.24

1. Select Partigon from the Particle FX Browser to place a Partigon Emitter in the Layout scene. See Figure 13.19.
2. Set the Particle FX Property>Generator page as displayed in Figure 13.20.

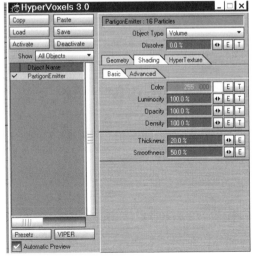

FIGURE *Use a bright yellow color.*
13.25

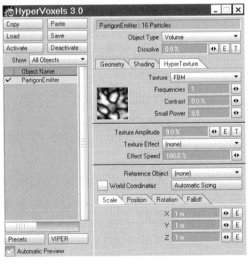

FIGURE *Use these parameters.*
13.26

3. Set the values on the Particle page as shown in Figure 13.21.

4. Set the values on the Motion page as shown in Figure 13.22.

5. Set the parameters on the Rendering page in Object Properties as shown in Figure 13.23.

6. Go to Scene>Effects>Volumetrics to assign HyperVoxel type and parameters. Activate the Partigon Emitter in the list. Select the Volume HyperVoxels type. See Figure 13.24.

7. Under Shading>Basic, use a bright yellow color. See Figure 13.25.

8. Use the parameters displayed in Figure 13.26 for the HyperTexture page.

9. Render some sample frames to see the popcorn, or, if you like, render the animation. See Figure 13.27.

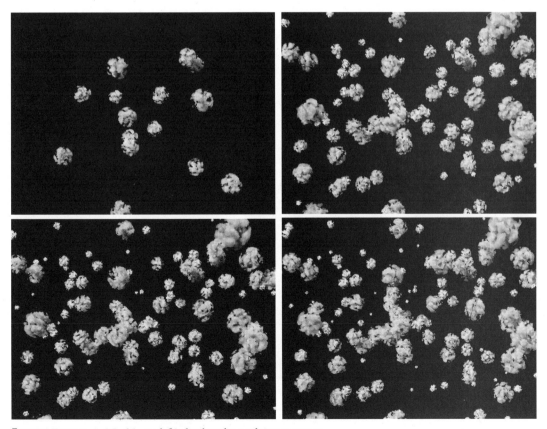

FIGURE *Frames 1, 25, 45, and 60 display the evolving popcorn.*
13.27

You have completed one example that shows you how Particle FX can be used to generate a variety of 3D content. Further explore the use of Particle FX on your own, keeping a record of what you are able to create.

ONWARD

In this chapter, we explored the uses of both HV Emitter and Partigon Emitter effects. In the next chapter, we'll look at pivots, parenting, hinges, bones, and endomorphs.

CHAPTER

14

Pivots, Parenting, Hinges, Bones, and Endomorphs

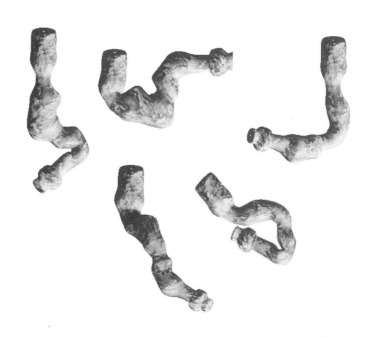

I t is common to find the topics covered in this chapter in an animation-specific book. Models whose parts can be adjusted in relation to each other are said to be "articulated." Articulated models are just as valuable for the image maker as for the animator, because articulated models can be posed. Four essential components of articulated models in LightWave that you must be aware of are Pivots, Parenting, Hinges, and Bones. Endomorphing, which will also be covered in this chapter, is a special deformation process that allows you to form special target states of a model and then influence the base (source) model with those target states.

TUTORIAL

PIVOTS

Pivots refers to the placement of the pivot point on a 3D object. Pivot points are essential when you need to pose an articulated mechanical object. Pivot points are best adjusted in Modeler before you transport the 3D object into Layout. Do the following to make sure you understand the manipulation of pivot points:

1. Create a default box in Modeler (which will be a cube if you use the Numeric method). See Figure 14.1.
2. Go to Modify>Move>More>Rest on Ground. This brings up the Rest on Ground parameters, with Y selected as a default. Click OK. See Figure 14.2.
3. Go to Detail>Layers>Pivot to show the pivot point of the box. See Figure 14.3.

FIGURE *Create a default box.*
14.1

FIGURE *The box will now rest on the*
14.2 *grid plane.*

FIGURE *Show the pivot point.*
14.3

4. As long as Pivot is highlighted, you can move the pivot point anywhere you like in any view. The pivot point is where the object will rotate and be scaled from. Move it to the top center of the box.

5. Try rotating the box to prove that it uses the pivot point as its center of rotation. When you create a linked chain of objects, which we will do next, having the pivot point in the correct place on all of the elements is essential.

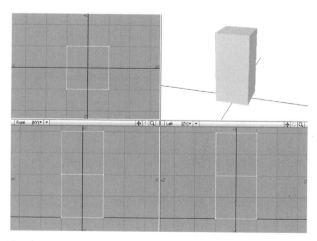

FIGURE *Now you have two boxes in a vertical stack.*
14.4

Let's create a series of similar boxes. Do the following:

1. With the box you created still in Modeler's workspace, go to Edit>Copy.
2. Edit>Paste the box to Layer 2.
3. Move the box on Layer 2 so that it sits exactly on top of the box on Layer 1. See Figure 14.4.
4. Repeat this action twice more to create a stack of four boxes. See Figure 14.5.
5. Logic may tell you that since all four boxes are duplicates of each other, they should each have a pivot point at their top center. Prove it by rotating the box on Layer 4. Yikes! What happened? The box on Layer 4 rotated around the pivot point placed at the top center of the box on Layer 1. You have just learned an important lesson.

There is only one pivot point per model in Modeler, no matter how many layers are involved.

NOTE

6. The duplicating and linking we want to do has to be done in Layout. Delete Layers 2 to 4 so that nothing remains but Layer 1 with the original pivot point placed at the top center of the initial box. Save the box as "MyBox_1." Synchronize with Layout, and port the box to Layout.

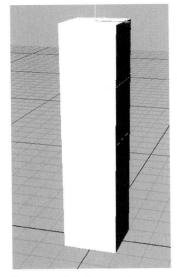

FIGURE *A four-box stack.*
14.5

LINKING AND PARENTING

Now that your box has been ported to Layout, do the following:

1. Load three more boxes into Layout, and stack them on top of the first one. See Figure 14.5.
2. If you look under Objects>Current Item, the list will show that the four boxes are named "MyBox_1 (1),""MyBox_1 (2)," and so forth, so they are all distinguishable and separate objects. Any one can be moved or rotated without affecting the others. Each box's pivot point is centered at the top, as we want it to be. Click on the Scene Editor to open it. See Figure 14.6.
3. As you can see, all of the boxes are aligned by name on the left. This means that they are separate and not connected. Click-drag the name of MyBox_1 (2) over MyBox_1 (1), and you will see that MyBox_1 (2) is now indented under MyBox_1 (1). Repeat this action by click-dragging the name of MyBox_1 (3) over MyBox_1 (2), and MyBox_1 (4) over MyBox_1 (3). Now your named objects should be aligned as shown in Figure 14.7.

FIGURE
14.6 *The Scene Editor opens, displaying the objects in the scene.*

FIGURE
14.7 *You have now linked the boxes in a hierarchical chain.*

FIGURE *Now the order reads correctly.*
14.8

4. This would be the way to go if we wanted the bottom box to be the parent—but we don't. We want the top box, MyBox_1 (4), to be the parent object. Move the names again so that the list reads "4, 3, 2, 1" from the top. You'll first have to move each to a blank area in order to break the chain. See Figure 14.8.

5. Accept the hierarchy. Create a keyframe with all components so the configuration will be saved after any explorations you take. Switch off AutoKey.

6. Select Box 4, which is the parent at the top of the list. Rotate in any direction. Notice that all of the children boxes follow it exactly, based upon its pivot point. See Figure 14.9.

7. Move the Time Slider quickly forward and back again to Frame 0 to reset the keyframe where it was.

8. Select Box 2, the second box from the bottom of the stack, and rotate it. Note that it rotates itself and its child, Box 1. Children obey parents in this virtual world. See Figure 14.10.

You have just begun to master the art of creating hinged joints. Hinged joints are used to link the movable parts of mechanical contrivances—like bulldozers and robots—so they can be posed and, when called for, animated.

FIGURE **14.9** *Parents control children objects in a hierarchy.*

FIGURE **14.10** *The linked objects obey the laws of parentage.*

HINGES

Let's look at two types of joints. One is used for telescoping parts—moving things like a telescope section or a gun barrel forward and backward. The other is a true hinged joint, like an appendage on a mechanical man.

TELESCOPING PARTS

TUTORIAL

This one's pretty much a no-brainer. Do the following:

1. Create a cylinder in Modeler. See Figure 14.11.

FIGURE *Create a cylinder.*
14.11

2. Copy the cylinder and paste to Layer 2.
3. On Layer 2, show Layer 1 as a background layer.
4. Use the Scale tool to reduce the overall size of the Layer 2 cylinder by about 20%. Use the Stretch tool to enlarge its height so that it rises above and below the cylinder on Layer 1. See Figure 14.12.
5. Make Layer 1 the active layer and Layer 2 the background layer.
6. Use Boolean subtraction to subtract the Layer 2 cylinder from the Layer 1 cylinder. This results in a tube. Delete Layer 2. Save the object. See Figure 14.13.

FIGURE *Reshape the Layer 2 cylinder like this.*
14.12

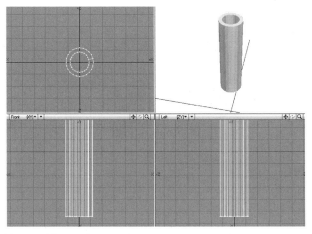

FIGURE *The result is a tube.*
14.13

7. Send the tube to Layout over the Hub. Bring up the Surface Editor and check Smooth and Double-Sided.

8. Load two more tube objects. Scale and place one inside the other to create three sections that diminish in size. See Figure 14.14.

9. Bring up the Scene Editor. Create a hierarchy with Tube 1 at the top, Tube 2 next, and Tube 3 last. See Figure 14.15.

10. Now you can pose the object by moving the smaller sections in and out of the larger section to create either a spyglass or a telescoping gun barrel. See Figure 14.16.

FIGURE **14.14** *Create a three-sectioned tube composite, with one scaled-down version inside another, like this.*

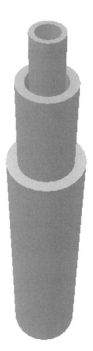

FIGURE **14.16** *The completed object.*

FIGURE **14.15** *Create a linked hierarchy like this.*

HINGED APPENDAGES

TUTORIAL

This tool is important when creating mechanical arms, legs, and other appendage-like elements, like crane arms. Do the following:

1. Create a cylinder and place a sphere at both ends. A spherical element will prevent the appearance of a gap at the joints when appendage elements are rotated. See Figure 14.17.

2. Move the pivot point to the center of the top spherical part. See Figure 14.18.

3. In Layout, create a hierarchical arrangement of three of these lozenges. Center the top spherical part of the lower ones on the bottom spherical part of the next highest. See Figure 14.19.

4. Save as a scene file called "Finger1.lws."

5. We are going to create the fingers for a mechanical hand. Rotate the top element in the chain in the front view as shown in Figure 14.20.

6. Go to File>Load>Load Objects from Scene. Load the finger object from the scene you just saved, which loads it into the previously saved position. Do not load lights. See Figure 14.21.

7. Repeat this process and rotate the third finger so you have a composited arrangement as displayed in Figure 14.22.

8. Open the Scene Editor and take a look at the way the hierarchies are formed. There are three: 1-2-3, 4-5-6, and 7-8-9. See Figure 14.23.

FIGURE *In Modeler, create a basic lozenge form with a*
14.17 *sphere at both ends .*

FIGURE
14.18 *Move the pivot point as shown.*

FIGURE *Create a linked hierarchy of three*
14.19 *elements like this.*

FIGURE *Rotate like this in the front*
14.20 *view.*

FIGURE *Load another finger.*
14.21

FIGURE *Now there are three posable fingers.*
14.22

FIGURE *The hierarchical structure so far.*
14.23

9. Select the top part in each chain, and use the Size control to vary the sizes of the fingers to create a more interesting model. See Figure 14.24.

10. Add one more finger object from the original scene. Size and stretch to create an arm, place in position, and keyframe all. See Figure 14.25.

11. The arm is elements 10, 11, and 12. We want to link the top finger elements in all three finger chains to element 12. Do this in the Scene Editor. See Figure 14.26.

FIGURE *Create a more interesting*
14.24 *hand.*

FIGURE *Create the linked object like this.*
14.26

FIGURE *Create an arm.*
14.25

FIGURE *The finished and linked appendage.*
14.27

12. You will have to position and scale the elements again in the workspace, but now you have your finished appendage. See Figure 14.27.

13. Now it's just a matter of rotating the needed elements in poses and rendering. See Figure 14.28.

Use a similar technique to create, link, and pose mechanical or robotic characters and equipment.

FIGURE *Now you can pose and render.*
14.28

BONES

TUTORIAL The mere mention of Bones causes many artists and animators to shriek in terror and run for the door. Bones, a method of modifying and bending solid forms without first breaking them into parts, is an industry standard tool. Most serious 3D applications have a Bones (or "Boning") facility. LightWave was one of the first 3D applications to offer Boning to artists and animators many years ago. Bones used to be much more complex to work with than they are at present. If history is any indication, they may become even simpler to use over the next few versions of LightWave, although they are currently quite user-friendly.

Bones are deformation tools made visible. They are usually placed inside of an object, just as your bones are located inside your outer layers. Just as the bending of your bones induces the rest of your body to follow along, so Bones as a 3D tool influence the solid 3D objects they are attached to. Bones can be simulated in Modeler by what LightWave calls Skelegons, but Bones have to be controlled and finally manipulated in Layout. Like all deformation operations, Bones are best used on objects that are composed of three-sided polygons. Only three-sided polys can be deformed without warping out of a plane, which can cause your objects to display holes and other anomalies. Bones also work well

on models with higher polygon counts, especially those with higher counts in the areas most affected by the resulting deformations.

Obviously, the direct implication of using Bones is to create smooth animations without any of the artifacting associated with hinged and linked processes. For this reason, Boning is the preferred method when deforming organic or "living" objects. If you've never worked with Bones before, or if you've shied away from their use, it's time that you try them. Do the following Boning exercise:

1. Go to Modeler. Sketch and lathe a form that could be used as an alien tentacle. See Figure 14.29.
2. Go to a front wireframe view so you can see what you're doing, expand the front view, and zoom in. Go to Construct>SubDivide>Triple to transform the polys into the three-sided type. See Figure 14.30.
3. Go to Detail>Layers>Pivot and move the pivot point to the top center of the model.
4. Go to Create>Elements>Skelegons. Click and drag the mouse to create four Skelegons, starting at the pivot point and moving downward. Skelegons, like Bones, resemble inverted cones. You will see them outlined in blue as they are created. Save the model when done.
5. Synchronize with Layout and transport the model to Layout over the Hub.
6. Go to a front bounding box view in Layout.
7. Go to Items>Add>Bones>Convert Skelegons into Bones. Four Bones are created and made visible. See Figure 14.31.
8. Turn off AutoKey and create a keyframe for all items. This assures that you can always return to the default condition of the object.

FIGURE *Lathe an alien tentacle form.*
14.29

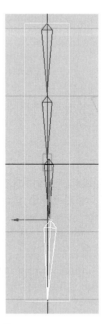

FIGURE **14.30** *The polys have been tripled.*

FIGURE **14.31** *Four Bones are created from the Skelegon "placeholders."*

9. Open the Scene Editor and you will see that none of the four Bones is parented to any other. See Figure 14.32.
10. Create a linked hierarchy for the Bones, with Bone 1 on top and Bone 4 on the bottom. See Figure 14.33.

FIGURE **14.32** *The Scene Editor shows that there is no Bone hierarchy.*

FIGURE **14.33** *Create a linked Bone hierarchy like this.*

11. Once you restructure the hierarchy, you will have to reposition the Bones by both movement and rotation. When you do that, make sure to keyframe all items every few moves so that things remain in place.

12. Highlight the Bones option at the bottom of the interface and click on Item Properties to bring up the Bones Properties parameters. See Figure 14.34.

13. Make sure you have keyframed all items before exploring the controls so that you can retrieve your default positions for the Bones. All Boned models react differently to the controls, so the only way to determine what is best for any single model is to tweak the controls, rotate a bone, and see what happens. Pay special attention to the Min/Max Limited Range, Joint Compression, and Muscle Flexing. Explore the possibilities now, returning to your keyframe at Frame 0 whenever you want to start over. The variations are almost limitless for any one model. See Figure 14.35.

It takes a lot of experimentation to get Bones right. Hollywood animators sometimes use hundreds of Bones on a single model in order to control everything precisely. The area of each Bone must be carefully adjusted so as not to interfere with others. You get to be a Bones master the same way you get to Carnegie Hall: practice, practice, practice.

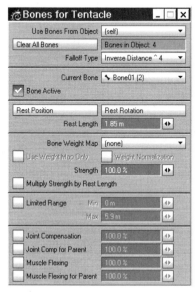

FIGURE **14.34** *Bones controls.*

FIGURE **14.35** *By tweaking the controls and rotating the bones, you can create all sorts of bends and bulges.*

ENDOMORPHS

TUTORIAL

Creating and controlling endomorphs is one of the most fun-filled experiences you can have in LightWave. Do the following:

1. Load the 747.lwo from the Objects>Aviation folder into Modeler. See Figure 14.36.
2. Click on the "M" on the lower right part of the Modeler interface. See Figure 14.37.
3. Next to the "M" is a list that reads "Base." Base is your source object for the morph, the model as it now exists. We want to create a few target objects that we can deform. Select New from the list and the Create Endomorph window pops up. See Figure 14.38.
4. Change the name data to "Plane.Warp1." This will be the name of our first target object. Click OK.
5. Remember, you are now working on a morph target object. Use a deformation tool, like Twist, to warp the object. See Figure 14.39.

FIGURE *Load the 747 model into Modeler.*
14.36

FIGURE *Click on the "M."*
14.37

FIGURE *The Create Endomorph window.*
14.38

FIGURE *Deform the first target object.*
14.39

6. Create another new endomorph, naming it "Plane.Warp2." Use the Magnet tool to deform the model. See Figure 14.40.
7. Repeat this process to create Plane.Warp3, which can be deformed by any method you prefer. See Figure 14.41.
8. Save the model to disk as "Endo1.lwo." Transport it to Layout over the Hub.

FIGURE *Deform the second morph target.*
14.40

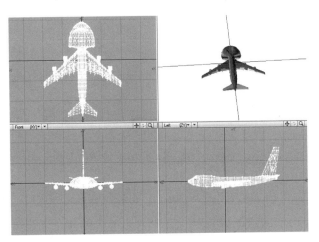

FIGURE *Plane.Warp3 is deformed in a different way.*
14.41

9. When the object appears in Layout, go to its Properties tool under the Deformation tab. Under Add Displacement, select MorphMixer from the list. See Figure 14.42.

10. Double-click on the MorphMixer line and you will see the Endomorph Mixer panel. See Figure 14.43.

. 11. You will see three sliders marked Warp1, Warp2, and Warp3. Each has a range from 0% to 100%. Use the sliders like a mixing board to apply different percentages of each deformation to the plane. Watch the object in the view to see how the mixes affect the model. See Figures 14.44 to 14.46.

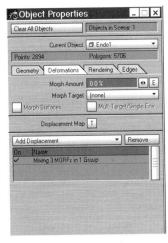

FIGURE *Select the MorphMixer*
14.42 *displacement option.*

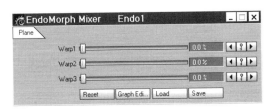

FIGURE *The Endomorph Mixer.*
14.43

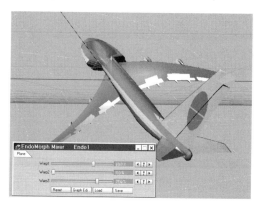

FIGURE **14.44** *Here's one example.*

FIGURE **14.45** *Vary the mix and the effect is quite different.*

FIGURE **14.46** *Keep trying different adjustments until you achieve something that you like.*

This is definitely the way to go when you want to pose all of the features on a face—as opposed to using the more cumbersome Boning method. You'll have more control over the results and a lot more fun!

ONWARD

In this chapter, we investigated a number of ways of creating 3D models that can be articulated. The next chapter begins a part of the book devoted to Light-Wave plugins.

PART III

Plugins

CHAPTER
15
Worley Labs

This part of the book is dedicated to plugins, which extend the reach of a 3D application. The most respected and professional high-end 3D applications are open architectured, meaning that they accept plugins from other developers. There are dozens of commercial LightWave plugins developed by a number of world-class companies that could be included here. Since we can't cover all of them due to the limitations of time and space, we will concentrate on the plugins of two central developers: the Worley Labs collections and E-oN Software's Ozone 3D plugin. Although plugins are developed for both Modeler and Layout, our focus will be mainly on Layout plugins.

In this chapter, we will look at Worley Labs's Sasquatch and Gaffer, as well as selections from their James K. Polk and William Howard Taft collections (*www.worleylabs.com*).

SASQUATCH

TUTORIAL

Sasquatch can add fur, hair, or grass to any object in your scene in Layout. After installing Sasquatch as a Layout plugin, you are ready to create your own abominable objects. Do the following to explore Sasquatch:

LightWave version 7 includes a "lite" version of Sasquatch for your use and exploration. This tutorial, however, references the
NOTE *full version of Sasquatch.*

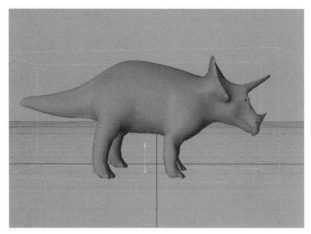

Figure
15.1 *The triceratops is positioned in the Camera view.*

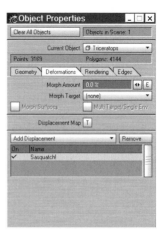

Figure
15.2 *Select Sasquatch from the Add Displacements list.*

FIGURE *The Sasquatch controls.*
15.3

1. Load the triceratops into Layout from the LightWave Objects>Animals folder. Go to a camera view and pose the triceratops so that it can be seen clearly in profile. You may have to adjust your light. See Figure 15.1.
2. Activate Item Properties for the triceratops and go to the Deformations tab. In the Add Displacements list, select Sasquatch. See Figure 15.2.
3. Double-click on Sasquatch to bring up the Sasquatch interface and controls. See Figure 15.3.
4. Sasquatch is the most extensive hair and fur plugin available for a 3D application—just perusing the interface proves the point. Set the Color Image Strength to 50% and set the mapping to Spherical on the Z axis. Click OK and do a test render.
5. No hair appears on the model. What happened? The answer is that you have to configure two separate plugin localities to get hairy results. Go to Scene>Effects>Image Processing. Select Sasquatch from the Add Pixel Filter list. See Figure 15.4.
6. Double-click on the Sasquatch item to bring up the controls. See Figure 15.5.

FIGURE *Select a Sasquatch*
15.4 *Pixel Filter.*

FIGURE *The Sasquatch Pixel Filter controls.*
15.5

7. Leave all of the settings as they are for now, and click OK to apply them. Now do a test render. See Figure 15.6.
8. Return to Object>Properties>Deformations>Sasquatch. Set Length to 125%, which should be around 1.76 meters. Click OK and do another render. See Figure 15.7.

FIGURE *The famous fuzzy triceratops.*
15.6

FIGURE *Hair can overwhelm the underlying object if*
15.7 *you're not careful with the parameter values. This looks more like a Tribble (a hairy little beast from an early* Star Trek *episode) than a triceratops.*

FIGURE *Now the beast is covered in peach fuzz.*
15.8

FIGURE *Now we have a wooly triceratops.*
15.9

9. Reset the length to 35%, and do another test render. See Figure 15.8.
10. Set Density to 80% and Length to 40%. Set Curling to 100% and Curl Variance to 40%. Render. See Figure 15.9.
11. Change the Start Root Color to white and the Tip to black. Do the same for the Pepper Root values. Add a Kink of 50%. Select a Diffuse value of 90%. Click OK and render. See Figure 15.10.
12. Go to the Surface Editor for the triceratops. Look at the Parts list on the left. Notice the spelling of "TriceratopsHorns," capitals included. Close the Surface Editor.
13. Go to Sasquatch in Item Properties again. Click on Apply Fur Only to Named Surface. Enter TriceratopsHorns in the naming field. Set Length to 60%. Click OK and do a render. See Figure 15.11.

FIGURE *Compare this render to Figure 15.8 to appreciate the*
15.10 *differences.*

FIGURE *You can apply Sasquatch to any selected surface that is*
15.11 *named in the Surface Editor.*

14. Set Density to 25% and Length to 75%. Set Surface Comb Strength to 40% and Max Sleekness to 50%. Set Curling to 75%. Render. Set Tip Flop to 35%. See Figure 15.12.

As you might guess, these exercises only hint at the amazing control you can generate over all sorts of hair looks. Try this plugin on terrain objects to make them come alive with grass and clumped shrubs. Make sure to name specific areas when you create your objects in Modeler so that you can apply Sasquatch effects exactly where needed.

FIGURE
15.12 *The hair on the horns has been refined for a more haute couture look.*

TUTORIAL

GAFFER

Gaffer is an advanced shading, lighting, and composting plugin for LightWave. Gaffer allows computer artists to have a great deal of control over the way an object's surface looks. Use the following tutorial to start your voyage of Gaffer discoveries:

1. Load the hammer object from the Objects>Tools folder. Go to the Camera view and rotate the hammer so it appears in profile. See Figure 15.13.
2. Zoom in for a close-up of the hammer head. We are interested in the metallic nature of this part of the object. See Figure 15.14.

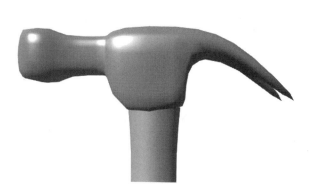

FIGURE *The model of the hammer.*
15.13

FIGURE *Zoom in on the hammer head.*
15.14

FIGURE *Select Gaffer.*
15.15

FIGURE *Use these parameters.*
15.16

3. Bring up Gaffer in the Surface Editor under Shaders>Add Shader>Gaffer. Make sure the head of the hammer is selected. See Figure 15.15.

4. Access the Gaffer controls by double-clicking on the Gaffer item in the list. Input the values displayed in Figure 15.16.

5. Apply the settings and render. Compare the metal to that displayed in Figure 15.14. Notice the subtle differences reflections can make in our perception of what an object is constructed of. See Figure 15.17.

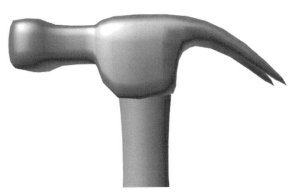

FIGURE *Adjusting the reflective quality and associated settings of an*
15.17 *object element can change our perception of what the object's made of. In this case, the type of metal used in the hammer head looks as if it has been altered.*

This exercise in no way describes the full range of uses and options Gaffer is capable of. Every LightWave user should be required to read the Gaffer documentation, since it is a highly organized and clear presentation of some of the more professional ways of manipulating light in a scene.

THE JAMES K. POLK COLLECTION

Worley Labs's James K. Polk Collection includes several different kinds of Layout plugins. We will cover three here: Acid, VFog, and DropShadow.

TUTORIAL

ACID

Acid is a Shader texture plugin that creates corrosion-like spots that can be mapped to an object's surface. To experiment with Acid, do the following:

1. Create a ball in Modeler. Triple and subdivide it so it is nice and smooth. See Figure 15.18.
2. Transport the ball to Layout and bring up its Properties controls.
3. Under the Rendering tab, set Polygon Size to 0, effectively making the ball disappear when the scene is rendered. You can do a test render to prove this out. See Figure 15.19.

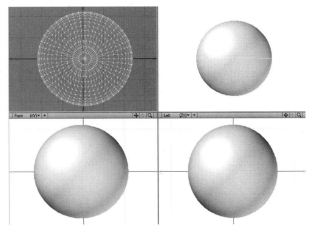

FIGURE *Create a smoothed ball in Modeler.*
15.18

FIGURE *Set the Polygon Size to 0.*
15.19

4. Go to Scene Editor>Visibility>Show Selected Objects As>Wireframe. See Figure 15.20.
5. You have just created an object called an Effector. Effectors can influence other objects in a scene. Create another ball object. Give it a nondefault Surface name. Save and import to Layout. Place inside the Ball 1 wireframe. See Figure 15.21.
6. Make Ball 2 the parent of the wireframe ball so that wherever you move Ball 2, the wireframe ball will tag along. The wireframe ball (the Effector) can move freely, however. See Figure 15.22.
7. Select the Surface Editor for Ball 2, and select Acid in the Shader tab's Add Shader. See Figure 15.23.

FIGURE *Change the ball's visibility in the Scene*
15.20 *Editor to a wireframe object.*

FIGURE *Ball 2 is now inside the wireframe*
15.21 *ball.*

FIGURE *Create this*
15.22 *hierarchy.*

FIGURE *Select the Acid Shader plugin.*
15.23

FIGURE *Select Ball1.lwo as the Effector, set the values you want (watching the*
15.24 *preview), and click on OK.*

FIGURE *Move, rotate, or scale the Effector so that the Acid texture maps differently*
15.25 *across the surface of Ball 2.*

8. Double-click on the Acid item to bring up its controls. You can set the values indicated in Figure 15.24 or explore other values on your own. The important thing is to select Ball1.lwo as the Effector.
9. The surface attributes for Ball 2 can be anything you like. The Acid Shader will create its effects on top of the other surface attributes. Moving Ball 1 will slide the Acid Shader texture (in this case, a corrosion bump map look) over the surface of Ball 2. See Figure 15.25.

You can study the Acid documentation to see what each control parameter does, and/or you can just explore different values on your own. You can also create multiple Effectors so that their combined parameters affect the surface of your targeted object in a variety of ways.

Color Plate 1 Strange cattle graze in the field, under trees created in Onyx's Tree Professional and exported to LightWave. The backdrop consists of a SkyTracer atmosphere punctuated by a LightWave Lens Flare.

Color Plate 2 This selection of frames from a LightWave animation displays pyrotechnic effects created in post-production with Impulse's Illusion.

Color Plate 3 A series of views of the head of TekMan, from Chapter 28 in the book.

Color Plate 4 TekMan's entire figure is displayed in a variety of poses here.

Color Plate 5 Volcano fire created by LightWave particle effects, from Chapter 29 in the book.

Color Plate 6 Volcano fire created in post-production with Impulse's Illusion, from Chapter 29 in the book.

Color Plate 7 The WaveRider craft, displayed against a Lens Flare background. The WaveRider tutorial is included in Chapter 30 of the book.

Color Plate 8 A selection of flora created in Greenworks's Xfrog that can be imported into LightWave scenes.

VFog

TUTORIAL

VFog is a quick fog generator. Do the following:

1. Place the canyon object from the Objects>Landscapes folder in a scene. Map it with the Bumpy_Mud shader in the Nature Shader library. Configure for a nice Camera view, and place a light blue backdrop behind it. See Figure 15.26.
2. Go to Scene>Effects>Image Processing and select VFog from the Add Pixel Filter list. See Figure 15.27.
3. Double-click on the filter name to bring up the controls. Tweak the controls while watching the preview on the right. See Figure 15.28.
2. Click OK and render to appreciate the effect. See Figure 15.29.

FIGURE **15.26** *Create a scene like this.*

FIGURE **15.27** *VFog is a Pixel Image Processing filter.*

FIGURE **15.28** *Tweak the settings while keeping an eye on the preview.*

FIGURE *The rendered VFog effect.*
15.29

TUTORIAL

DROPSHADOW

This plugin uses an Alpha channel to create a basic drop shadow on a background. Do the following:

1. Create a text line in Modeler and extrude for depth. Give it a metallic surface and use Smoothing and Double-Sided. See Figure 15.30.
2. Transport to Layout after saving it. Create an interesting position for the text in Camera view. See Figure 15.31.

FIGURE *Create an extruded line of text in Modeler.*
15.30

3. Go to Scene>Effects>Image Processing and select DropShadow from the Add Image Filter list. See Figure 15.32.
4. Double-click on the plugin name, which brings up the controls. Render once at the default settings in order to get a preview image. From then on, tweaking the controls will give you a real-time preview. Select OK when satisfied. See Figures 15.33 and 15.34.

FIGURE
15.31 *The text as it appears in Layout on a light background color.*

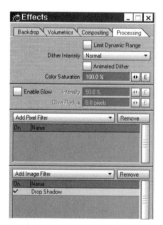

FIGURE *Select DropShadow from the Add*
15.32 *Image Filter list.*

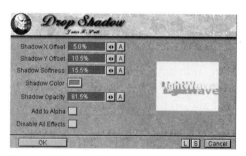

FIGURE *The DropShadow controls are pretty*
15.33 *easy to understand.*

FIGURE *The rendered result.*
15.34

THE WILLIAM HOWARD TAFT COLLECTION

This collection of valuable LightWave plugins contains more Layout filters of various types. We'll investigate three: Hoser, HeatWave, and Mosaic.

HOSER

Hoser is one of the most valuable modeling alternatives you will ever come across. Hoser allows you to smoothly bend hose-like objects—or any object that follows a few simple modeling rules—without needing to use Bones. Do the following:

1. Create a lathed form on the X axis in Modeler. Make it rather long and cylindrical. Make sure it ranges from the 0 origin to a positive X direction. See Figure 15.35.
2. Go to Surface and Triple. Save and port to Layout.
3. Go to Objects>Item Properties>Deformation. Select Hoser from the Deformations tab. See Figure 15.36.
4. Create a null object (or import one from the Objects>Miscellaneous folder) and place it at the end of the lathed form, opposite the base.
5. Open the lathed form's Properties and double-click on Hoser under Deformations>Add Deformations. This brings up the controls. See Figure 15.37.

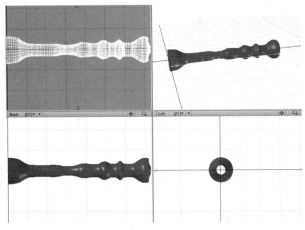

FIGURE *Create a lathed form on the X axis.*
15.35

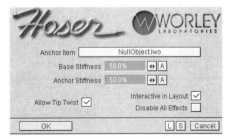

FIGURE *Select the Hoser filter.*
15.36

FIGURE *The Hoser controls.*
15.37

6. Set the null object as the Anchor Item, and set the other parameters as shown in Figure 15.37. You can explore other settings on your own.

7. Back in Layout, select the null object. Rotate it and move it so as to warp the lathed object. You can also operate on the lathed object in the same manner. Scaling also has an effect. This type of operation would be impossible to replicate with Bones without a horrendous amount of preparation. See Figure 15.38.

Use Hoser for reptilian necks, worms, and other organic body parts.

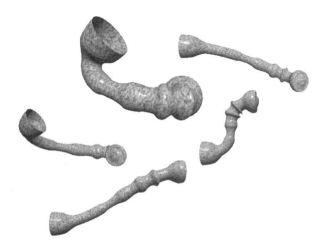

FIGURE *You can bend the lathed object in any number of ways*
15.38 *using the Hoser filter.*

HEATWAVE

This is a neat filter dedicated to one purpose: the creation of the distortions caused by heat waves rising from the ground. Do the following:

1. Create a scene with the volcano object from Objects>Landscape, using a SkyTracer sky for a backdrop. See Figure 15.39.

FIGURE **15.39** *Create a scene something like this, as seen from the Camera view.*

FIGURE **15.40** *Select HeatWave.*

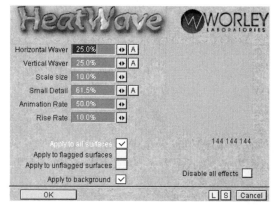

FIGURE **15.41** *Bring up the HeatWave controls.*

2. Go to Scene>Effects>Image Processing and select the HeatWave item from the Add Image Filter list. See Figure 15.40.
3. Double-click on HeatWave to bring up the controls.
4. Use the values displayed in Figure 15.41 or explore your own settings. The result is displayed in Figure 15.42.

FIGURE *HeatWave can cause fairly global distortions.*
15.42

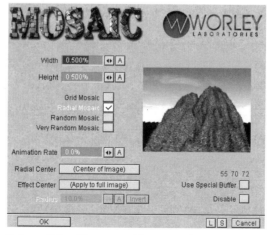

FIGURE *Select Mosaic and bring up the controls.*
15.43

MOSAIC

TUTORIAL

Mosaic gives your images a tiled look. Do the following to explore its use:

1. Use the same scene you created for the last exercise. Go to Scene> Effects>Image Processing and delete HeatWave from the Add Image Filter list. Select Mosaic from the same list. Double-click on it to bring up the controls.
2. Use the settings displayed in Figure 15.43 or use your own settings. Click OK and render. See Figure 15.44.

FIGURE *This rendered mosaic uses a Radial option.*
15.44

ONWARD

In this chapter, we introduced you to the volumes of commercial plugins developed by Worley Labs. In the next chapter, we'll explore the world of the Ozone 3D plugin from E-on Software.

CHAPTER
16 Ozone 3D

E-on Software (*www.e-onsoftware.com*) is best known for its exemplary environment generation application Vue d'Esprit, now in version 3. Vue allows you to create skies and other atmospherics and terrain effects. If you have Vue, you can create environmental images that can be used in LightWave for backgrounds. See Figure 16.1.

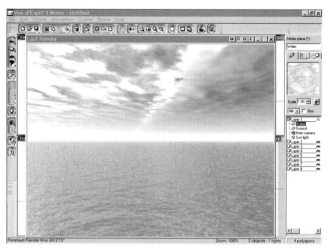

FIGURE *Vue d'Esprit can create startling environmental*
16.1 *imagery.*

After saving the image from Vue, go to Scene>Effects>Compositing in Layout. Load the image as a background image. See Figure 16.2.

Use the Vue background with any foreground object content you like. See Figure 16.3.

Vue can be a very effective way to create backgrounds in LightWave; however, it does not allow for the displaying of different views of a background image. No matter how you rotate the camera, the same exact background image will appear. That's the drawback of using images for backgrounds. As a response to this problem, E-on developed Ozone 3D, which includes the sky generator aspects of Vue, as a LightWave plugin. If you rotate the camera when using Ozone 3D, each angle will present a different sky view. You may wonder why you would want to use this plugin, when LightWave's SkyTracer 2 utility creates skies. In many ways, Ozone 3D does resemble SkyTracer, but it also offers additional options important for professional use. If you have Ozone 3D, do the following tutorials.

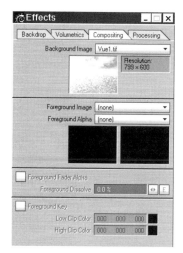

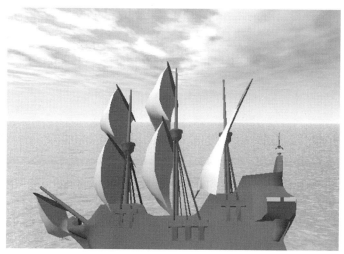

FIGURE **16.2** *Images rendered from Vue d'Esprit can be imported to LightWave and used as backgrounds.*

FIGURE **16.3** *Use the Vue background image with your choice of foreground content.*

TUTORIAL

A BASIC OZONE SKY

Here's how to use Ozone 3D in LightWave to create a sky background. Do the following:

FIGURE **16.4** *Rotate the camera upward.*

FIGURE **16.5** *Add the Ozone 3D plugin.*

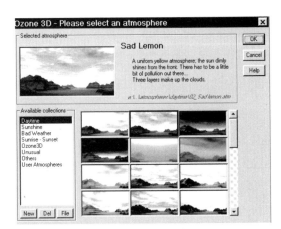

FIGURE **16.6** *The Ozone 3D preset skies.*

1. Open Layout. Go to a right view and select the Camera. Rotate as shown in Figure 16.4. We want to create renders with a maximum view of the sky.
2. Go to Scene>Effects>Image Processing. Add the Ozone 3D plugin in both the Pixel Filter and the Image Processing Filter areas. See Figure 16.5.
3. Double-click on the Ozone 3D Image Filter to bring up the parameters. The first thing that appears are the preset libraries. See Figure 16.6.
4. After you select a preset to work on, the next control window appears. The first tab in that window, named "LW Layout," it just lists data. See Figure 16.7.
5. Sun and Light is the second tabbed area. See Figure 16.8.
6. Double-click on the Sun Color swatch to bring up the Sun Color presets. See Figure 16.9.

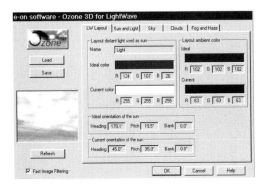

FIGURE **16.7** *LW Layout is the first tabbed area that appears.*

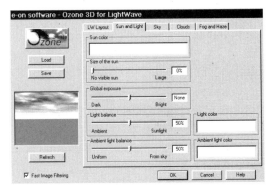

FIGURE **16.8** *The Sun and Light controls.*

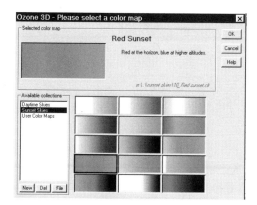

FIGURE 16.9 *The Sun Color presets.*

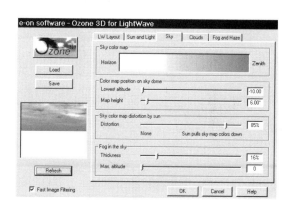

FIGURE 16.10 *The Sky controls are adjusted next.*

7. Select a preset Sun Color swatch. Tweak the other controls as you watch the preview (select Refresh), and stop when you have created something you like.

8. Next are the Sky controls. Adjust them and do Refresh previews until you are satisfied. See Figure 16.10.

9. Next are the Cloud controls. You can add as many cloud layers as you like. Each cloud layer can have its own cloud content. To select the Cloud preset type, double-click in the Cloud preview map area. See Figures 16.11 and 16.12.

10. Select a preset, making sure you set the rest of the controls, and do a preview render. Continue on to the Fog and Haze tabbed area. See Figure 16.13.

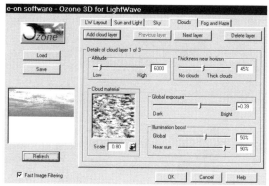

FIGURE 16.11 *The Cloud controls.*

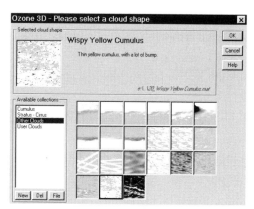

FIGURE 16.12 *Cloud map presets.*

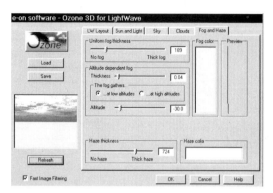

FIGURE *The Fog and Haze controls.*
16.13

11. Set the Fog and Haze colors and adjust the other controls. Do a series of previews to get an idea of how the background will look.
12. When you are finished, render the background. See Figure 16.14.

The most interesting Ozone 3D skies are created by using multiple cloud layers.

FIGURE *The same Ozone 3D sky background from different camera*
16.14 *angles.*

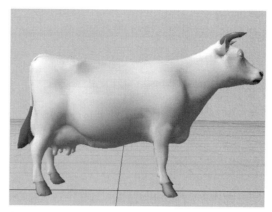

FIGURE **16.15** *Load the LightWave cow from the Objects>Animals folder.*

TUTORIAL

OZONE 3D IMAGE MAPS

You can also use Ozone 3D to create Shader maps for a selected object. Do the following:

1. Load the cow object into a scene. See Figure 16.15.
2. Go to the Surface Editor and select Ozone 3D from Shader>Add Shader. Use spherical mapping for the Cow Hide element. See Figure 16.16.

FIGURE **16.16** *Select the Ozone 3D Shader for the Cow Hide element.*

FIGURE *Set all of the parameters as before.*
16.17

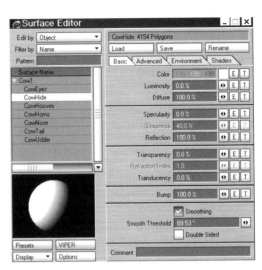

FIGURE *Set the Cow Hide Reflection to 100%.*
16.18

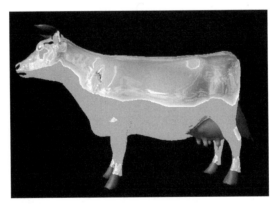

FIGURE *Congratulations on the creation of a*
16.19 *chromed cow!*

3. Double-clicking brings up the Ozone 3D controls as before. Set the Sky parameters. See Figure 16.17.

4. Set Reflection to 100% in the Surface Editor for the Cow Hide element. See Figure 16.18.

5. Render. See Figure 16.19.

ONWARD

In this chapter, we took a look at E-on Software's Ozone 3D LightWave plugin. We move on to cover noncommercial plugins in the next chapter.

17

Noncommercial Plugins

There are four types of noncommercial software:

1. **Freeware.** This refers to plugins that are free for the taking—or rather, the downloading. There are no costs or other stipulations involved.
2. **Shareware.** The developers of shareware ask that you contribute something for their efforts and trust that you will do so. Sometimes, the developer will accept items other than cash, such as books, videos, or other materials.
3. **Charityware.** Developers of this category of noncommercial software ask that you donate a sum of your own choosing to your favorite charity in return for the software.
4. **Rewardware.** This is my own term. Rewardware is software offered to you as a reward for the purchase of other software from the same developer.

LightWave plugins falling under these categories can be found on the Web by going to a LightWave site you are familiar with or by typing "LightWave Plugins" into a Web search engine. There are literally hundreds of LightWave-associated sites, and many of them offer links to noncommercial plugin sites.

Be aware that LightWave plugins are usually version sensitive, meaning that they were written for specific versions of LightWave. Because LightWave has gone through deep rewrites over the years, the plugin you download may not function with the version of LightWave you are using.

SELECTING SHAREWARE/FREEWARE PLUGINS

As you search the Web for downloadable LightWave plugins, keep in mind that many of them were created for earlier versions of LightWave. This means that, in most cases, they will not work with version 7 or above. You can, of course, contact the developer and inquire when or if the plugin will be upgraded to work with your version of LightWave.

This chapter will focus on a trusted developer of plugins for LightWave 7 and above: Worley Labs. Since many of Worley Labs' commercial plugins were covered earlier in the book, this choice also makes sense in terms of continuity. The plugin we will dwell upon here, Disgusting, is rewardware. You can download it and use it free of charge as long as you have proof that you have previously purchased another Worley Labs plugin.

DISGUSTING

The things that turn off the lay person are likely to intrigue the computer graphics artist and the animator. Rust, mold, dirt, fungus, excrement, and blood and guts, for example, are all regarded by the computer graphics artist as valuable resource imagery for developing innovative and interesting textures to map objects with.

Although a strongly recommend practice for computer graphics artists is to take a digital still camera out into the world to search for textural imagery, the Disgusting plugin provides a level of detail unattainable with a digital camera. The difference between digital camera imagery and Disgusting imagery is based upon the difference between pixelated texture maps and procedural texture maps. With camera imagery, any close-up inspection will reveal the picture elements (pixels) that make up the images. Zoom close enough and the interesting detail will be lost in squarish blocks of pixels. Disgusting is a procedural-based plugin; the textures it creates are based upon mathematical interactions. No matter how close you zoom in on such a procedural texture, you will still get realistic detail. A rusty look developed with an application like Disgusting, therefore, would be far superior to one produced by mapping an object with a

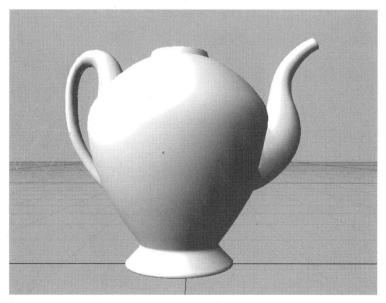

FIGURE *The stretched teapot as it appears in the Layout Camera view.*
17.1

picture of a rusty plate (although sometimes, mixing both procedural and image-based textures can create some startling results). Explore Disgusting's use by doing the following exercises:

1. Go to Modeler and load the teapot object from the Objects>Misc folder
2. Stretch the object as you like to create a taller version of it. Save it as "MyTeapot1.lwo" or as a name of your own choosing. Do not port the object to Layout, but instead, load the saved object into Layout. See Figure 17.1.

Although the Disgusting shader will appear in the Surface Editor list in Modeler, it has to be activated from Layout. Trying to use it in Modeler will not work.

3. Open the Surface Editor. Use a Silver_Raytrace material on all of the teapot's parts. Raise the Diffuse level for all elements to 50%. See Figure 17.2.
4. Go to the Shader tab in the Surface Editor and add Shader>Disgusting. See Figure 17.3.
5. Double-click on the shader name to open the controls. You are presented with the parameter control interface, which looks like Figure 17.4.

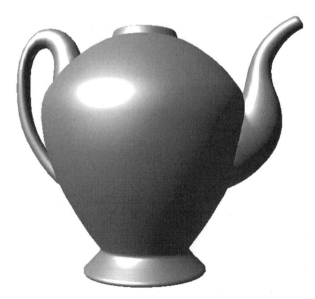

FIGURE *The teapot is now silver.*
17.2

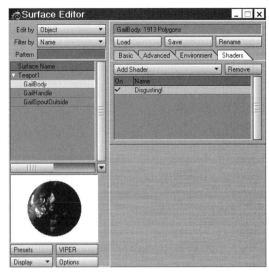

FIGURE *Add the Disgusting shader.*
17.3

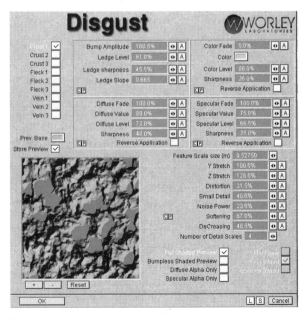

FIGURE *The Disgusting shader's controls.*
17.4

Disgust **WORLEY**
 LABORATORIES

Bump Amplitude	217.5%	◆	A	Color Fade	0.0%	◆	A
Ledge Level	96.5%	◆	A	Color			
Ledge sharpness	45.5%	◆	A	Color Level	80.0%	◆	A
Ledge Slope	0.665	◆	A	Sharpness	35.0%	◆	A

C P C P Reverse Application

Diffuse Fade	45.0%	◆	A	Specular Fade	82.5%	◆	A
Diffuse Value	100.0%	◆	A	Specular Value	75.0%	◆	A
Diffuse Level	100.0%	◆	A	Specular Level	66.5%	◆	A
Sharpness	58.0%	◆	A	Sharpness	35.0%	◆	A

C P Reverse Application C P Reverse Application

Crust 2
Crust 3
Fleck 1
Fleck 2
Fleck 3
Vein 1
Vein 2
Vein 3

Prev. Base
Store Preview ✓

Feature Scale size (m)	0.52750	◆	
Y Stretch	104.0%	◆	A
Z Stretch	128.0%	◆	A
Distortion	31.5%	◆	A
Small Detail	42.5%	◆	A
Noise Power	23.0%	◆	A
Softening	67.0%	◆	A
DeCreasing	21.5%	◆	A
Number of Detail Scales	4	◆	

C P

Bumpless Shaded Preview
Diffuse Alpha Only
Specular Alpha Only

+ − Reset

OK L S Cancel

FIGURE *Use these values.*
17.5

FIGURE *One result of applying the Disgusting shader to the stretched*
17.6 *teapot.*

6. Click through the nine types on the upper left and watch the preview window. There are three types of Crust, Fleck, and Vein shaders. The preview is very fast and shows you what the shader will look like. You can zoom in or out of the preview by clicking on the plus and minus boxes underneath it.

7. Select the Crust 1 shader type. You can always adjust the parameter values on your own to explore a myriad of possibilities. For right now, use the values indicated in Figure 17.5.

FIGURE **17.7** *The differences are sometimes subtle when applying different Disgusting shader types with the same parameters. Top row: Crust 1, 2, and 3. Middle row: Fleck 1, 2, and 3. Bottom row: Vein 1, 2, and 3.*

8. Click on the small "s" at the bottom right of the interface and save your settings. Click OK to accept your settings. Use the Disgusting shader on the other parts of the teapot, loading in your saved settings.

9. Do a test render to appreciate the power of this shader. See Figure 17.6.

10. Leaving all of the values as they are, alter only the type. Save and apply to each teapot part. Render each to appreciate the differences in the Disgusting shader types. See Figure 17.7.

One obvious use for this shader would be to create more natural foreground weathered rocks in a scene. It could also be used to give a home that chaotic, lived-in look or to create disgusting ridges and bumps on a face. No matter what you use it for, it's guaranteed to make the viewer look twice at the object.

Remember to browse your favorite LightWave sites on the Web every week or so to keep aware of other noncommercial LightWave plugins that will work with the version you're using.

ONWARD

In this chapter, we focused our attention on the LightWave rewardware plugin Disgusting. Starting with the next chapter, we'll explore the use of some interesting handshaking applications, software that can be used to create or modify LightWave content.

PART IV

Handshaking

18

Eovia's Amapi

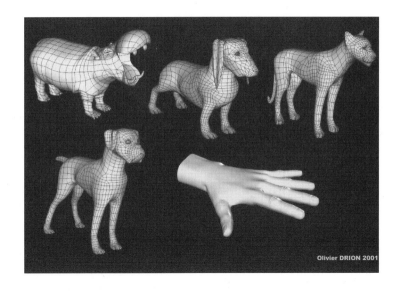

Olivier DRION 2001

In this part of the book, we will look at a selection of handshaking applications. A handshaking application is a software package that creates content that LightWave can import. There are two general types of handshaking applications important to LightWave users. First, there are image applications that create 2D image formats that LightWave can use as backgrounds and/or texturing content. Since LightWave can read just about every 2D image format—at least all of the ones used most frequently by professional users—you could safely say that every 2D image application can handshake with LightWave. Some of the most popular of these are Photoshop, Painter, PhotoPaint, and PaintShop. Since LightWave's ability to handshake with these 2D applications is so extensive, and since you are already aware of the ways in which images can be used as backgrounds and for texturing components, there really is no need to spend much more time on this type of handshaking application.

The second type of handshaking application of interest to LightWave users are those that can connect with the input and/or output of other 3D applications and transfer 3D object files back and forth. These will be the main focus of this section. The most obvious files to be used in this respect are LightWave Object files (.lwo) and LightWave Scene files (.lws). Any 3D application that can be used to generate either of these 3D file types can handshake with LightWave. But there's more: LightWave can also import 3D data in the DXF, WAV, and 3DS formats, among others. Since all professional applications read and write at least one of these 3D formats, a wide array of potential handshaking applications could be covered here. Due to constraints of space and time, however, this part of the book will devote itself to a narrow but important group of handshaking applications that are sure to benefit LightWave users.

The following text and images were supplied by Oliver Drion (*http://perso.club-internet.fr/odrion; odrion@club-internet.fr*). Contributions were also made by Philip Staiger, Eovia Amapi evangelist.

AMAPI: THE IDEAL COMPANION TO LIGHTWAVE

LightWave is presently marketed as a complete solution and, indeed, it truly is. The speed and quality of its rendering are well known. Its Modeler is powerful and offers original design tools. See Figure 18.1.

Nevertheless, for most projects I am involved with—and particularly when modeling characters and animals or other organic creatures—I still prefer to create the original model in Eovia's Amapi 3D (*www.eovia.com*). Very often I create my subjects in Amapi, touch them up in LightWave, and, if necessary,

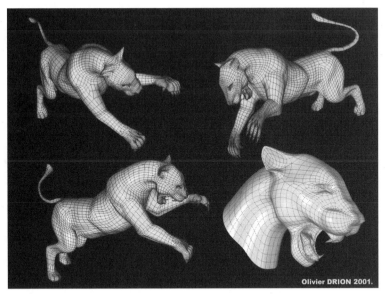

Olivier DRION 2001.

FIGURE *An example of LightWave's potential for modeling.*
18.1

reimport them into Amapi for further modifications. In the end, everything goes to Layout in LightWave for texturing, lighting, animation, and rendering.

Amapi is flexible, offers many smoothing methods, and offers the extra benefit of being able to control the tension when needed. Handling sophisticated models in Amapi is efficient, thanks to its optional per-object simplification, which includes decimation, a scene manager for layering and grouping control, and the ability to hide even a subset of the current element in order to concentrate on specific details without loss of performance. Amapi is designed to be a perfect companion to LightWave's Modeler, and thus offers a great number of 3D and 2D export formats—including, of course, the LightWave object format (and a few oriented towards Web publishing or CAD, such as STL and IGES).

One of the strongest reasons to combine Amapi with LightWave is the resulting ability to share quadrilateral polygon sets. The SubPatches of Light-Wave provide pretty much the same internal smoothing results as Amapi's Catmull-Clark smoothing method (one of the five methods offered). It is a fairly simple procedure to pass data from Amapi to LightWave (with Amapi's native LightWave export) and back to Amapi (with the VRML 1.0 export from LightWave, for instance, and the VRML 1.0 import into Amapi)—without losing quadrilateral polygons to triangulation or other topology in the process.

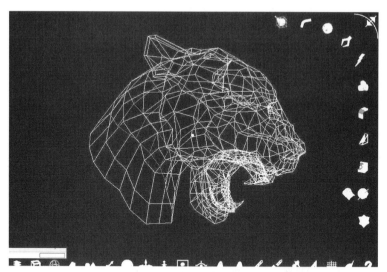

FIGURE *The Amapi interface.*
18.2

These alterations are sometimes encountered in other modelers. See Figure 18.2.

The concept behind Amapi's user interface is that of a sculptor's studio. The initial view is presented as a perspective, but, like in LightWave, it can easily be seen from various angles: top, front, and sides. The modeling tools appear as icons hanging along the right-hand side of the screen. You grab a tool, use it to operate on the model, then throw the tool back by moving the cursor to the right edge of the screen. It's like grabbing a chisel, chiseling away at a sculpture, then putting the chisel back into the toolkit.

The initial toolkit exposes the essential construction tools. By moving the cursor to the right edge as if tipping the turntable, the initial toolkit will switch to reveal another one, known as the Modeling toolkit. Repeat this flick-of-the-wrist motion to the right edge once more and a third toolkit appears, the Assembly toolkit.

Almost everything in Amapi is accessible through these three toolkits, and it is rarely necessary to spend any time in the pull-down menus, submenus, or other interface areas. Other tools can be immediately be accessed through the customizable Shortcuts Editor, which allows you to assign single or combination keys from the keyboard to your preferred, most often used tools. Although some of Amapi's tools resemble those found in LightWave, its general design philosophy distinguishes it from LightWave and offers a unique way to create a model.

From Amapi to LightWave

Amapi exports directly to LightWave's 3D file formats, both .lwo and .lws. In general, once you've finished creating and modeling your objects in Amapi, all you need to do is import the models into LightWave Modeler or Layout. Occasionally, you may have to verify the orientation of facet normals and make them consistent using the Flip command. Note that Amapi also offers a tool—Orient Normals—for this same task.

Naturally, as is often the case when importing geometry from other sources, you'll want to check and verify the size and dimensions with which LightWave has retrieved the model created by Amapi. There are options in Amapi to apply a scale factor upon import/export and to work in relative or absolute coordinates, among other options. If necessary, just rescale the model once it's in LightWave to give it the proper size. You can then concentrate on doing the usual things in LightWave, like naming and designating your surfaces, applying textures, and selecting rendering options.

Smoothing

Most 3D modeling applications let you create low-polygon models first, then offer various tools for surface subdivision and smoothing. In LightWave, you have three ways of subdividing the surfaces: by using Faceted, Smooth, or Metaform. You can also use SubPatches, which provide a result more or less like the Metaform subdivision.

In Amapi, you have a choice of five subdivision methods, or algorithms (see Figure 18.3). The first uses a Bezier smoothing algorithm in the form of an external smoothing hull that goes through the vertices of the coarse mesh and sometimes "overshoots" it. This is very similar to what you get with LightWave's Smooth subdivision method.

Another method, known as Catmull-Clark, passes through the center of each facet in the coarse mesh. Catmull-Clark is the equivalent of the Metaform or

FIGURE *The smoothing tools in Amapi.*
18.3

SubPatches method in LightWave, but is slightly softer. Using Catmull-Clark on a coarse polygon cage or mesh of a human face will give you results that appear a little less harsh or bony than you would get with Metaform or Sub-Patches. Another smoothing method, called Doo-Sabin, is sort of a compromise between Amapi's first and third methods: it is more affected by both the vertices and by the centers of facets. Amapi's last two smoothing methods are targeted for use in 3D formats containing triangles and can be very useful when you want to smooth a model that was imported from a DXF file. One of the main advantages of doing your modeling in Amapi is that you can chose a smoothing method, then return to the original coarse mesh (or control cage) for editing and choose a different smoothing method later. In Amapi, smoothing is part of what makes up the "dynamic geometry" capabilities, which allow a history of modeling steps to be retained. Certain parameters of the original geometry (e.g., before smoothing) can still be edited and carried forward through successive levels of construction and modeling. To provide a more complex example, it would be possible to edit and move a single vertex or even the control point of an interpolated curve used to sweep another section (curve), which may result in a new coarse mesh (swept surface), which gets dynamically re-smoothed (with the current smoothing method applied to the coarse mesh). This capability can significantly speed up the modeling process, as it may remove the need to individually edit each vertex of the smooth mesh.

One great feature in Amapi that goes beyond LightWave's capabilities of subdivision is the ability for tension control on the smoothing. In the example dis-

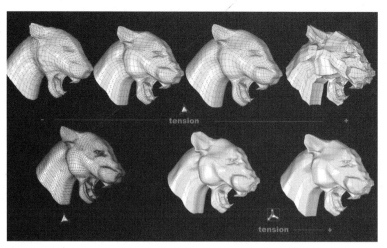

FIGURE *The first three smoothing types were used on this model.*
18.4

played in Figure 18.4, the first three smoothing methods were used on the lion's head.

In Figure 18.4, the tension was exaggerated in order to enable you to more clearly see its effects on these respective smoothing methods. The tension control operation proceeds in a very intuitive fashion—simply by selecting a Tension Control icon and then using the +/- keys to adjust the amount. Starting from the same coarse model (which in LightWave terminology would be called a MetaNurbs control cage), many drastically different results can be easily obtained simply by changing the tension of the particular smoothing method. It is also possible to apply various tensions to different parts of the object, an option that offers further detail control and modeling options.

If these smoothing methods and their options still don't make your model convincing enough, you can further excite or calm (bump or unbump) your model's geometry. The Bump/Unbump tools add or remove noise to the geometry without increasing the polygon count or changing the topology. After selecting the desired tool, it's as simple as using the +/- keys to adjust the operation and bring the model to perfection. See Figure 18.5.

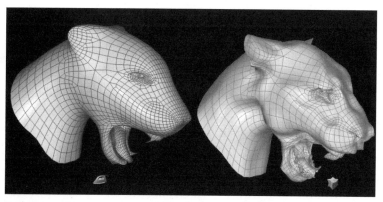

FIGURE *A calming operation and its results.*
18.5

FROM LIGHTWAVE TO AMAPI

Let's say you've brought a model from Amapi into LightWave and have altered it in Modeler. If you then decide to bring the model back into Amapi for further editing, all you need to do is export the model from LightWave in the

WaveFront object file format. Amapi will then be able to easily retrieve the quads from the object file without triangulation.

Here again you may need to check and adjust the scale of the reimported model or to set the appropriate scale factor in the Import/Export Preferences dialog. But the key thing is that the integrity of your model's topology will have been maintained. You can thus port your models back and forth between the two applications, using each for whatever they do best or whenever you feel most comfortable with a specific tool.

For those of you who own an earlier version of LightWave, the same technique can be used with the VRML 1.0 export from Light-Wave and VRML 1.0 import to Amapi.

A FEW EXAMPLES

Amapi has a wide selection of modeling tools that offer ease of use, a short learning curve, and speedy execution. The animals and hand shown in Figure 18.6 that were modeled in Amapi each took about six to eight hours to create.

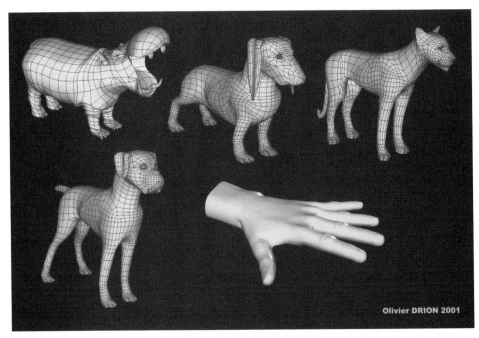

Olivier DRION 2001

FIGURE *A selection of models created in Amapi.*
18.6

Most of these models are made of barely 1000 polygons (some even less than 800) and were smoothed with Amapi's Catmull-Clark method, which corresponds to LightWave's SubPatches. The hand, which is more detailed than most of the other models, amounts to about 2000 polygons, but the lion, with about 3600 polygons, took the longest to model, as it has the most detail (teeth, claws, etc.). It typically takes two to three days to create a model as complicated as the lion. Some of these models are included in Amapi 3D v6's large model and material collection on the product CD.

As can be seen in the image of the dog, it is easy to model with Amapi with SubPatches in mind. See Figure 18.7.

Figure 18.8 shows the earlier greyhound dog transformed into a longhair cousin, who perhaps lived in the 1960s. This look was achieved with a famous LightWave plugin for hair and fur from Worley Labs: Sasquatch.

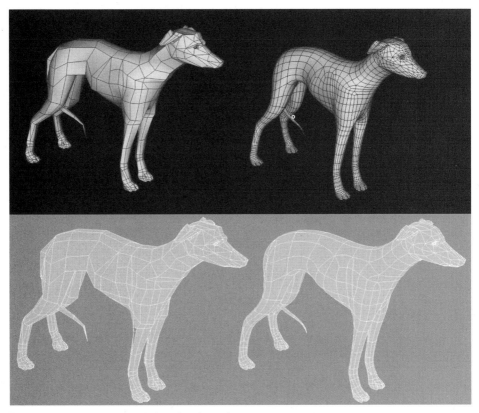

FIGURE *This dog was modeled with SubPatches.*
18.7

FIGURE *Sasquatch was used to add fur to the dog shown here.*
18.8

ONWARD

In this chapter, we learned from a master modeler how Eovia Software's Amapi handshakes so effectively with LightWave. Next, we'll take a look at dvGarage's grime mapping images.

This book's CD contains both demo and full working versions of Amapi. Be sure to check it out.

ON THE CD

19 DvGarage's Surface Toolkit

lthough it was stated at the start of this part of the book that our attention would be focused upon 3D applications and formats and not 2D texture handshaking, that rule will be bent just a bit in this chapter. Dv-Garage (*www.dvgarage.com*) markets a CD collection of what they call "grime maps" as part of their expanding Surface Toolkit product that are absolutely perfect (if not, indeed, essential) for LightWave use. You can register on their Web site to receive a free tutorial every week (in downloadable QuickTime format) that teaches you how to use grime mapping as well as a lot of other stuff about 3D modeling and more. These tutorials are also present on the CDs dvGarage markets. There are over 150 separate grime maps on the Surface Toolkit CD that can be previewed right off the CD, as well as a version of Extensis Portfolio. If you plan to use these maps a lot, you might want to print out the Portfolio thumbnails. Printing them in landscape mode will take seven pages, which will give you a quick visual reference for using the maps. See Figure 19.1.

The included grime maps give you images resembling dirt, mud, and rust and can even be used to create some pretty horrid flaking skin. Grime mapping could definitely be considered a companion to the Worley Labs Disgusting plugin we detailed previously. Unlike Disgusting, however, grime maps are not ap-

FIGURE *The individual grime maps can be previewed using the included*
19.1 *copy of Extensis Portfolio, as shown here.*

plied as shaders. Instead, like any pixelated texture, they are applied to selected channel textures. Most of the time, you will want to use grime mapping in the Specular and Bump channels. If your model has enough polygons, you can also try using grime maps as deformation alternatives.

TUTORIAL

AN EXERCISE IN GRIME MAPPING

Do the following exercises to experiment with grime mapping:

1. Lathe a form you would like to work with in Modeler. Smooth in the Surface Editor and triple the polys. Save it. See Figure 19.2.

FIGURE *Lathe a form to work with.*
19.2

2. Port the object to Layout.
3. Open the Surface Editor and apply a silver texture from the Metals drawer to the object. Make sure to apply the SilverReflection.tga map as well. Raise the Diffuse level from its default of 20% to 40% to brighten the object. See Figure 19.3.
4. Do a test render of the object. See Figure 19.4.

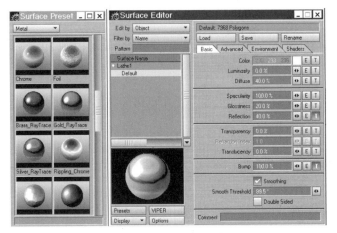

FIGURE *The Surface Editor settings.*
19.3

FIGURE *Our object at the start.*
19.4

5. The way the object looks now, it could be displayed on a shelf in a fancy store. But what if the object were old, even ancient? No matter how much polish was applied, we would expect to see some flaws or smudges. That's where the grime maps come in. Open the Surface Editor again and load Grime Map 90.psd into the Specular channel as a texture. The specularity controls the play of light on the surface. Right now, the light is smoothed

over the entire surface, making the object look new and polished. Adding a grime map to the surface in the Specular channel will cause irregularities in the play of light, making the object look more worn. See Figures 19.5 and 19.6.

FIGURE
19.5
Add a grime map in the Specular channel.

FIGURE *The re-rendered object takes on a more worn appearance.*
19.6

FIGURE *Image content makes a difference.*
19.7

FIGURE *By adding a grimy bump, the effects of age and wear become*
19.8 *more apparent.*

6. The flaws look real enough, but let's use a different grime map to see what difference the image content makes. Use Grime Map 85.psd and set the XYZ mapping sizes to 50 cm each. Render to preview. See Figure 19.7.

7. If we wanted the flaws to be more observable—to change their appearance from blemishes to dents, say—we could use another grime map in the Bump channel. Select Grime Map 08.psd for a bump texture, and set the bump to 200%. See Figure 19.8.

8. Try Grime Map 39.psd as a Bump channel texture, with a value of 350%. Use spherical mapping. Boost the XYZ Scale factors to 5 meters each to create larger splotches. See Figure 19.9.

FIGURE *Now the object looks truly worn and has a definite personality.*
19.9

9. If you have Worley Labs' Disgusting shader, go to the Shader tab in the Surface Editor and explore layering a Disgusting texture over everything else. The results can be interesting and can make the object look as if it were an archaeological find. See Figure 19.10.

FIGURE **19.10** *By applying a Disgusting shader over the grime maps, very complex textures can be created.*

ONWARD

In this chapter, we explored the use of grime maps from dvGarage. The hand-shaking topics continue in the next chapter with a spotlight on Tree Professional from Onyx Software.

20

Onyx's Tree Professional

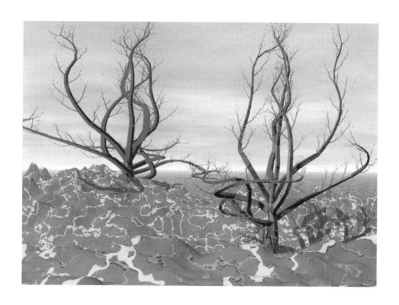

Tree Professional, or TreePro, from Onyx Software (*www.onyx.com*) is a valuable add-on for LightWave users who need to create high-quality tree and other flora models. TreePro allows you to alter the parameters of any of the preset tree forms in its vast library of examples or to create your own tree and/or bush models from scratch. The presets include both real-world trees and fantasy models (the Romulan trees are great for alien-world scenes), any of which can be customized to whatever extent you need. Models can be saved in a number of 3D formats for LightWave incorporation, including the LWO format, Wavefront, and DXF.

AN EXERCISE IN USING TREEPRO

TUTORIAL

Do the following to explore how TreePro handshakes with LightWave:

1. Open TreePro and load the preset in the Romulus Series folder called "Romulus 106." Fantasy trees make up the content of this folder. See Figure 20.1.
2. Set the Bough Length slider to about 50% as displayed in Figure 20.2.
3. Set Branch Density as displayed in Figure 20.3, and switch on the options as displayed at the bottom left.
4. Set Trunk Mold as displayed in Figure 20.4.
5. Export as a LightWave model. Apply different textures to component surfaces. Create a scene using the tree. See Figure 20.5.

FIGURE **20.1** *The Romulus 106 model parameters are loaded, and the tree appears on the TreePro preview screen.*

FIGURE **20.2** *Set the Bough Length slider to about 50%, as shown here.*

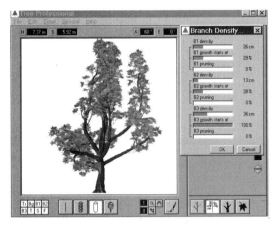

FIGURE *Set Branch Density as shown.*

20.3

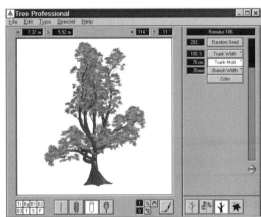

FIGURE *Set Trunk Mold as displayed here.*

20.4

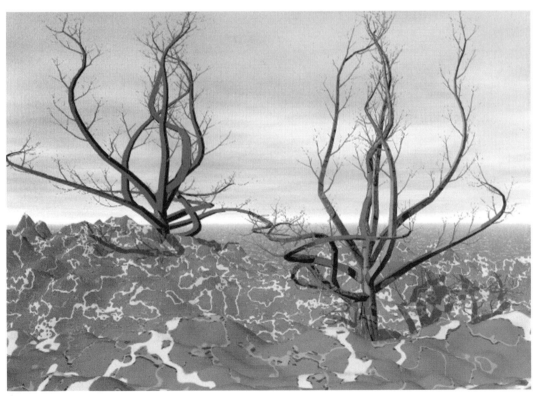

FIGURE *A scene with rendered trees.*

20.5

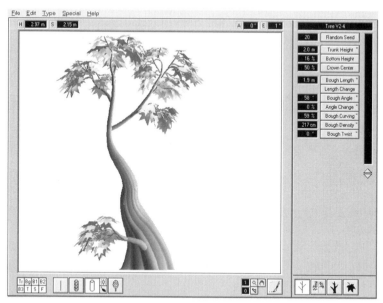

FIGURE *Load the tree called V2-4.*
20.6

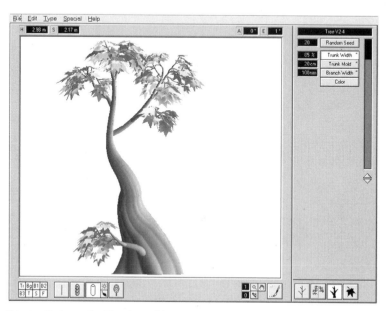

FIGURE *Enlarge the Trunk Width.*
20.7

ANOTHER TREEPRO/LIGHTWAVE PROJECT

TUTORIAL

Do the following to further explore TreePro/LightWave handshaking:

1. Open TreePro and load the parameters for the tree V2-4 from the Fantastic Trees Volume 2 parameter library. See Figure 20.6.
2. Enlarge the Trunk Width to 85%, as shown in Figure 20.7.
3. Set the Bough Curving to –250%. See Figure 20.8.

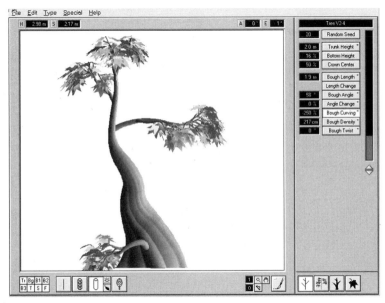

FIGURE *Set Bough Curving to –250%.*
20.8

4. Set the Leaf type to Number 7 Medium. See Figure 20.9.
5. Use the parameters displayed in Figure 20.10 to export the object in Light-Wave format.
6. Open Layout and import the tree you just created. See Figure 20.11.
7. You will have to own the Sasquatch plugin from Worley Labs in order to do this next part. Go to the tree's Object Properties display and select Sasquatch under Deformations>Add Displacement. See Figure 20.12.
8. Go to Scene>Image Processing and add the Sasquatch Pixel Filter. See Figure 20.13.

FIGURE *Use this Leaf Type.*
20.9

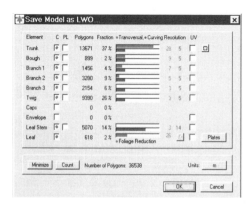

FIGURE *Export as a LightWave object.*
20.10

FIGURE *Import the tree into Layout.*
20.11

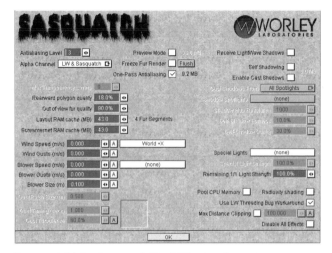

FIGURE
20.12 *Add the Sasquatch plugin.*

FIGURE
20.13 *Add the Sasquatch Pixel Filter as shown.*

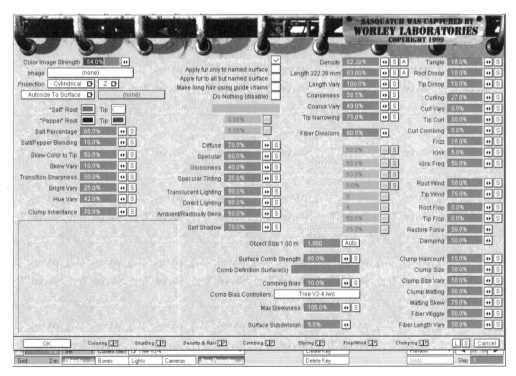

FIGURE *Use these Sasquatch parameters.*
20.14

FIGURE *Now the TreePro tree, covered in tangles of*
20.15 *moss, is fit for the bayou.*

2. Apply the values displayed in Figure 20.14 to create the transformed tree
shown in Figure 20.15.

ONWARD

In this chapter, we explored the wonders of Tree Professional from Onyx Software. In the next chapter, we'll take a look at the handshaking magic of Amorphium Pro from Electric Image.

21

Electric Image's Amorphium Professional

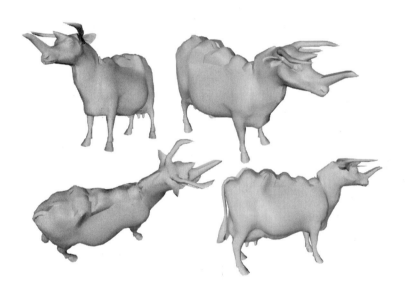

You can think of Amorphium Pro from Electric Image (*www.electric image.com*) as a plugin for all of the high-end 3D modeling applications on the market; it both reads and writes the 3D formats that directly support many of these applications. Aside from the fact that Amorphium offers you modeling alternatives and tools not found in other packages, all of its operations are real-time interactive, giving you the sense that you're working with clay. Since Amorphium reads and writes the LightWave 3D format, you can easily port models back and forth between the two applications.

Although Amorphium does feature a 3D painting mode, it is recommended that you stick with LightWave when it comes to applying textured surfaces.

AN AMORPHIUM EXERCISE

TUTORIAL

If you don't own Amorphium, you might want to browse this chapter to get some sense of what it does and how it does it. If you are already an Amorphium user, you can follow along with the tutorial. Do the following:

1. Open Amorphium and import the LightWave cow object from the Objects>Animals library. See Figure 21.1.

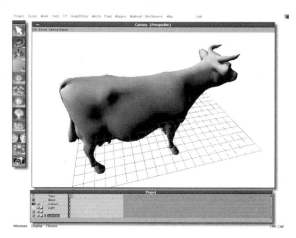

FIGURE *The LightWave cow appears on Amorphium's*
21.1 *Composer screen.*

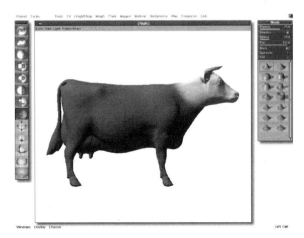

FIGURE *Mask out everything but the cow's head.*
21.2

2. Go to the FX screen. Use the Scale effect to increase the size of the model so that it fits the screen.
3. Select the cow with the arrow tool, and use MeshMan Quad to quadruple the number of polygons. This provides a better modeling surface.
4. Go to the Mask screen and select a right view. Mask out everything on the cow but its head, using the tools provided. Use a Smooth operation to blend the boundary between the selected and unselected polygon areas. See Figure 21.2.

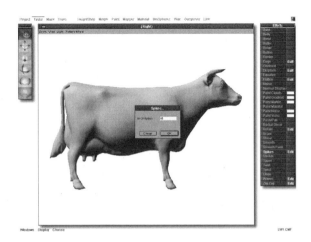

FIGURE *Set the number of spikes at 16.*
21.3

5. Go to the FX screen. Select the Spike effect and then edit. Set the number of spikes at 16. Remember that this will work on the unmasked head only. See Figure 21.3.

6. Slowly click and drag the mouse left and right until you see a form like that shown in Figure 21.4. Release the mouse.

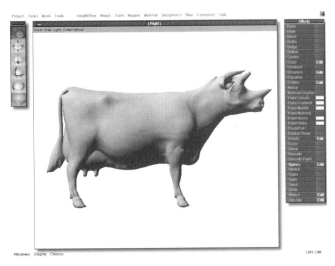

**FIGURE
21.4** *Use interactive mouse movements to alter the head with the Spike effect.*

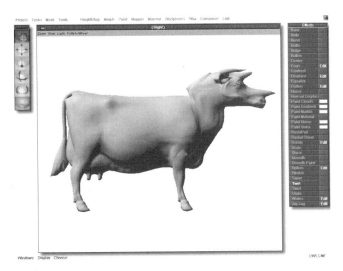

**FIGURE
21.5** *Twirl modifies the head even further.*

7. Now select the Twirl effect. Carefully click and drag the mouse until you achieve a form that resembles that displayed in Figure 21.5.

8. Use the Taper effect to add a slight taper by click-dragging the mouse slightly to the left. See Figure 21.6.

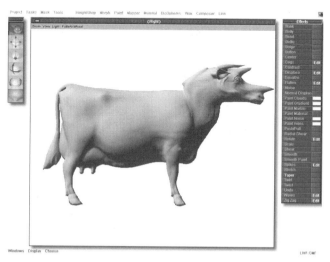

FIGURE *Add a slight taper.*
21.6

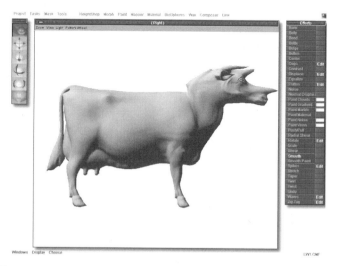

FIGURE *Smooth the head a little.*
21.7

9. Finally, apply a Smooth effect to the head to even things out a bit. See Figure 21.7.
10. Return to Mask mode and delete the mask. Apply a new mask as shown in Figure 21.8.
11. Use a Twirl effect to raise the back as displayed in Figure 21.9.

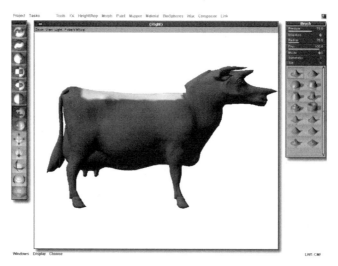

FIGURE *Mask everything but the top of the cow's back.*
21.8

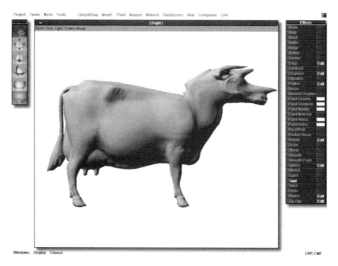

FIGURE *Twirl the unmasked area like this.*
21.9

12. Go to the right view of the Mask screen and create a mask for the cow's back that resembles that shown in Figure 21.10.
13. Back on the FX screen, apply a PushPull effect followed by a Smoothing operation to create some ridges on the cow's back (can we still call this a cow?). See Figure 21.11.

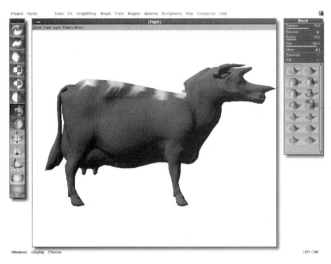

FIGURE *Create this mask.*
21.10

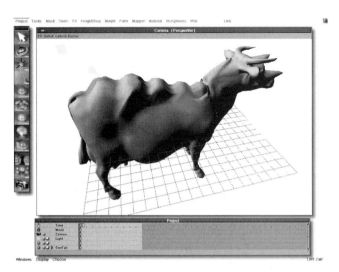

FIGURE *Create ridges.*
21.11

14. In Mask mode, mask everything but the nose horn. Use a Stretch effect followed by a Bend effect to reshape it. See Figure 21.12.
15. Use the same principle to mask and stretch out the top horns. See Figure 21.13.
16. Export to LightWave and texture. See Figure 21.14.

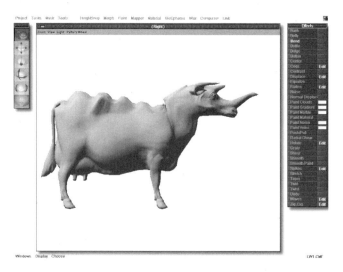

FIGURE *Reshape the nose horn.*

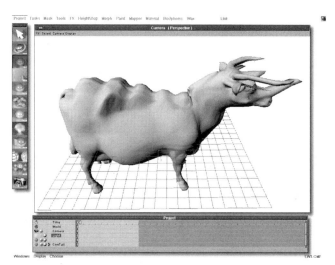

FIGURE *Stretch out the top horns.*
21.13

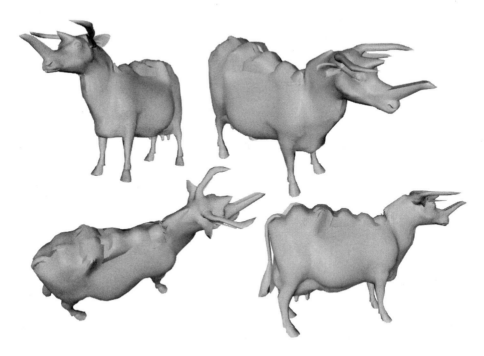

FIGURE *You can always use LightWave Modeler's vertex modeling options to tweak the*
21.14 *model further.*

 There are times when it's best to export a LightWave model from Amorphium in another 3D format, or even to pass it through another 3D application first. Experience will teach you the ropes.

ONWARD

In this chapter, we explored the magic handshaking capabilities of Amorphium Pro from Electric Image. In the next chapter, we'll take a look at BodyPaint from Maxon Software.

22

Maxon's BodyPaint 3D

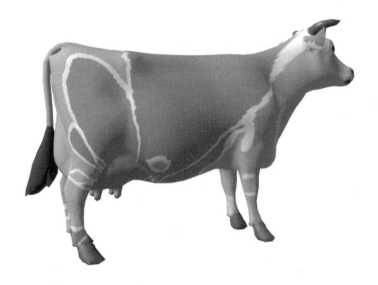

There are times when the surface of the model you have created—or the LightWave stock model you are using—just doesn't look the way you'd like it to. Perhaps you need to see indiscernible color shifts in specific areas or a bump map applied with varied depths across the model's surface. One way to apply different colors or textures to various parts of a model is to break apart the model, name the parts, and apply separate surfaces to each named part. Yet besides being a tremendously time-consuming undertaking, this method is of no help when it comes to creating blended surfaces.

The alternative is to paint on your surface attributes in 3D, adjusting the values and components of each channel as you proceed. There are several applications on the market that allow you to do this. One of the best is BodyPaint 3D from Maxon Software (*www.maxonsoftware.com*). BodyPaint 3D offers the following advantages over competing 3D painting applications:

- It provides full support for the latest versions of LightWave and is capable of both loading and saving LightWave objects.
- It is a multiplatform application, so both Windows and Mac LightWave users can utilize it.
- It has more painting, texturing, and mapping features than its counterparts, and new libraries of downloadable effects tools are constantly being added to the Maxon Web site.
- Its documentation is extremely clear, covering every aspect of BodyPaint 3D's tools and attributes in over 600 pages.
- As new technologies for 3D painting and texturing become available, they are folded into the software and users are notified.

The following tutorials should give you a better idea of how BodyPaint 3D can aid you in your LightWave projects.

A PAINTED COW

TUTORIAL

Here's how to use BodyPaint 3D to create an abstractly painted cowhide. Do the following:

1. Open BodyPaint 3D. See Figure 22.1.
2. Load the LightWave cow from the LightWave>Objects>Animals folder into BodyPaint 3D. Scale to fit the right side view. See Figure 22.2.
3. Locate the Materials panel. Click on the material named CowHide and drag-drop it onto the cow's hide in the 3D preview. A Texture panel will appear, showing the parameters for this material. You could alter the pro-

FIGURE *The BodyPaint 3D interface. Every part of the*
22.1 *BodyPaint 3D interface can be relocated and*
scaled, so your interface may look different from
this example.

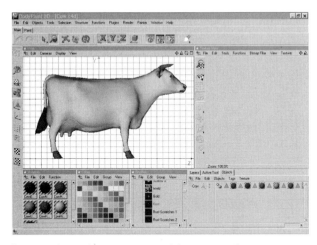

FIGURE *The LightWave cow model is imported into*
22.2 *BodyPaint 3D.*

jection type here, but for now, leave it at its default of Spherical. See Figure 22.3.

4. Click OK to close the panel. Go to Layers>Channels>Color. The New Texture panel appears, allowing you to set the resolution and size of the image you are creating. Set the color to white and click OK. See Figure 22.4.

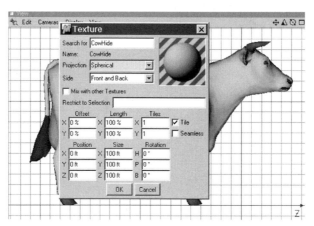

FIGURE *A Texture panel appears.*
22.3

5. Select a yellow color from the palette. Go to the Brush panel. Open the Standard Brushes folder and select Brush. Double-click to bring up its parameter settings.

6. Use the parameters displayed in Figure 22.5 and close the panel. Activate the 3D Painting tool from the toolbox (the icon shaped like a palette), and start to paint on the cowhide with a yellow hue. Watch the Textures panel to the right as you paint on the model. It displays what the texture map will look like in 3D. See Figure 22.6.

7. After accessing the Paint tab select the Fill tool from the toolbox at the top of the screen. Fill enclosed areas of your pattern with another hue. See Figure 22.7.

FIGURE *The New Texture panel.*
22.4

FIGURE *Brush settings*
22.5 *parameters.*

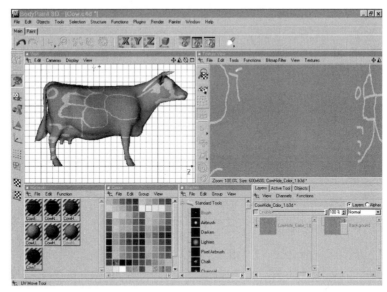

FIGURE *Start to paint on the cowhide.*
22.6

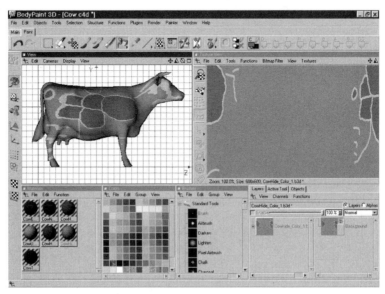

FIGURE *Use the Fill tool to add paint to enclosed shapes in your design.*
22.7

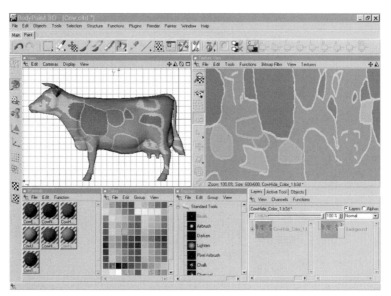

FIGURE **22.8** *Continue your painting in alternate views to complete the texture.*

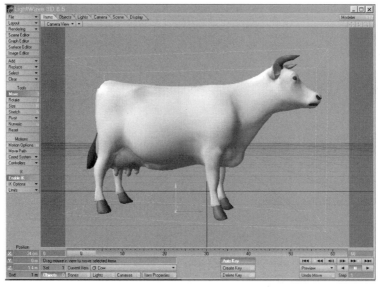

FIGURE **22.9** *Load the cow into Layout.*

8. Use other views to continue your painting on the cowhide. Also paint in the Texture view if you like, and watch how your strokes are applied to the 3D model. See Figure 22.8.

9. When you are through, go to the Texture panel and go to File>Save Texture As. Save the texture as a format that LightWave can read, naming it whatever you like.

10. Open Layout and load the cow object. See Figure 22.9.

11. Go to the Surface Editor and select the CowHide surface. Go to the Texture button next to Color. In the Texture Editor for the CowHide surface, use an Image Map Layer Type, and locate and load the texture you just created in BodyPaint 3D. Make sure to use the same mapping type, which in this case was Spherical. See Figure 22.10.

12. Click on Use Texture. Do a test render to see your image placed on the surface of the cowhide. See Figure 22.11.

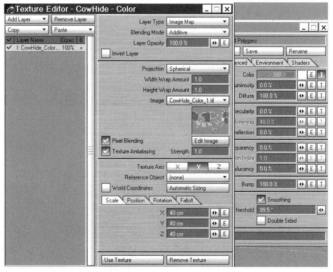

FIGURE *Load the texture you created in BodyPaint 3D.*
22.10

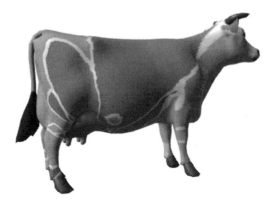

FIGURE *Your BodyPaint 3D image is rendered as*
22.11 *the cowhide surface in LightWave.*

OTHER TEXTURES

TUTORIAL

You can apply a lot more than color in BodyPaint 3D. Do the following:

1. Open BodyPaint 3D and repeat the steps you followed earlier to get the cowhide ready to paint.
2. This time go to the Brushes panel and select the Rivet brush from the MultiBrushes>NonOrganic folder.

FIGURE *Create a series of rivet heads.*
22.12

3. Go to Layers>Channels>Bump to create a Bump Map Layer. Click and drag the mouse in a series of arcs in the Texture view, creating a series of rivet heads. See Figure 22.12.
4. Select the Zip (Zipper) brush from the same folder and, using a white color, draw a series of zippered elements in the Texture view. See Figure 22.13.
5. Save the texture.
6. In Layout, with the cow loaded, open the Surface Editor. Remove the image texture from the Color attribute and use a plain light gray color.

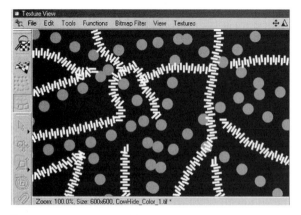

FIGURE *Draw a series of lines with the Zip brush.*
22.13

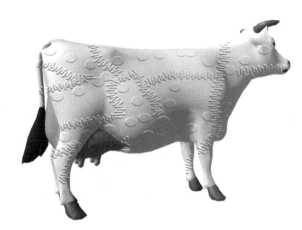

FIGURE *The BodyPaint bump map is applied.*
22.14

FIGURE *The BodyPaint 3D image, originally developed as a*
22.15 *bump map, has instead been applied here as a*
Specular map.

7. Open the Texture parameters in the Bump channel and load the image you just created in BodyPaint 3D. Set mapping to Front Mapping and the Bump Value to 300%. Render to see what you've got. See Figure 22.14.

These exercises touch upon just a few ways you can craft complete textures for your LightWave objects. Once a texture is completed, there is no reason you can't use it in a channel other than the one it was originally designed for. For instance, look at Figure 22.15. It displays a cow mapped with the standard gold reflective material for the cowhide surface. The difference is, the bump map that was created in BodyPaint 3D has been applied to the Specular channel, altering the regions of the cowhide that reflect light.

ONWARD

In this chapter, we introduced you to the capabilities of BodyPaint 3D from Maxon Software. In the next chapter, we'll look at how LightWave and Poser, from Curious Labs, can handshake.

23 Curious Labs's Poser

urious Labs's Poser (*www.curiouslabs.com*) is an astounding application that allows you to create and animate dozens of human and animal forms. All Poser models are articulated, so the movement of a form's parts does not involve just hinged joints, but rather Boned elements. In version 4.2 (also called the ProPack) and above, Poser addresses LightWave directly, through both an export option and a LightWave plugin. The LightWave plugin allows you to export complete animated figures to LightWave. Since this book is not concerned with animation per se, we will not detail that process, although it is simple enough to understand and initiate by following the appropriate Poser documentation.

A POSER EXERCISE

TUTORIAL

Because Poser includes a LightWave export option for posed figures, you can port any posed geometry offered in Poser to LightWave in a few simple steps. Here is how that process takes place:

1. Open Poser and load any figure you like from its library of choices. See Figure 23.1.

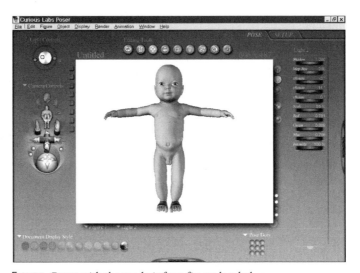

FIGURE *Poser with the nude infant figure loaded.*
23.1

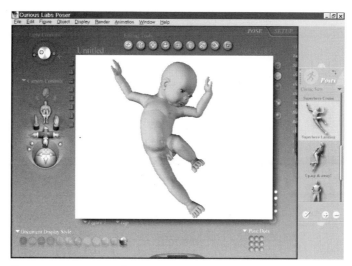

FIGURE *Create a pose for the figure.*
23.2

2. Go to the Pose Library, and load your favorite body pose. You may select to configure your body pose by using the parameter dials. See Figure 23.2.
3. Create a facial expression by using the Head parameter dials, or apply a facial expression from the Faces library. See Figure 23.3.

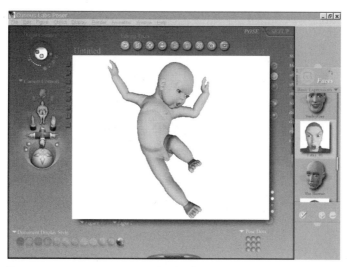

FIGURE *Create an expression for the face.*
23.3

FIGURE *Apply a wig.*
23.4

4. Apply a wig from the Hair library. See Figure 23.4.
5. Go to the Poser Props library and add a prop of some kind to the scene. Place the prop in the figure's hand, and parent the prop to the hand. In this case a sword was selected as the prop. Adjust the pose as needed. See Figure 23.5.
6. Save the Poser project file in case you want to return to it later for another posing session. Export the geometry as a LightWave object file, but don't

FIGURE *Add a prop.*
23.5

export the hair. Export the hair separately. Import both the figure and the hair object into Layout. See Figure 23.6.

7. Open the Surface Editor. Alter the surface of each part any way you like. See Figure 23.7.

8. Do a test render. See Figure 23.8.

FIGURE **23.6** *The figure and the hair object appear in Layout.*

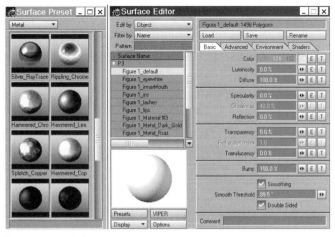

FIGURE **23.7** *Tweak the surfaces as needed.*

FIGURE *The rendered figure.*
23.8

9. The figure looks all right, but the hair looks a bit like plaster. If you have Sasquatch, do the next steps. Go to Scene>Effects>Image Processing and add the Sasquatch Pixel Filter. See Figure 23.9.
10. Go to Object Properties under Hair and add the Sasquatch Displacement item. The Sasquatch controls appear. See Figure 23.10.

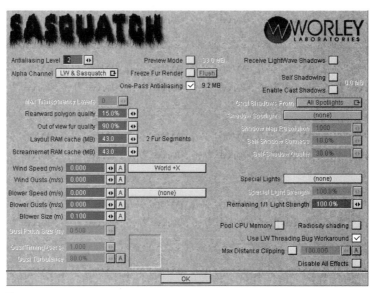

FIGURE *Add the Sasquatch Pixel Filter.*
23.9

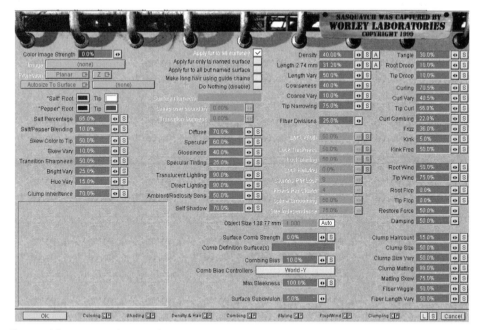

FIGURE *The Sasquatch controls.*
23.10

11. Tweak the Sasquatch controls and do test renders until you achieve a look you like. See Figure 23.11.
12. You will want to parent the hair to the head.

Explore the creation and import of additional Poser figures on your own, tweaking the models with LightWave deformers and other plugins and effects.

NOTE

You may be a Character Studio user who prefers to use that application for figure design instead of Poser. That should work fine, as long as you export to LightWave in a format LightWave can read. Poser, however, presents the following advantages over Character Studio:

- *It is multiplatform and therefore supports LightWave on both the Mac and PC.*
- *Its use does not require 3D Studio Max, which Character Studio users have to have and which runs only under Windows.*
- *It has a huge library of stock figures—any of which can be customized to fit your needs—that is being added to all the time.*

FIGURE *Create the Sasquatch enabled hair you prefer.*
23.11

ANOTHER HANDSHAKING OPPORTUNITY WITH POSER

When it comes to accepting morphs for projects, Poser prefers the Object format. Since LightWave can write WaveFront format for export, you could import Poser heads, create Endomorph transitions in LightWave, and then export them as Object files for Poser use as morphs.

ONWARD

In this chapter, we touched upon ways that Curious Labs's Poser can be used to create content in LightWave. In the next chapter, we'll take a look at NewTek's Aura 2 for some advanced LightWave image processing possibilities.

CHAPTER

24

NewTek's Aura 2

In addition to producing LightWave, NewTek develops other software that augments LightWave output. Aura is one such application, and, as of this writing, it's in version 2 of its development (Windows-only application). Aura 2 is a video paint system that allows you to paint on and add effects to animations. Aura was originally intended for specific use with the NewTek Flyer non-linear editing system, and it still serves that purpose as well. It can also be used as an image editor to customize single images. If you have Aura 2, you can use this chapter as a basic guide for exploring its use. If you don't yet own Aura 2, this chapter may help you decide whether it would behoove you to purchase it.

TUTORIAL

EXPLORING AURA

Do the following to begin exploring Aura's features:

1. Open Aura 2. The first thing that greets you is the Configuration panel. Select an 800 x 600 configuration (VGA HiRes) and click on OK. See Figure 24.1.
2. You are greeted by the Aura 2 interface. See Figure 24.2.
3. Select a yellow hue in the Color Picker Bin, and use the default Freehand Brush to spell out "Aura." See Figure 24.3.

FIGURE *The Aura 2*
24.1 *Configuration panel.*

FIGURE *The Aura 2 interface.*
24.2

FIGURE *Spell out the word "Aura."*
24.3

4. Select other brush types in the Tools panel and explore what they do. Note that the Oil Brush looks as if it has a 3D thickness when applied. See Figure 24.4.

FIGURE *Explore the uses of the other brush types.*
24.4

5. Click on the "X" in the upper image window to delete the project. Load a new image/project from the disk. Here we've used the Poser figure created in the last chapter. See Figure 24.5.

FIGURE *Load an image.*
24.5

6. Right-click on the box in the timeline and select Make Anim. The box transforms into a thumbnail of the image.
7. Right-click on the thumbnail in the timeline and select Make Duplicates. Input the number 12. Now you have a twelve-frame animation of the same image. See Figure 24.6.

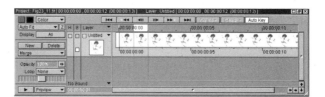

FIGURE *You have created a twelve-frame animation project.*
24.6

8. Select Windows>George Panel to bring the George Panel to the interface. George Scripts are F/X scripts that automatically add specific transitions to a selection of frames, creating an F/X animation. See Figure 24.7.

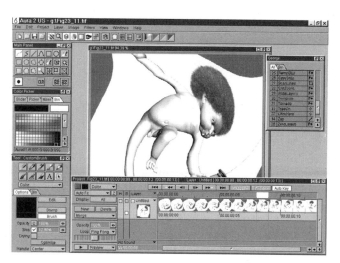

FIGURE **24.7** *The George Panel lists the available George Scripts in Aura 2.*

FIGURE **24.8** *The timeline displays the effect applied to each frame.*

9. Select the George Script named Tornado and double-click on it to set the parameters. Tornado creates a vortex effect. Set Frame 1 of your sequence to 360 degrees. The last frame will automatically default to 0 degrees of revolution. Select to continue, and the effects will be applied sequentially to the frames. Manually moving the time slider to any frame in the series displays the effect applied to that frame in the larger preview screen. See Figure 24.8.

10. Go to Project>Preview>Play to see your animation played in real time at full size. See Figure 24.9.

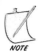

*A company called Visual Inspirations (*www.visualinspirations.com*) specializes in creating volumes of effects as George Scripts that can be added to Aura 2. The effects are high quality and save you big chunks of time when you need transition and other effects applied to an image or an image sequence. If you are an Aura 2 user, be sure to check out Visual Inspirations for the latest George Scripts.*

NOTE

11. Save the animation to disk as a QuickTime movie.

Aura 2 is a full-featured video paint application, and we have barely scratched the surface as far as what it can do, but you should now have some idea of how easy it makes it to paint on your animations or create animations from a single image.

FIGURE *Play the preview.*
24.9

 If you want to apply the animation sequence as a texture or back-drop in LightWave, make sure to save the animation as a sequence of single frames.

ONWARD

In this chapter, we took a peek at Aura 2 and how it can be used to add effects to the renderings created in LightWave. In the next chapter, we'll take a look at another image effects application: Ripple Rain.

25

Kerlin's
Ripple Rain

Ripple Rain from Kerlin Softworks (*www.kerlinsoftworks.com*) creates two interconnected effects—ripples and rain. The effects are interconnected in that the raindrops look as if they are causing the ripples. Either can be created on its own, however, giving you even more options. The ripples are created for use as bump maps for a horizontal plane (perhaps to emulate a pond or lake), and the rain is created as an animated texture map meant to be targeted to vertical planes. The simulation is extremely clever, and it works like a charm.

Before we detail some of the items to explore in Ripple Rain, however, we need to back up to make sure you understand some things about LightWave.

TUTORIAL

ANIMATED MAPPING

To understand how Ripple Rain creates objects and backgrounds from animations, you have to know how to tell LightWave how to treat animated textures. Animated textures here refers mainly to animated images—either movie files (QuickTime or AVI) or numbered single frame sequences. (Procedurals can also be animated, but that is not relevant to the topic at hand.) If you have never applied an animated texture before, or if you need a little refresher course, do the following:

1. Open Layout and go to Scene>Effects>Compositing.
2. Under Background Image, select Load Image. Find an animation file (QuickTime or AVI) on your system and select it. The animation file—here a QuickTime movie scene of a temple created with Corel Bryce—is now a background animation. See Figure 25.1.

FIGURE **25.1** *Load a movie file as an animated background.*

FIGURE **25.2** *Target an animation file in the Texture Editor for the sphere.*

3. Now create a sphere in Modeler and port it to Layout.

4. With the sphere selected, go to the Surface Editor. Click on the "T" button (Texture) for Color to bring up the Texture Editor. Make sure Planar Mapping is selected, and make both the Width and Height Tiles read "Reset." Select Load Texture under Image, and select any QuickTime, AVI, or single frame sequence of animation files (if you opt for the latter, all you need to do is to select the frame you want to start with, and LightWave will recognize and load the other frames). Here we've used a QuickTime movie file created with MetaCreations' PowerGoo, a face morphing application. Although MetaCreations is no longer in business, you can still find this application at many software distributors. Having placed animation files in both the background and on your sphere, you can render the animation or any single frame from it. See Figures 25.2 and 25.3.

You can find this finished animation in the Anims drawer on this book's CD. It is called "Mapped1.mov."

Now we're ready to move on to Ripple Rain.

FIGURE *Sample frames from our animated background/foreground rendering.*
25.3

EXPLORING RIPPLE RAIN

As we stated at the start of the chapter, Ripple Rain creates two separate but interconnected components: bump map data meant to be targeted to a horizontal plane (ripples) and texture maps meant to be targeted to vertical planes (raindrops). As the rain strikes the horizontal plane, the ripples are generated. Ripple Rain is a most elegant solution to what would otherwise be a computer graphics design nightmare, saving you time and gray hairs. Documentation and examples can be found on the Kerlin Softworks Web site, so we will not try to duplicate the full documentation here. We will also skip over the rain creation in this brief tutorial, focusing instead upon the ripples, because the bump maps generated for the ripples offer a number of additional uses:

- They can be used in channels such as the Bump, Transparency, and Specular channels.
- Their data can be targeted to any 3D object, allowing you to create ripple-affected logos and all sorts of other models.
- They can be associated with a wide range of phenomena to produce such effects as meteorite impacts, bubbling mud, or even the flux of an interdimensional doorway (like a StarGate).

With all of this in mind, let's try using Ripple Rain to generate ripple data. Do the following:

1. Open Ripple Rain. At first, the interface looks entirely blank. See Figure 25.4.

FIGURE *Ripple Rain greets you with a blank interface.*
25.4

FIGURE *Set Preferences first.*
25.5

FIGURE *The Add Emitters*
25.6 *button.*

2. Go to File>Preferences to make any alterations in the items listed. You can set preview colors and the bits per file format for Save options. Save any changes you make. See Figure 25.5.
3. Click on the Add Emitters button in the toolbar. See Figure 25.6.
4. Click in the large Layout preview window where you want to place your first ripple, and the settings will appear. See Figure 25.7.
5. Select one of the items from the top list for a ring profile. This profile represents a vertical slice through the ring. See Figure 25.8.
6. Click in the Ring Profile Silhouette preview window to bring up the Edit Silhouette window, where you can customize the shape of the ring profile,

FIGURE *The ripple parameters settings window.*
25.7

FIGURE *Select a ring profile, which will then*
25.8 *appear in the Ring Profile Silhouette preview window.*

FIGURE *Edit the silhouette to your liking.*
25.9

FIGURE *A view of your bump map.*
25.10

including simultaneously generating multiple rings to create peaks and valleys. See Figure 25.9.

7. Clicking on Preview in this window gives you a bird's eye view of the bump map being generated from the silhouetted profile. See Figure 25.10.

8. Click OK to accept the shape, which will return you to the parameter settings. Select an Emitter Profile from the list at the bottom right. Name the emitter in the space provided. See Figure 25.11.

9. Click OK. Now your interface resembles Figure 25.12, with the rings indicated where you stamped the emitter.

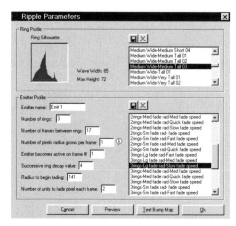

FIGURE *Select an Emitter Profile from the list and*
25.11 *name your emitter.*

FIGURE *The interface shows the first emitter placement.*
25.12

10. You can create as many ripples as you like, configuring each one sepa-rately, by clicking the LMB anywhere else in the Layout window. As an al-ternative, you could use the RMB to place a clone of the emitter you just created—you would just need to indicate a frame for the new ripple to start on. This way, you could create all sorts of interference patterns. See Figure 25.13.
11. Click on the Preview Ripples button to see the animation as a wireframe in the Layout window. See Figure 25.14.
12. Click on the Render button when everything looks right. See Figure 25.15.

FIGURE *Create as many ripples as you like.*
25.13

FIGURE *Watch a preview by*
25.14 *clicking this button.*

FIGURE *The Render button.*
25.15

FIGURE *Set the parameters and save the*
25.16 *folder you want here.*

13. The Rendering Options window appears. See Figure 25.16.
14. Uncheck Render Rain, since we are only going to use the ripple bump map data. After the rendering is complete, quit Ripple Rain and open LightWave Layout.
15. Decide on an object you want to map the ripples to. It can be a flat plane or another 3D object. Go to the Surface Editor for that object and to the Texture Editor for the Bump channel. Load the image and find the first frame of the sequence you just created for the ripples. LightWave will automatically recognize this as a sequence of frames and will load them all. You can see the results of mapping the ripples to a sphere object in the Anims folder on this book's CD. The folder also shows how these maps look when targeted to other channels.

ON THE CD
Go to the Anims folder on this book's CD and play the Quick-Time animations RipRan1.mov, RipRan2.mov, and RipRan3.mov.

ONWARD

In this chapter, our focus was Ripple Rain from Kerlin Softworks. In the next chapter—the last in this part of the book—we'll take a look at Illusion from Impulse.

CHAPTER

26

Impulse's Illusion

hen it comes to creating entire animated movies augmented with
dozens of particle effects—or just creating a single image with super-
realistic pyrotechnic elements—you'd be hard-pressed to top what Il-
lusion (Windows-only application) from Impulse Software has to offer. Illusion
effects are based upon a high-end 2D particle system, with new libraries of ef-
fects being offered free for download every month on the Impulse Web site
(*www.coolfun.com*). The site also runs contests every few months or so to invite
Illusion users to vie for prizes for designing the best new effects. All entries are
subsequently posted for free download. Browse this chapter to see what Illusion
can do, or, if you are already fortunate enough to be an Illusion owner/user,
you can use the following tutorial to get a better idea of how Illusion can aug-
ment LightWave graphics and animations.

TUTORIAL

AN EXERCISE IN USING ILLUSION

We are going to stick to Illusion's stock (downloaded) effects, although you can
certainly design thousands of your own effects once you are familiar with the
software. Do the following:

NOTE

*"Two-D particle system" refers to the fact that Illusion particle
effects are applied to a 2D image or frame. The particles them-
selves behave as 3D volumes, giving your 2D image or frame an
enhanced 3D look.*

FIGURE *The Illusion interface with nothing yet loaded.*
26.1

1. Open Illusion. The interface appears. See Figure 26.1.
2. Double-click on the small gray swatch at the upper left. This is a footage thumbnail, indicating the image or animation you want to use. Although you can place your effects on a blank background and composite them with an animation in another application (like Adobe After Effects), we'll use some footage here. After you double-click on the swatch a load window appears, allowing you to locate the image or animation you want to use as a canvas for your effects. Load an image that you want to use from somewhere on your system. See Figure 26.2.
3. If asked if you want to make the Stage the same size as the image, select Yes.
4. Select the Blocker item from the toolbox at the top of the screen. See Figure 26.3.
5. Using the Blocker process, you can select areas of the image where you want to block any effects from being applied. Click and drag out an outline with the LMB to define a blocked area. When complete, right-click. In the case of the image used here, we've blocked out the floor.
6. Go to the Effects list on the right side, which should include a number of effects folders. If not, right-click and select Load Library to load effects from the Illusion folder. Any effect you click on will show its animated preview in the top preview window. Select an effect you want to apply. See Figure 26.4.
7. Look at the timeline at the bottom of the window. It features a time slider that can take you to any frame. See Figure 26.5.

FIGURE **26.2** *Locate and load a saved LightWave image, and drag and drop it so that it appears on the stage.*

FIGURE **26.3** *Select the Blocker tool.*

FIGURE *The timeline window.*
26.5

FIGURE *The Effects*
26.4 *list.*

FIGURE *The VCR controls.*
26.6

8. Decide what frame you want the effect you selected to start on, and click in the image to place an emitter at that position. You can do this as many times as you want that effect to appear, and you can set each starting frame differently.

9. Go to the VCR controls at the top of the screen. See Figure 26.6.

10. There are four items in the VCR controls: the Return to Start button, Play button, Frame Counter, and Record button. Hit the Play button to see a real-time playback of your effects in action. Each placed effect will start at the frame you selected for it to start on. The Play button transforms into a Stop button that will stop the action at the frame selected. You can also input a frame number in the counter to have the image instantly transit to that frame. See Figure 26.7.

11. Repeat the preceding four steps as many times as you need to so that additional effects can be applied where desired. Remember to preview the effects each time to be sure you are getting what you want. Keep in mind that effects applied over a light part of the image tend to produce light explosions and washouts.

12. When you are satisfied that you have created the effects you want, click on the red Record button. You will be asked for a name for the image or animation and to specify a format to save it to. Comply with these requests and Illusion will render out the data. See Figure 26.8.

FIGURE
26.7
Play the effects to preview.

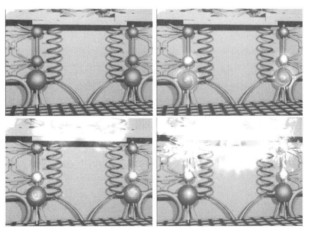

FIGURE
26.8
The image started out as a LightWave rendering of a laboratory. Here are four frames from the animation after Illusion effects were applied.

13. Go to LightWave Layout and Scene>Effects>Compositing. Load the Illusion animation you created as a background image. See Figure 26.9.
14. Go to Display>Display Options. At the bottom of the panel, under Camera View, select Camera View Background>Background Image. This allows you to see the image or animation in Layout. See Figure 26.10.
15. Open Modeler and create a lathed object that can be added to the scene. See Figure 26.11.

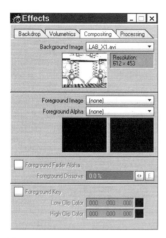

FIGURE *Load the Illusion animation*
26.9 *as a LightWave background.*

FIGURE *Display the Illusion data in Layout.*
26.10

16. Add the object to the scene with the Illusion background. Give it a slight bump mapping (your options) so that it can be noticed as rotating when we rotate it. Make its reflection mapping contain the Illusion animation. Make sure you set the total frames to the same number as the Illusion animation. See Figure 26.12.

FIGURE *Create a lathed object to add to the scene.*
26.11

FIGURE *Place the lathed object in the scene.*
26.12

17. Rotate and keyframe the object on its vertical axis so that it makes one full rotation from the start of the animation to the end. This just provides some interest against the background animation.
18. When your animation is complete, you will not be done yet. The neat thing about Illusion is that animations can be processed over and over again, so that you can create ever more complex F/X scenes. Open Illusion

FIGURE *Import the LightWave animation back into Illusion.*
26.13

FIGURE　*Frames from the finished animation, showing the new emitter effect at the bottom of*
26.14　*the rotating object.*

and import the animation you just completed in LightWave. See Figure
26.13.

19. Select some part of the object and attach an emitter to it. We've selected a
sparkling star. Make sure either that the part of the object you select
doesn't move or, if it does, that you keyframe-move the emitter over time
as well. See Figures 26.14 and 26.15.

Look in the Anims folder on this book's CD for the following
ON THE CD　*animations that reference this chapter: Lab_X1.mov,*
Lwfin.mov, Illus1.mov, Illus2.mov, and Illus3.mov.

FIGURE *Frames from another LightWave/Illusion project created in the same manner as the previous one.*
26.15 *This time, the subject is a conflagration.*

ONWARD

In this chapter, we took a look at Impulse's Illusion. In the next chapter, the target is Xfrog, a flower-, tree-, and alien plant-creating application.

27

Greenworks's Xfrog

Xfrog, from Greenworks (*www.greenworks.de*) is unlike any organic object creation application you have seen before. Although it can be used to create objects that represent the diversity of flora on this planet, its real strength lies in its ability to help you generate fantastic new plant forms—forms that are perfect for your more exploratory LightWave projects. Xfrog writes out Object formatted models that LightWave can import. If you don't own Xfrog yet, make sure to download the demo from the Greenworks Web site.

GRISELLA

TUTORIAL

This tutorial explains how to build Grisella, one of the abstract models shipped with Xfrog. It should demonstrate how easy it is to build abstract and botanical models.

1. The first step is to have a look at a picture of the model you are going to build. See Figure 27.1.
2. The heart of Grisella is the red ball in the center of the model. Since all other parts stem from this ball, it will be the first object in the model hier-

FIGURE
27.1 *An image of the finished model.*

FIGURE
27.2 *Create a simple component in the hierarchy.*

archy. Create a simple component in the Hierarchy Editor and link it to the Camera. See Figure 27.2.

3. Go to the Primitive tab of the Parameter Editor window, select the sphere primitive from the Primitive Type pull-down menu, and assign it to the simple component. The ball will appear in the origin of the global coordinate system. To make the sphere really round and its surface smooth, set the Resolution slider to a higher value. See Figure 27.3.

4. With the simple component selected, go to the Material tab of the Parameter Editor window and set the Color option to Set. Click the Edit button of the Diffuse option and the Color Editor window will open. Specify a red color and close the window. The color appears in your model. In the Specular option you can specify a green color for the highlights. See Figure 27.4.

FIGURE *Set Resolution to a higher value.*
27.3

FIGURE *Specify a green color for the*
27.4 *highlights.*

5. Now create a leaf component and add it to your model by linking it to the Camera. The leaf will also appear in the origin of the global coordinate system. Since the leaf component comes with a default primitive, it will be immediately visible in the Model View window. See Figure 27.5.

FIGURE *Link a leaf component*
27.5 *to the Camera.*

6. As the default size of the leaf component is far too small for Grisella, go to the Leaf tab of the Parameter Editor window and set the Length slider and the Scale X slider to higher values. Also set the Segments slider to a higher value to produce a smooth outline of the leaf. See Figure 27.6.

7. Now make the leaf a bit more heart-shaped by setting the second slider of the Shape>Range double slider to a higher value. See Figure 27.7.

8. Play with the sliders of the Curvature section to bend the leaf. You can also assign mathematical functions to the range definitions made in the double sliders. The sliders' pull-down menu offers a number of predefined functions that you can assign to your range definition. In our example, we used a quadratic function ("sqr") to achieve the twisted shape of the leaf. See Figure 27.8.

9. Go to the Material tab of the Parameter Editor window and set the Color option to Set. Specify a green color in the Color Editor for the Diffuse option and a pale yellow for the Specular option. See Figure 27.9.

10. To create the stems emanating from the red ball, you can use a multiplier component. Create a "PhiBall"component and link it to the Camera. (As the PhiBall does not have a default primitive, you will not see any changes in the Model View.) The PhiBall multiplies all components linked to it. To build the

FIGURE *Produce a smooth outline of the leaf.*
27.6

FIGURE *Make the leaf more heart-shaped.*
27.7

FIGURE *Set the Curvature.*
27.8

FIGURE *Set the Diffuse and Specular*
27.9 *colors.*

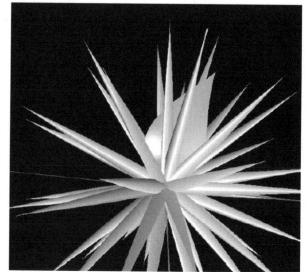

FIGURE *Link the horn to the PhiBall.*
27.10

FIGURE *Reduce the number of horns.*
27.11

stems, use the Horn tab to produce a conical horn-like shape, which is perfect for all kinds of stems. Link the horn component to the PhiBall and you will see that the red ball has sprouted a number of horns See Figure 27.10.

11. With the PhiBall component selected, go to the PhiBall tab of the Parameter Editor window. Set the Number slider to a lower value to reduce the number of horns on the ball. See Figure 27.11.

12. Now select the horn component and go to the Horn tab of the Parameter Editor. Make the horns thinner by setting the first slider of the Shape>Range double slider to a value close to the value of the second slider. See Figure 27.12.

13. Bend the stems by assigning a rotation value in the Curvature section of the Horn tab. In our example, we used a slight rotation around the X axis. See Figure 27.13.

14. Open the Color Editor in the Material tab and assign a yellow color to the stems. See Figure 27.14.

15. Create a new simple component and link it to the horn component to add balls to the stems. Use a Simple link to place the balls on the end of the stems. Click the line connecting the two components to select the link. Choose Simple from the Link pull-down menu at the bottom of the Hierarchy

FIGURE *Make the horns thinner.*
27.12

FIGURE *Curve the stems.*
27.13

Editor. Use the horn component both a Simple link to connect geometry to the end of the horn and with a Multiple link to multiply geometry along the horn. See Figure 27.15.

16. Go to the Primitive tab of the Parameter Editor window and select the sphere primitive from the Primitive Type pull-down menu. Then set the

FIGURE *Assign a yellow color to the stems.*
27.14

FIGURE *Multiply the*
27.15 *geometry.*

Resolution slider to a higher value to make the sphere really round. See Figure 27.16.

17. Open the Color Editor of the new simple component and specify a white color for the Diffuse option, a blue-green color for the Ambient option, and a yellow color for the Specular option. To make the balls semitransparent, reduce the value of the Alpha slider. See Figure 27.17.

18. With the second simple component selected, click the Copy button at the bottom of the Hierarchy Editor window. A copy of the selected component

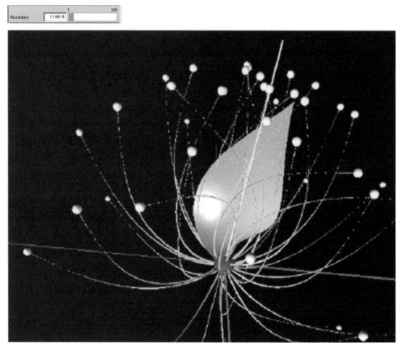

FIGURE *Make the sphere more round.*
27.16

FIGURE *Adjust the colors.*
27.17

FIGURE *Multiply the component along the stems.*
27.18

will appear in the Hierarchy Editor window next to the current hierarchy. Link this component to the horn component, this time using the Multiple link. Click on the link connecting the two components to activate it, then choose Multiple from the Link pull-down menu at the bottom of the window. The component will be multiplied along the stems. See Figure 27.18.

19. With the new simple component selected, go to the Material tab and set the Color option to Inherit. The component will use the color definition of the stems. See Figure 27.19.

FIGURE *Set the Color option to Inherit.*
27.19

20. Go to the Primitive tab, switch the Lock Scale option to On, and scale down the new simple component. The multiplied balls will now be just a detail of the stems. See Figure 27.20.

FIGURE *The final detail.*
27.20

ONWARD

In this chapter, we took a look at Xfrog from Greenworks. In the next chapter, we begin the final part of the book, devoted to advanced projects, and the creation of TekMan.

V

Advanced Projects

28

TekMan

This part of the book dwells upon the completion of several advanced projects that incorporate all of the skills and techniques (or should we say "Tekniques"?) that you have mastered so far. Some of these projects also entail the use of plugins. If you don't have the required plugins, you can still do a project up to the point where the plugin is called for—perhaps finishing it when you have a chance to purchase the plugin. The projects we will focus on are named TekMan, FireMouth, and WaveRider.

CREATING A HEAD

TUTORIAL

In this project, we'll create a posable figure that is part mechanical and part organic. Do the following:

1. Open Modeler. Use Metaballs to create a head shape. You should be able to generate a basic form with about eight Metaballs, scaling and positioning as necessary to create the proper gooey bridges between the shapes. You can use the object shown in Figure 28.1 as a model or create your own form. Don't try to get everything in one shot, just model a basic shape that you can work on.
2. Go to Construct>Convert>Freeze to change the Metaballs to polygons. See Figure 28.2.
3. Smooth in the Surface Editor.

FIGURE *Create a basic head form with Metaballs.*
28.1

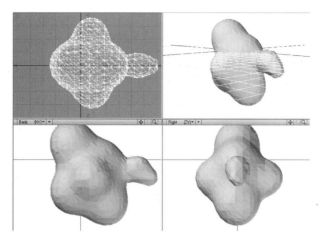

FIGURE **28.2** *Convert the Metaballs to polygons with the Freeze command.*

4. Using any shaping tools you prefer, tweak the model until you achieve a pleasing shape. Stretch is always a good idea for getting better proportions.
5. Make the head a foreground layer and create a background layer. Place a flattened sphere on the background layer to be used as a Boolean cutter for the mouth. See Figure 28.3.
6. Go to Multiply>Combine>Boolean>Subtract to cut the hole for the mouth. See Figure 28.4.

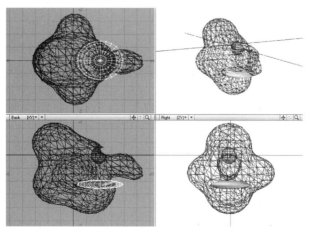

FIGURE **28.3** *Create a flattened sphere on the background layer for cutting out the mouth.*

FIGURE *Cut the hole for the mouth.*
28.4

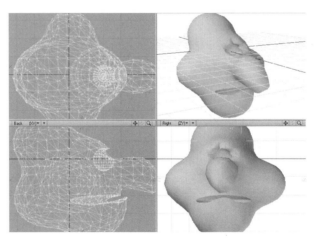

FIGURE *Create the hole for one central eye.*
28.5

7. Use a similar process to create a hole for one central eye. This character
 will be a cyclops. See Figure 28.5.
8. Use Edit>Copy and Paste to place the head on the first layer. Delete the
 spheres used to cut away the mouth and eye.
9. Select points on the lower lip, and use the magnet tool to give the lip a bit
 more shape. See Figure 28.6.

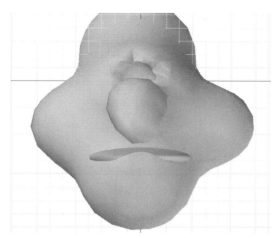

FIGURE *Give the mouth a bit more character*
28.6

10. Select the polygons around the eye, and go to Triple then Smooth. Don't worry about a few creases. They will actually add some nice features to this character.
11. Using the head as a background layer, create an ear from a flattened sphere on a foreground layer. See Figure 28.7.
12. Rotate, twist, bend, and stretch until you have an ear shape you want. See Figure 28.8.

FIGURE *Create and place one ear.*
28.7

FIGURE *Shape the ear.*
28.8

FIGURE *Now we have two ears.*
28.9

13. Copy and paste the ear to another layer, and delete the ear on the first layer. Mirror the ear in the top view. See Figure 28.9.

14. Select the ear layer as the foreground and the head as the background layer. Use the head as a guide to move the out-of-place ear into position in the top view. Do this by selecting all of its polygons and by using the Move tool. See Figure 28.10.

FIGURE *Move the second ear into position.*
28.10

FIGURE *Now the head and ears are one model.*
28.11

15. Cut the ears from their layer and paste them to the head layer. See Figure 28.11.
16. Go to the Surface Editor. Rename the Default surface to HeadSkin, and apply the Brain surface from the Strange surfaces presets folder. Alter the bump mapping to 500%. See Figure 28.12.
17. Port the model to Layout after saving it. Do a test render in Layout to see what you have so far. See Figure 28.13.

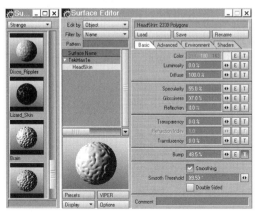

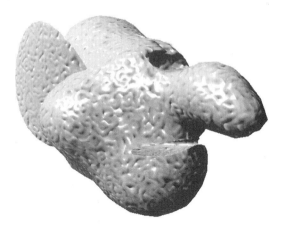

FIGURE **28.12** *Create a surface texture.*

FIGURE **28.13** *The old boy is shaping up.*

18. Create an eyeball for the creature on a separate layer, and use the Neon_Green surface preset from the Generic surfaces folder on it. This creates a glowing green eyeball.

19. Update the object save and port to Layout. In the Scene Editor, make the eye the child of the head. Do a test render now. See Figure 28.14.

20. Create a cone on a separate layer in Modeler. Make it an array of twelve cones on the Z axis, with a Z spacing of a meter. Bend the array in a side

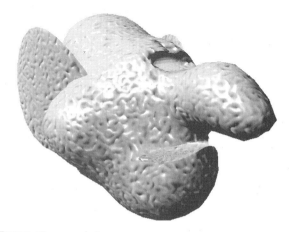

FIGURE **28.14** *Very spooky!*

FIGURE *Create an array of cones and bend the array to look*
28.15 *like this.*

view to get a semicircular arrangement of cones. These will become teeth.
See Figure 28.15.

21. Duplicate and rotate the teeth for the bottom row. On a separate layer, use
 a silver reflective surface to texture them.

22. Go to Detail>Layers>Layer Settings. Name each layer (Head, Eye, Teeth 1,
 and Teeth 2) and select OK. Go back to the same settings window and se-
 lect the head as the parent of the eye and both teeth layers. Save the object

FIGURE *The sharp metallic teeth give our character a rather*
28.16 *nasty disposition.*

and port to Layout for a test render. Since the object is already parented, there's no need to parent the parts in the Scene Editor. See Figure 28.16.

23. On a separate layer, create a tongue from a squashed sphere. Place as needed. Surface with a dark-red color and parent to the head. Do a test render. See Figure 28.17.

24. On a new layer, shape a sphere to act as a hairpiece for the character, stretching and tapering it. Parent to the head. See Figure 28.18.

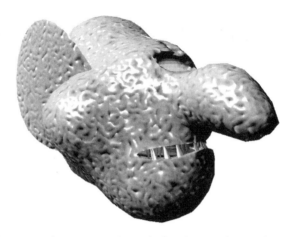

FIGURE *With tongue in place, the head is nearly complete.*
28.17

FIGURE *Select polygons that form a toupee surface.*
28.18

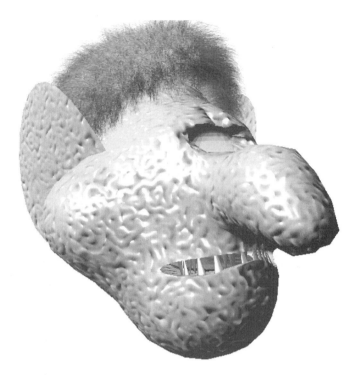

FIGURE *A definite new look.*
28.19

25. Port the head to Layout, and use Sasquatch (if you have it) to configure
 hair. Don't forget to use the Sasquatch Pixel Filter as well as the Deforma-
 tion plugin. See Figure 28.19.
26. As a last step for the head, go to Detail>Pivot and move the Pivot to the
 base of the head so it can rotate on a neck.

*On your own, you can create a range of morph targets for the
head, manipulating them with the Endomorph facility in Layout.
You can also elect to create the rest of the body of this character
in one file in Modeler. We chose to save the head separately and
to model the rest of the body as another file, connecting them in a
hierarchy in Layout.*

TUTORIAL

THE REST OF THE BODY

The rest of the figure you will model for this character will not be what you might expect. Although its head looks organic enough, with its skin and hair in place, the rest of the model will be mechanical in nature—metallic, in fact. In a further touch of the unexpected, instead of having legs and feet, this character will attain mobility through the use of a motorized wheel. Do the following to create the balance of the model, starting with the neck and torso.

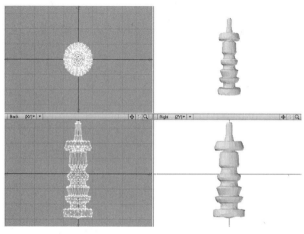

FIGURE *Lathe this form.*
28.20

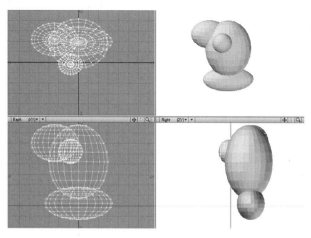

FIGURE *Create this form from spheres.*
28.21

NECK AND TORSO

We are going to build the neck and torso as one part and will then use morph targets to pose it.

1. Open Modeler. We'll create a neck first. Create a form by lathing a sketched shape somewhat resembling the one depicted in Figure 28.20.
2. Triple, and reduce the polys by applying gemLOSS2 three times.
3. In the Surface Editor, smooth and apply a Gold_Raytrace texture to the neck. Rename the surface "Neck." In Detail>Layers>Layer Settings, name the layer "Neck." Move its Pivot to the bottom center of its base.

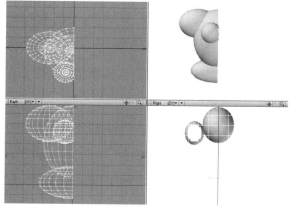

FIGURE *Delete half of the polygons.*
28.22

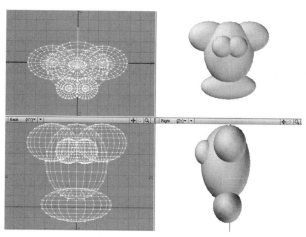

FIGURE *Mirror the other half of the form.*
28.23

4. Use spheres and the Edit/Copy and Paste operations to create a shape that winds up on a single layer, resembling that shown in Figure 28.21.
5. Move the object so that it is centered upon the origin, and delete the polygons on the right side. See Figure 28.22.
6. Go to Multiply>Duplicate>Mirror. Place the cursor on the Z axis in the top view, and click-drag to create the other half of the form. See Figure 28.23.
7. Go to Construct>Triple. Use Stretch to flatten the form a bit in the Z direction in the top view. See Figure 28.24.

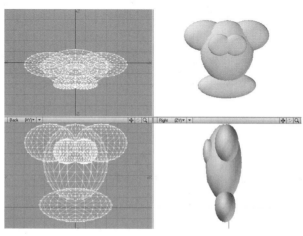

FIGURE **28.24** *Flatten the form a bit.*

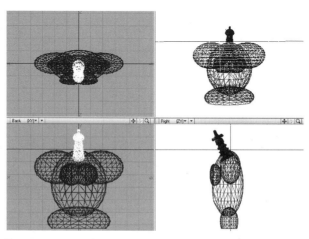

FIGURE **28.25** *Position the parts you have so far.*

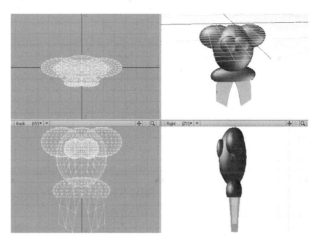

FIGURE *Add wheel struts.*
28.26

8. Delete the polys at the base of the torso. Angle and place the neck as displayed in Figure 28.25, scaling the torso accordingly. Name the Layer "Torso," and make sure the neck layer is named "Neck."

9. On a separate layer, create a wheel strut from a tapered box. Copy and paste it to the torso layer when it is positioned the way you want it. Go back to the strut layer and rotate the strut for the opposite side. Copy and paste it to the torso layer. Delete the original strut layer. See Figure 28.26.

FIGURE *Create your own disk-based form.*
28.27

10. On a new layer, create a custom form in the top view by starting with a disk and manipulating its points. Extrude it to give it some thickness. This will be one tooth of a gear-like form. See Figure 28.27.

11. Set the origin as the Action Center, and move the extruded form away from the origin a bit.

12. Go to Multiply>Duplicate>Array. Create an array on the Y axis with eight components. You will have created a gear-like object. See Figure 28.28.

FIGURE *You will generate a gear-like object.*
28.28

FIGURE *Add gear parts to give the torso more interest.*
28.29

FIGURE
28.30
Add the struts and an axle as shown.

FIGURE
28.31
Create the tires.

13. By using the torso layer as a background guide, copy and paste multiple gears to the torso to give it more interest. See Figure 28.29.
14. Using scaled cylinders, add struts, an axle, and another gear at the center. See Figure 28.30.
15. Use a separate layer to create the tires. Create and place using the torso background as a guide. See Figure 28.31.

FIGURE **28.32** *The body so far.*

FIGURE **28.33** *Poses are created by using the sliders.*

16. At this point, if you port the body to Layout and do a test render, you should see something like Figure 28.32.

17. Use the MorphMixing process in Modeler to create a series of morphs for the torso. You may want to copy and paste the neck to the torso layer beforehand. When finished, save the model and port to Layout. Use the En-

FIGURE **28.34** *The more sliders you use, the more complex the pose.*

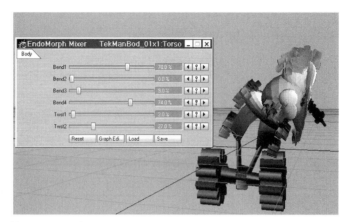

FIGURE **28.35** *Note that too much morphing can severely distort the geometry.*

domorph Displacement filter to bring up the MorphMixer panel. Use the sliders to create morphed poses for the torso. See Figures 28.33 to 28.35.

18. Create arms from bent capsule objects. Make a lower and upper arm part on both sides of the body. Move the Pivots where they belong so that the arm parts will rotate correctly. Apply a Peas surface from the Strange surfaces

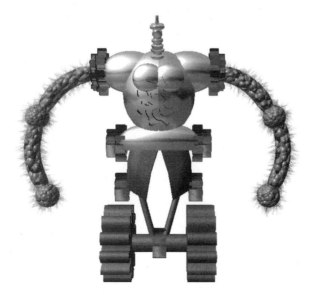

FIGURE **28.36** *A rather imposing personality is emerging, even without the head placed yet.*

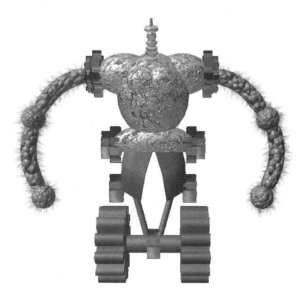

FIGURE **28.37** *The torso looks more worn after the application of the Disgusting shader.*

presets, and up the bump to about 200%. You can use a sphere for hands because this character is rather brutish, and using a sphere you can shape hands that look like clubs or demolition balls. If you have Sasquatch, apply some fuzzy hair to the arm parts. See Figure 28.36.

19. Hmmm … I wonder what this character's torso would look like mapped with the Disgusting shader from Worley Labs. Let's try it. See Figure 28.37.

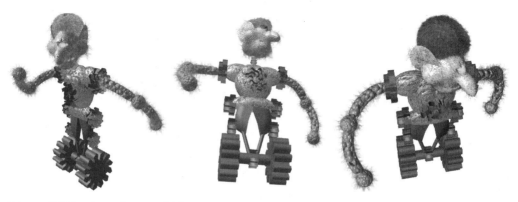

FIGURE **28.38** *TekMan is ready to rumble!*

20. At last we can add the head object and parent it to the torso. We've used Sasquatch to give TekMan a curly head of red hair—and a somewhat shaggy facial appearance as well. Parent the head to the torso and save, and also save out the object if you want to load the Sasquatch settings again. See Figure 28.38.

ONWARD

In this chapter, we used many of the skills detailed in this book to create Tek-Man, a rather unpleasant bloke. The next advanced tutorial looks at the creation of FireMouth and requires the Illusion application from Impulse Software.

CHAPTER

29

FireMouth

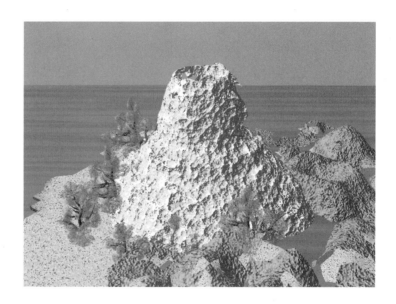

ireMouth is not a posable character who has eaten too many chili peppers, but is rather a monster of sorts. FireMouth is a conjectured active volcano, dominating the landscape of a distant island somewhere in the Pacific Rim. This project gives you a chance to explore the application of some fire effects through the use of both HyperVoxels and Illusion from Impulse Software. Let's get to it!

USING FIREMOUTH

Allow your consciousness to float out over the Pacific Ocean to the domain of FireMouth, and do the following:

1. Open Modeler. Create a profile of FireMouth with the Bezier Pen tool that will be lathed. Move some of the points around until you have a randomly curved semiconical shape. See Figure 29.1.
2. Lathe the shape. See Figure 29.2.
3. Triple the polygons. Check Smooth and Double-Sided in the Surface Editor. Use gemLOSS3 to reduce the number of polygons by about 75%.
4. Right now, the form is extremely conical and symmetrical. Break the symmetry to create a more natural form by using the Magnet tool to create bumps and ridges on its surface. Work intuitively. See Figure 29.3.

FIGURE *Create the profile for a volcano.*
29.1

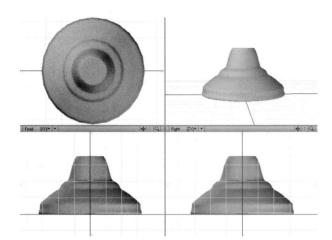

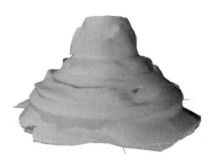

FIGURE *Lathe the shape to create the basic form.*
29.2

FIGURE *Break the symmetry by shifting*
29.3 *the polygons around.*

5. Create a cylinder from an extruded disk, positioning it and sizing it to act as a cutter for the vent. See Figure 29.4.
6. Go to Multiply>Combine>Boolean>Subtract to form the vent. See Figure 29.5.
7. Add a Rock_1 texture from the Rock folder in the Surface Editor to the volcano. Increase the bump to 300%. See Figures 29.6 and 29.7.

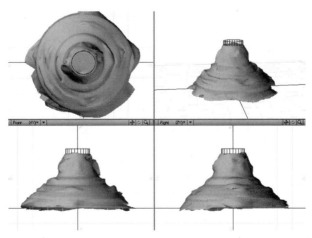

FIGURE *Create a cylinder.*
29.4

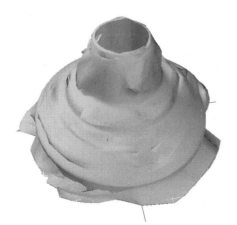

FIGURE **29.5** *Create the vent by Boolean subtraction.*

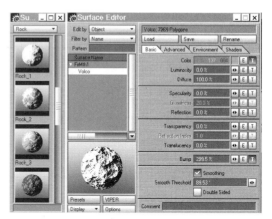

FIGURE **29.6** *Add a Rock_1 texture to the volcano's surface.*

FIGURE **29.7** *The rendered result.*

8. Go to a separate layer in Modeler. Go to Create>More>Plot 2D. Accept the defaults after highlighting Rectangle. Rotate the 2D plot so that you have a standard elevation display.

9. In the Surface Editor, switch on Smooth and Double-Sided. Map with a Vine Ridges texture preset from the Nature library. See Figure 29.8.

10. Go to Triple and Smooth SubDivide. From the top view, cut away polygons on the edges to give the surface a shape like an island. Add some depth by using Extrusion on the height. Stretch as needed. See Figure 29.9.

FIGURE *The 2D plot.*
29.8

FIGURE *Give the plot an island shape.*
29.9

11. Move the island layer so that the volcano rests off center, breaking any symmetry. Scale as desired. See Figure 29.10.

12. As you can see, there are some low-lying hills on the island. Leaving them mapped with the same rocky texture as the island would look strange, since the island is supposed to be in the Tropics, and the volcano is dormant much of the time. So here's the trick: copy/paste the island to another layer.

FIGURE *The volcano is placed on the island.*
29.10

13. On the pasted layer, cut away that part of the terrain not associated with the hills, and also cut some holes in the hilly part. See Figure 29.11.
14. Save the object.
15. Delete the volcano and island layers so that all you have left is the foliage (yes, that's what it will be) layer.
16. Cut and paste the foliage to the bottom layer. Save it as a separate object.
17. Create a bumpy green texture for this object and save again.

FIGURE *The cut-away layer.*
29.11

FIGURE *FireMouth Island.*
29.12

18. Go to Layout and import both objects. Move the foliage object up so that it casts a slight shadow on the terrain below. Now you have an island with a volcano, surrounding terrain, and some foliage on the low-lying hills. See Figure 29.12.

19. Something's missing. Of course—the water plane is needed! Import the water object from the Landscape folder. Explore altering the surface texture until you get something you like. Position in the scene. See Figure 29.13.

20. Inside the Landscape folder is another folder called Parks. In that folder you'll find a tree object. Load it in the scene.

FIGURE *Add the water.*
29.13

FIGURE *Add some trees.*
29.14

FIGURE *Add a dark-red sky.*
29.15

21. Go to the Scene Editor and highlight the tree object. Right click on it (Windows) or Option click (Mac) and select Clone from the list. Clone the tree object five times.
22. Scale and position the clones to give the island more interest. See Figure 29.14.
23. If you have the Ozone 3D plugin we covered previously, use it to create a dark-red sky. If you don't own Ozone 3D yet, use SkyTracer to create a sky. Another option would be to import your own sky image (photo or painting) as a sky backdrop. See Figure 29.15.
24. The reason for using a dark sky is that pyrotechnics work best against a darker backdrop. Save your work.

PYROTECHNICS

There are three ways you can add fire effects to a LightWave scene, image, or animation:

- You can map a fire or explosion image or animation to an object. Images and animations usually come with Alpha channel data that can be mapped to the Transparency channel in LightWave, allowing irregularly shaped data, like a fire or explosion, to seem as if it is taking place in 3D. One drawback

to this approach is that the image or animation must not reach the borders of the object, or you'll wind up with linear edges that look strange when rendered. Because of this disadvantage, we will not go into further detail on this method. If you prefer using it, however, it is strongly recommended that you check out Artbeats Reel collections (*www.artbeats.com*). Artbeats Reel collections are CDs bulging with high-quality smoke, fire, water, clouds, and other photographic material, all of which was shot for use in the movies as a compositing source. You can also use source material like that found in the Reel collections in a post-production environment, doing your compositing work in an application like Adobe After Effects, Discreet's Combustion or Effects, or NewTek's Aura.

- A second option would be to use a particle system effect inside of Light-Wave itself. This could be the particle system that ships with LightWave 6.5 and above or a LightWave particle system plugin; in the next few pages we'll look at a way of adding these effects to LightWave's native particle system. The advantage of using a particle system is that you are working in a virtual 3D realm, so if you wanted to fly the Camera through the choking smoke and searing flames, you could. The disadvantage is the significant amount of rendering time. High-quality particle system effects require lots of extra rendering time—and often a good amount of testing and previewing before that—to get things just right.

- The third option is to utilize a post-production effect engine. This could be a plugin that creates pyrotechnics over a 2D image or animation as part of an application like After Effects, Combustion, or Aura. When you get right down to it, however, these applications can be limiting in terms of fine-tuned controls and creative options. To work effectively, then, the post-production effect engine must be able to apply what appear to be 3D particles in a 2D environment, as well as allowing maximum intuitive interaction and design options. There is only one choice available that meets all of these criteria: Illusion from Impulse, which we have already touched upon in the part of the book dealing with handshaking applications. Later in this chapter we will focus on using Illusion as a way of solving the volcano challenge.

A LIGHTWAVE SOLUTION

TUTORIAL

Note that this is *a* LightWave particle system solution, not *the* LightWave particle system solution. There are hundreds, if not thousands, of ways to tweak the

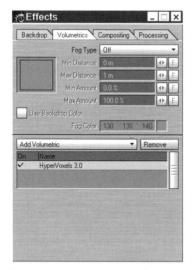

FIGURE **29.16** *Select a HyperVoxel Volumetric.*

FIGURE **29.17** *The Geometry tab.*

FIGURE **29.18** *In the Shading tab, use a Texture for the color. Select a gradient that ranges from yellow at the bottom to red at the top. This means the particles will be yellow as they are born from the emitter and will turn more red as they journey along and age.*

FIGURE **29.19** *The HyperTexture tab.*

parameters in a LightWave particle generator that will give you respectable fire-like results. It all depends on how much you are willing to explore and what your taste (or your art director's opinion) dictates. Here is one way to go:

1. Adjust the Camera view so that it represents the perspective you are looking for with the volcano scene.
2. Go to Items>Add>FX>Emitter. This places a particle emitter in the scene. Move the emitter so that it is inside of the volcano vent, somewhere just below the top. Check the top and a side view to center the placement.
3. Go to Scene>Effects>Volumetrics and select a HyperVoxel item from the Add Volumetrics list. See Figure 29.16.
4. Double-click on this item to bring up the HyperVoxel settings. Highlight the name of your emitter by double-clicking on it and the parameters will become available. For a start, use the settings indicated by Figures 29.17 to 29.19 for the parameters. You can always explore your own settings later.
5. Bring up Object Properties for the emitter. See Figure 29.20.
6. Double-click on the FX Emitter item under Add Custom Object. This will bring up the particle parameter settings. Use the values displayed in Figures 29.21 to 29.24 for the particle parameters.
7. Remember, this is just one solution to the problem, and it may not be your favorite one. Tweak all of the parameters and render to preview other possibilities. See Figure 29.25.

You can explore the Volumetric as opposed to the Sprite HyperVoxel to get a more robust 3D solution, but be prepared to wait much longer for the system to render.

FIGURE **29.20** *The emitter's Object Properties window.*

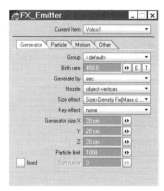

FIGURE **29.21** *The Generator tab.*

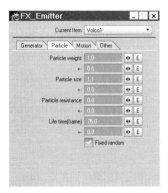

FIGURE
29.22
The Particle tab.

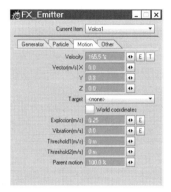

FIGURE
29.23
The Motion tab.

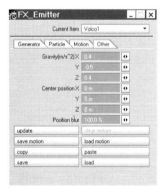

FIGURE
29.24
The Other tab.

FIGURE
29.25
The particles generated by the parameters suggested created this fiery example.

AN ILLUSION SOLUTION

TUTORIAL

Now we'll explore how Illusion can help out in this situation:

1. Open Layout and load the volcano scene you created. Remove all plugin references that have anything to do with the particle system, and delete the emitter. Render a scene that you can save as an image for export to Illusion, and save it to disk. See Figure 29.26.

FIGURE *The image to be ported to Illusion.*
29.26

2. Open Illusion and double-click on the thumbnail that represents the image content of the present layer. When the Path window appears, locate the volcano image you just rendered and saved from Layout and load it. When asked if you want the Stage scaled to suit the image, enter Yes. The image will appear on the Illusion Stage. See Figure 29.27.
3. It is assumed that you have already mastered the names and locations of the Illusion toolset, since we covered them in Part IV of the book. Activate

FIGURE *The image appears in Illusion.*
29.27

FIGURE *Smoke is the first sign that something is going to*
29.28 *happen.*

the Blocker tool and carefully block out the front of the volcano vent and the rest of the volcano beneath that. Extend the horizontal portion of your blocking mask to encompass some of the sky to each side; this will prevent your emitter from leaking particles where they are not wanted.

4. The first emitter you'll want to apply is one that creates fiery smoke prior to an explosion. Here we used Fiery Clouds Rays. Place the emitter below the vent inside of the mask. That way, the smoke will seem to be emitted from somewhere deep in the core of the volcano. Preview. See Figure 29.28.

FIGURE *Place an emitter for the explosion.*
29.29

FIGURE *Create some sparks.*
29.30

5. Repeat the same emitter about a third of the way down the timeline to the final frame. This allows the effect to composite against itself.

6. About halfway down the timeline towards the finished frame, place an emitter for an explosion effect. We used Blast, which creates an explosive blast followed by a shower of sparks—perfect for a volcano. See Figure 29.29.

7. About a quarter of the way from the end of the animation, use an emitter that create a shower of sparks that fall to the ground. We like the one called Sparks. See Figure 29.30.

8. Create the animation. If all you need are single images, then create the animation as a single frame sequence, taking the frame or frames you need..

ON THE CD

Look in the Anims folder on this book's CD for the animation called "Volco2.mov." It displays the results of the LightWave/ Illusion handshaking.

ONWARD

In this chapter, we created an active volcano. In the next chapter, we'll exit the planet on the Starship WaveRider.

WaveRider

cience fiction topics continue to dominate the way computer graphics and animation are used by amateurs and professionals alike, perhaps because of their widespread application in major films and broadcast pursuits. In recognition of this fact, we will create a spaceship in this chapter. There are two basic design concepts that are applied in the creation of spacecraft. The first is based upon a clean design—on producing something that is aerodynamically sleek and that perhaps possesses an allover chromed surface like the grille of a 1956 Buick. LightWave is certainly famous for the application of this design concept, including its implementation in the creation of the Star Trek ships. The second design concept, however, which is aimed at creating complex, convoluted models mapped with rust and grimy surfaces, could be said to be the more interesting of the two. It also offers more opportunity for applying your own original elements. And think of it—you can always excuse whatever unusual design results by calling your model an "alien ship," with the understood implication that alien designers and civilizations think and design differently than Homo sapiens do. That's the type of craft we will walk through here. Let's begin:

TUTORIAL

1. Open Modeler. Sketch a profile that can be lathed to form the engine outlets. Use the side view. Refer to Figure 30.1.
2. Lathe the engine and stretch it out until it looks like the form you want. See Figure 30.2.
3. Triple and reduce the polygons. There is no need for excessive polys on this part.

FIGURE *The profile to be lathed.*
30.1

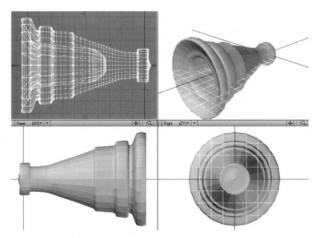

FIGURE *Lathe the engine form.*
30.2

4. Open the Surface Editor. Rename the Default surface "Engine." Configure a surface texture. We've used the Cow Eyes texture from the cow model, increasing the Diffuse percentage to 90%. See Figure 30.3.

5. If you were to accept the current surface, you would have a nice, smooth, metallic look. But this ship has been away from its home port for centuries and bears the marks of micrometeorite impacts and space dust accumulation; in other words, we need to dirty it up. Apply the bump map texture settings displayed in Figure 30.4, and set the bump map percentage to –250%.

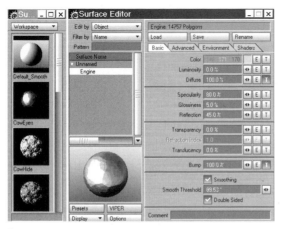

FIGURE *Rename the surface and apply a texture.*
30.3

FIGURE *Use these values.*
30.4

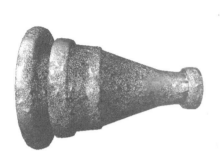

FIGURE *The crusty result.*
30.5

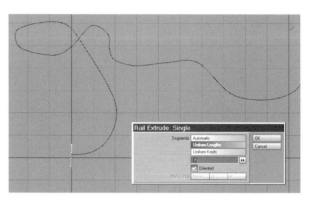

FIGURE *Use these parameters.*
30.6

6. Port to Layout and render. See Figure 30.5.
7. Create a random curved path on one layer (a background layer) and a disk on another layer (a foreground layer). Click on Rail Extrude and set the parameters as displayed in Figure 30.6.
8. Click OK to create the convoluted tube. See Figure 30.7.
9. Rotate and position the tube (which is really both an engine strut and a fuel line) in relation to the engine, using the engine as a background layer guide. See Figure 30.8.
10. Use the Modes menu list to make the origin the Action Center.

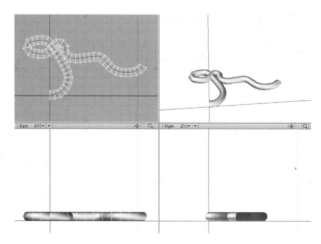

FIGURE *Create the curvy tube.*
30.7

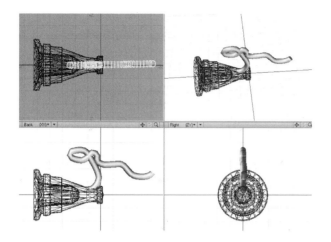

FIGURE *Rotate and position the tube.*
30.8

FIGURE *Use these parameters.*
30.9

11. Go to Multiply>Duplicate>Array. Use the settings displayed in Figure 30.9 and click OK.

12. The result is a star-shaped array of struts to hold the engine in place. See Figure 30.10.

13. Go to Layer settings to make the engine the parent of the struts layer. In the Surface Editor, apply a suitable metallic texture to the struts. Port the model in its present phase to Layout and do a test render. See Figure 30.11.

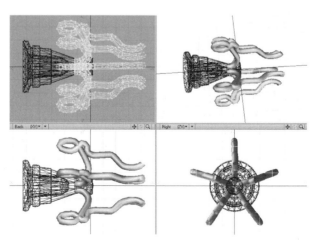

FIGURE *The struts are formed.*
30.10

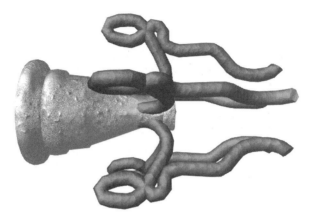

FIGURE *A test render.*
30.11

14. Since it might be useful to have more than one engine, we don't really need two layers. Cut the tubes layer and paste to the engine layer. Make sure the layer is still named "Engine."

15. Make sure Modes is still set to the Origin Point. In a view that displays the engine from the front or back, move the engine so that it relates to the origin of the grid as displayed in Figure 30.12.

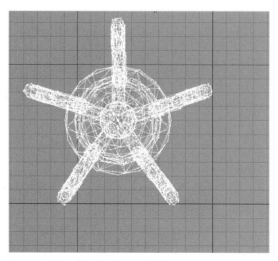

FIGURE *Move the engine complex.*
30.12

16. Create a four-element radial array on the X axis, resulting in the quad-engine model shown in Figure 30.13.
17. Stretch on the X axis for a little more length. See Figure 30.14.
18. Do a test render to see what you have so far. See Figure 30.15.
19. Using a side view, move up the engine complex so that it sits on the Y axis relative to Figure 30.16.

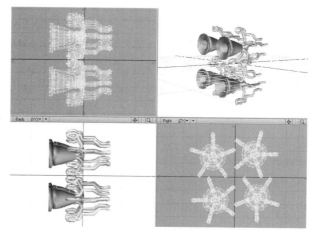

FIGURE *The quad-array is created.*
30.13

FIGURE *Stretch on the X axis.*
30.14

FIGURE *Looks like some serious plumbing.*
30.15

FIGURE *Move the engine complex in a side*
30.16 *view like this.*

20. On a separate layer, using the engine complex as a background guide, we are going to create a blast shield. Create a disk on a view that shows the engines head on and manipulate the points on the disk as displayed in Figure 30.17.
21. Extrude to create the blast shield. See Figure 30.18.
22. Use the Taper 1 operation in the top view to create a more interesting shape for the blast shield. Do a test render. See Figure 30.19.

FIGURE *Create a disk-based shape like this.*
30.17

23. Edit, cut, and paste to place everything on one layer in Modeler.
24. Copy and paste to another layer, and move to create two side-by-side blast shield/engine elements. See Figure 30.20.
25. On a separate layer, use your modeling skills to create the form shown in Figure 30.21 from a sphere, using the Magnet tool on selected polys.

FIGURE **30.18** *Extrude to create the finished blast shield.*

FIGURE **30.19** *Taper the blast shield.*

FIGURE **30.20** *Duplicate the constructs.*

26. Go to Multiply>Duplicate>Mirror in the top view to double the form on the origin. See Figure 30.22.
27. Surface by placing an image map (like one of the dvGarage grime maps) in the Specular channel to dirty up the texture, and use the Gold Metal texture. See Figure 30.23.
28. Use a similar technique on a separate layer to create half of the bottom of the ship from a sphere, modifying it with the Magnet tool. See Figure 30.24.

FIGURE *Reshape a sphere to resemble this object.*
30.21

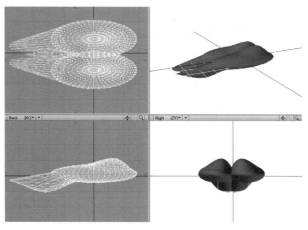

FIGURE *Mirror the form.*
30.22

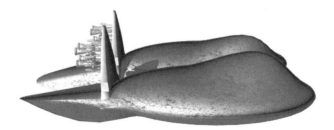

FIGURE *Use a grimy map in the Specular channel.*
30.23

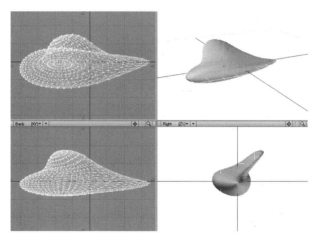

FIGURE *Create this form or one that is similar.*
30.24

TUTORIAL

GREEB MAPPING

A Greeb (sometimes called a "Greeble") is that part of a model that makes it look very complex, while actually being just an added-on structure that means nothing. A good example of a Greeb is the surface of the Death Star from the Star Wars films. The Death Star is a model whose surface contains all sorts of complex add-ons, most of which were placed there just for the sake of adding to the complexity. Greebs can be created by bump mapping or displacement mapping. If you are going to remain at a good distance from the model with the

Camera, then bump mapping may suffice. If you plan a close-up view, displacement maps will work far better. Displacement maps, however, require a much heavier poly count to get the 3D effect to work right. We'll map the part of the fuselage we just created with Greebs, trying both a bump and a displacement map so as to compare the two. Do the following:

1. Triple and Smooth SubDivide the model you just created to give it a heavier poly count. You may even want to Smooth SubDivide twice.
2. Open an image editing application. Photoshop will do. Open the Microchip.tga image from the Images>Computer folder.
3. Quadruple the size of the canvas you are working on and copy and paste a few more of the microchip images next to each other. You should wind up with something that looks like Figure 30.25.
4. Collapse all layers into one image and heighten the contrast.
5. In LightWave Modeler, import this image as a bump texture to apply to the part of the ship most recently modeled. Use planar mapping. Do a render to see what it looks like after exploring different bump percentages. See Figure 30.26.
6. Here we were unable to arrive at an image that looked anywhere near as good as the bump map when applying a deformation map, so we stuck with the bump. You may have better luck. In Modeler, Mirror the part just

FIGURE *The finished Greeb configuration.*
30.25

FIGURE **30.26** *Here's one workable bump map example of the Greeb texture. Planar edge-to-edge mapping was used on the Z axis, with Amplitude set to 2. The object was referenced for Automatic Sizing. Bump was set to 1,000%.*

FIGURE *Mirror and position.*
30.27

FIGURE *The finished model. The Greebs show up nicely against a gold*
30.28 *metallic texture.*

completed in the top view and place it in relation to the rest of the model. See Figure 30.27.

You can add more small components if you like, but the ship can also serve just as it is. See Figure 30.28.

ONWARD

In this chapter, we concluded the book with a tutorial that detailed the creation of a spacecraft, the WaveRider. We hope that you have found this book informative and enjoyable, and that you keep "riding the Wave."

On the CD

The CD that accompanies this book is full of all sorts of goodies for your use and exploration. The contents include the following LightWave material:

ANIMS FOLDER

Here you'll find a collection of LightWave animation examples, all in QuickTime format. You can download QuickTime from *www.apple.com* if you don't have it.

COLOR PLATES FOLDER

All of the color plates in the gallery are included in this folder in TIF format.

MODELS FOLDER

This folder contains 3D models that you can import into LightWave.

PROJECT FOLDER

Here you'll find all of the LightWave projects alluded to in this book.

SCENES FOLDER

Various LightWave scene files are located here.

TEXTURES FOLDER

This folder includes ten textures created with the help of U&I Software's ArtMatic on a Mac. The files are in TIF format, so they will work on either a Mac or PC.

The CD also includes a wealth of demos for you to explore. They are included in the Software folder in separate Mac and Win folders. This handshaking software can expand your LightWave creativity.

Included is:

AcidPro 3 Demo (Win):
AcidPro can be used to create music tracks for your LightWave projects.

Amapi (Mac and Win)
This is a full working version with no constraints. A demo of Amapi version 6.1 is also included, allowing you to distinguish the new features of the higher version in case you want to upgrade from version 4.15. Use Amapi as an alternate modeling system to create LightWave models, or as a 3D conversion system to export other modeling formats into models that can be exported to LightWave.

BodyPaint 3D Demo (Mac and Win)
Use this demo of Maxon Software's BodyPaint to paint in 3D in real time on your LightWave models, creating textures not possible to arrive at using other methods.

Illusion Demo (Win)
Impulse's Illusion is the best and easiest way to create post-production pyrotechnic effects on a LightWave image or animation.

Poser and PoserProPak Demo (Mac and Win)
Demo versions of Poser 4, Poser ProPak, and the LightWave plugin are included here for both Mac and Windows users. Use Poser to create articulated poseable models for your LightWave scenes.

Xfrog Demo (Win)
Use this demo of Xfrog, from Greenworks, to create all manner of flora that can be exported as a WaveFront file for use in LightWave.

SYSTEM REQUIREMENTS FOR LIGHTWAVE 7

Windows

Pentium III or higher

- 24 bit color card & Monitor capable of displaying high resolution (at least 800 x 600)
- WIN 98/Me/NT4 (Svc Pk 6a)/2000 (Svc Pk 2)
- Min of 128 MB RAM. More is better.
- TCP/IP Network Protocol Installed
- CD-ROM
- Hardware Lock Port—USB or Parallel
- Minimum HD space of 32MB. More is better.

Mac

Power Mac Processor G3 or higher

- 24 bit color card & Monitor capable of displaying high resolution (at least 800 x 600)
- Mac OS 9.x/OSX
- Min of 384 MB RAM for OS 9.x; 128 MB RAM for OSX.. More is better.
- CD-ROM
- Hardware Lock Port—USB or ADB
- Minimum HD space of 32MB. More is better.

B Contact Information

Use the following URL addresses to view the Web sites of LightWave and other developers:

www.newtek.com This address brings you to the NewTek Web site. Visit it often to stay aware of upgrades and news, as well as to access its list of authorized plugin developers.

www.worleylabs.com Worley Labs is constantly creating new LightWave plugins and upgrading existing ones. Check out this site at least once a month.

www.dvgarage.com Stay abreast of the texture offerings of dvGarage.

www.eovia.com This is the home of Amapi, which is upgraded on a frequent basis.

www.greenworks.de Xfrog lives here. Refer to this site for news of coming upgrades and other wares.

www.maxoncomputer.com Information on new editions of BodyPaint 3D and Maxon's other wares can be found on this site.

www.electricimage.com This is where you'll find the latest information on Amorphium, a very useful handshaking application for LightWave modeling.

www.curiouslabs.com Go here for the latest news on Poser upgrades and releases.

www.daz3d.com When it comes to high-quality Poser models, you can't beat Daz 3D. Check this site at least once a month for new collections and free downloads.

www.sonicfoundry.com Sonic Foundry not only develops AcidPro, but also dozens of looped WAV files for creating high-quality music and F/X sound

tracks that can be added to your LightWave animations. Sonic Foundry offers a number of additional multimedia applications as well.

> *www.coolfun.com* This is where you'll want to head to download the free Illusion library files, released each month. Also check out information on the latest Illusion releases.

> *www.onyxsoftware.com* Tree Professional is the software LightWave users depend on for creating realistic trees and shrubs for their scenes.

Don't forget to check out additional sites to download LightWave plugin freeware and shareware. Just type in "LightWave Plugins" in your favorite Web browser.

Index